SCULPTURE
IN PAINTING

On the Meanings of Sculpture in Painting

Curated by Penelope Curtis

Henry Moore Institute

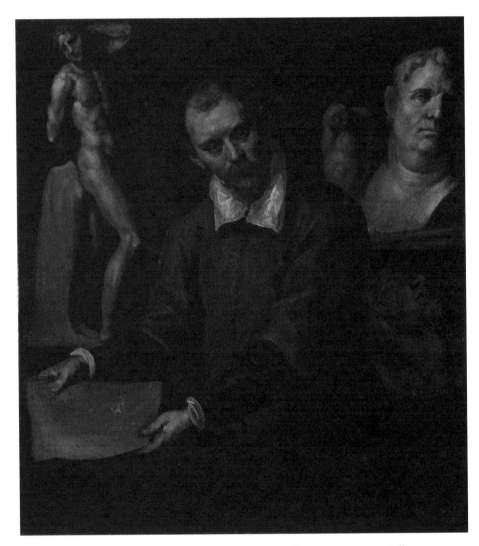

fig. 1. Palma il Giovane, *Portrait of a Collector*, 1600–20, Birmingham Museums & Art Gallery

Penelope Curtis

SCULPTURE IN PAINTING:
AN INTRODUCTION

The relationship between sculpture and painting has long been debated. Their relative merits have been the subject of countless learned discussions which have themselves been subsequently analysed. Their distinctive qualities have also long been a spur to artists seeking to achieve painterly effects in sculpture or vice versa. The subject of this exhibition, however, is not so much the comparison of sculpture and painting, but rather the dialogue between them. We do not seek to establish their relative strengths and weaknesses, but rather to ask why painters use sculpture, what it means when they do, and how to understand the relationship as it is expressed within the single painted surface. Our selection is focused on paintings in which sculpture is represented, rather than on artworks where the two are completely fused.

Ironically, perhaps, the paintings which are least well represented here are those which most readily spring to mind if we think of sculpture's appearance in painting. The many portraits of collectors holding a prized piece of sculpture, or of Grand Tourists posing in front of a well-known piece of antique sculpture, are not part of our selection. This show is not about the identification of particular works of sculpture at a particular time and in a particular place. We are not looking to understand Taste by means of the representation of sculpture in painting, but rather to approach more closely their inter-relation. This means that few identifiable pieces of antique sculpture appear within these pages (although a few more modern pieces do) and thus the more usual disparity—old sculpture in new painting—is noticeably underplayed. (fig. 1)

The selection is more heavily focused on the qualities of sculpture and painting than on actual sculptures. If it is, in this sense, more abstract than concrete, we nevertheless hope that the dialogue between them will raise more stimulating questions than those raised by narrower matters of identification. Rather we want to ask how artists thought of the relative meanings of sculpture and painting, and how viewers, more or less consciously, are affected by those meanings.

The works have been separated into three sections. Beginning with the relationship between inanimate sculpture and the 'living' human subject, we move through a more deliberately ambiguous section, in which we do not quite know if we are looking at paintings of sculptures or at paintings of paintings, to a group of works which portray sculpture alone and in which we are the only viewer.

Underlying the show as a whole is the relationship between sculpture as something more or less dead, and painting as something which is clearly more alive.

7

Painting animates sculpture; the painted subject is alive and brings life to the sculpture which he or she touches or admires. On the other hand, sculpture is always something which offers the possibility of a longer and more enduring life than the transient passage of the painted subject.

In conjuring with questions of life and death, of immediacy and of immortality, we play with the senses, and above all the senses of sight and touch, by which we apprehend sculpture. Sight and touch are shown, in action, throughout the first section, as the way in which the human subject bestows meaning on the sculpted object. They are also the ways in which we can choose to ignore sculpture; by actively putting it beyond sight or touch, or by treating it so casually (with the careless look or gesture) that we effectively diminish its status.

In the discussions which preceded this selection we took a longer and broader view of sculpture in painting. This included works in which sculpture appears as the backdrop—whether in the city, the countryside or the domestic interior—and as a topographical marker, whether of place or of an historical event. It was possible to develop a narrative in which sculpture gradually moved forward, from being the foil to events to itself playing a part in the action. (fig. 2)

In this journey from background to foreground there is a position in which sculptures act to mirror, echo or otherwise comment on the action going on in front of them. Oftentimes this involves the sculpture in representing what is to come (as in a scene of flirtation) or what has just happened. Sculptures are used to represent the narrative's past or its future, or its alternatives. There is also an amus-

fig. 2. Charles-Marie Bouton, *The Madness of Charles VI*, 1891, Collection Musée de Brou, Bourg-en-Bresse

ing range of pictures in which sculptures in the domestic space seem to comment on the occupants' behaviour, adding the saucy or jaundiced observations of a seasoned observer, perhaps standing in for the painter or his client. (fig. 3)

A major area in which sculptures are shown in paintings concerns representations of the artist in his (or her) studio. While we have included one or two such works, we have concentrated on the closer focus portrait, leaving a fuller assessment of the sculptors' studio to other projects. Such works—which in fact show painters as often as sculptors—belong also to a more topographical genre in which sculpture is effectively the landscape which the sitter inhabits. The views of the studios of Vincenzo Vela, for example, (fig. 4) but also of Hubert Robert, have this all-embracing spatial quality which has excluded them from the more direct—and puzzling—relationship which our project has taken as its subject. Nevertheless, portraits of sculptors engaged in making a work involve the kind of animation with which our show begins, and could make up an entire exhibition in themselves. (fig. 5)

Our selection comes up to the present day but even the most recent works might be seen as traditional in nature. While our discussions encompassed works in which sculpture had been more completely subsumed by painting, or vice versa, we have decided here to concentrate more clearly on the representation of sculpture in painting. Thus, while we looked at works from the late 1950s onwards, especially in the American field (by Robert Rauschenberg, Jasper Johns, Donald Judd and Eva Hesse in particular), we decided that our narrative was in a sense simpler, and yet sufficiently complex to deserve special consideration.

fig. 3. Simon Petit, *Defend me*, 1863,
Victoria and Albert Museum, London

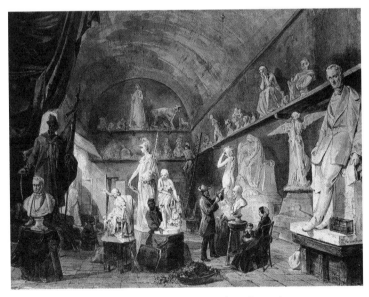

fig. 4. Pierre Henri Tétar van Elven, *Vincenzo Vela's studio, Turin*, 1858,
Museo Vincenzo Vela, Ligornetto

9

There are a number of modernist artists whose work is renowned for its fascinating interplay between sculpture and painting. Picasso, Matisse and Giacometti all painted and sculpted, and their own three-dimensional works occupy a fascinating place within their own studio paintings. At times their paintings approach the sculptural (as with Picasso), and at others their sculptures approach the living model (Matisse). It is perhaps regrettable that we were unable to secure their works for exhibition here, if it is some consolation that these works have already elicited considerable attention within this context.

At the other end of the timescale, we had originally imagined we might include works from the medieval period, in which, as we have already shown at the Institute, painting and sculpture enjoyed a dynamic relationship. Ultimately however, it seemed that, in a way not dissimilar to the twentieth century, sculpture and painting were so deeply intertwined in the late medieval or early modern period that it was difficult if not inappropriate to prise them apart. Nevertheless, we thought for some time about including works by Lorenzo Monaco, for example, which demonstrated how sculpture can be quoted within a painting, nesting within other quotations, and how it might represent one artist's homage to or comment upon another. In this it seemed very modern indeed.

Instead we commissioned three longer essays which go beyond the exhibition and its premise by taking on the wider ramifications of the subject's potential for cross-fertilisation. These essays look at how sculpture and painting mimicked, appropriated and absorbed each other, often in similar ways, but across three distinct

fig. 5. William Blair Bruce, *Sculptress—portrait of the artist's wife, Carolina Benedicks-Bruce*, 1891, Gotlands Konstmuseum, Visby

10

time-frames, from the Renaissance to the Modern. To what extent sculpture and painting were equal partners, whether painting was more ingenious in its imitation, or whether sculpture was painting's destination, depends as much upon the writer as the time-frame. These three essays precede the catalogue, which is divided into the three sections in which the exhibition is hung, and in which each entry has been specially commissioned. Together these texts combine to demonstrate how rich a subject this is; tangible, intangible, solid or evanescent, it opens our eyes to the ways in which we apprehend sculpture and painting and the meanings they make together.

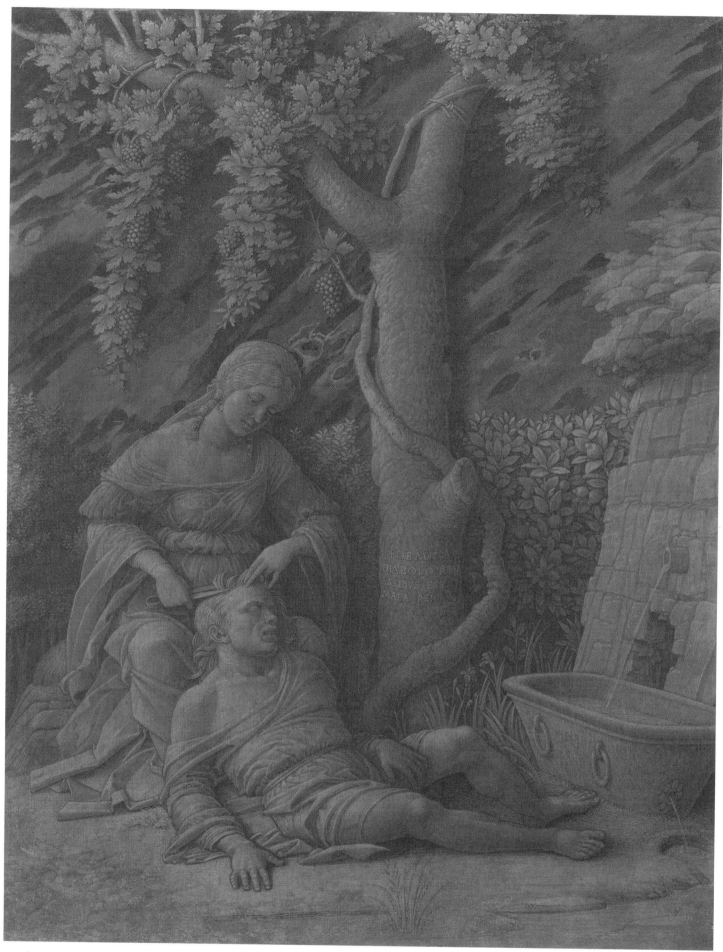

fig. 2. Andrea Mantegna, *Samson and Delilah*, *c.*1495 – *c.*1505, The National Gallery, London

Fabio Barry

SCULPTURE IN PAINTING/ PAINTING IN SCULPTURE (ITALY, *c.*1485 – *c.*1660)

When Leonardo chose to open his treatise on painting, written in the 1490s, by defending its merits at the cost of sculpture he instigated a debate over their relative merits that would linger into the eighteenth century under the name of the 'paragone' ('comparison').[1] Leonardo had set out to defend painting from any charge that it was merely a 'mechanical art', in order to elevate the artist from mere artisan to an intellectual status paralleling that of men of letters.

During the course of the sixteenth century a thick stream of artistic and literary theorists, but also actual practitioners, took up the gauntlet for the opposing teams. They included Michelangelo, Giorgio Vasari, Pomponio Gaurico, Paolo Pino, Benedetto Varchi, Vincenzo and Raffaello Borghini, Agnolo Bronzino, Benevenuto Cellini, Giancristoforo Romano, Baldassare Castiglione, and, in the following century, Giovanni Battista Armenini, Federico Zuccari, Giulio Mancini, Giovan Battista Marino, Vincenzo Giustiniani, Galileo Galilei, and Orfeo Boselli.

The ongoing debate tended to reshuffle the same deck of ideas, sometimes in a disturbingly simplistic manner, not always free of pedantry, and as a rule organised into binary oppositions. Even before Leonardo, from at least Petrarch in the 1350s, sculptors had extolled the durability of sculpture over paint, to which Leonardo rejoined (and would still be echoed by Galileo) that this owed nothing to art and everything to the material; sculptors countered that the physical challenge of carving the block was a measure of the 'difficulty' of the art; painters replied that such difficulty was more labour than art, contrasting the courtly 'facility' of the painter's endeavour with the strivings of the brutish sculptor; sculptors rejoined that while the painter could improvise and always retouch his painting (it was therefore the 'art of addition') there was no room for error in sculpture (which was the 'art of subtraction'). Sculptors were virtually claiming infallibility. They also disparaged the shallow illusionism of painting in contrast to the multiple viewpoints of freestanding sculpture. Giorgione (1478–1510) famously responded by painting a 'St George', reflected in a pool as well as in two mirrors, to demonstrate that painting alone could present an entire figure in a single glance. And so on, and so on. A consistent motif was that while painting could conjure up the appearance of reality—not only the handling of light, shade, and colour but also the ability to portray distance and thereby collapse several scales into one plane—sculpture was at best a transcription of reality because it could merely reproduce figures at 1:1. Indeed, the ultimate accomplishment of painting, it was

1. In formulating my ideas about the paragone, I have often profited from discussion with Maarten Delbeke and Steven Ostrow. Some aspects of this essay were presented at a round-table at the Scottish National Portrait Gallery in 2008, others at the 2009 international conference *Bernini's Paragoni* held at the National Gallery of Scotland, co-organised by the author and Genevieve Warwick.

ESSENTIAL READING ON THE PARAGONE INCLUDES:
L. Fallay d'Este, *Le Paragone: Le parallèle des Arts*, Paris, 1992, M. Pepe, 'Il "Paragone" tra pittura e scoltura nella letteratura artistica rinascimentale', *Cultura e scuola*, 1969, vol. 8, pp. 120-31, M. Collareta, 'Le "Arti Sorelle". Teoria e pratica del "Paragone"', in *La Pittura in Italia: Il Cinquecento*, ed. G. Briganti, Milan, 1988, pp. 569-80, S. La Barbera Bellia, *Il Paragone delle arti nella teoria artistica del cinquecento*, Rome, 1997, P. Barocchi, 'Die Wettstreit zwischen Malerei und Skulptur: Benedetto Varchi und Vincenzo Borghini', in *Ars et Scriptura: Festschrift für Rudolf Preimesberger zum 65. Geburtstag*, ed. H. Baader, U. Müller Hofstede, K. Patz and N. Suthor, Berlin, 2001, pp. 93-106, C. Farago ed., *Re-reading Leonardo: The Treatise on Painting across Europe 1550–1900*, Farnham/Burlington VT, 2009.

argued, lay in its mimetic superiority: the further the means of imitation were from the object in question, the greater the degree of illusion required, and thereby the mental skill that elevated art above craft. Painting by its very nature was the two-dimensional representation of volume, and therefore took the palm.

One of the few places, however, where minds met was in the realm of relief, especially the most flattened sort (*rilievo schiacciato*) that had been pioneered by sculptors of the calibre of Donatello (1386–1466), Desiderio da Settignano (*c.*1430–64) and Agostino di Duccio (*c.*1418–*c.*1481). Relief was already akin to painting by virtue of its planarity, in fact by even having a background at all, but *rilievo schiacciato*, in which the planes of carving might be as subtle as a millimetre, required a command of illusion that vied with painting in its ability to compress the representation of space into so shallow a field. Even Leonardo had conceded that this sort of relief was 'a mixture of painting and sculpture'.

Furthermore, while the paragone was often couched in adversarial terms, pitting the brush against the chisel, and although each side may have been wary of being supplanted by the other in the battle for commissions, experience also taught the teams of artists involved in large-scale public works that the arts were just as collaborative as they were competitive. Moreover, because the pursuit of the paragone offered an arena for the interaction of the arts in theoretical terms, it became a stimulus to invention not only thanks to the commonalities that made any comparison possible, but also to the distinctions that provided a creative differential. In short, it encouraged the artist to think across any party lines.

A well known example of the paragone in practice is Titian's 'La Schiavona' (*c.*1510–12) in this exhibition (see p. 80). Some comparison between the arts must have been intended in this yin-yang composition, otherwise Titian would not have devised the implausible profile of a parapet that morphs into a relief. In the conventional terms of the paragone the smiling and buxom lady would contrast favourably with the bloodless, almost sepulchral, relief, while the limitations of sculpture would be further evidenced by the fact that she is shown only in profile; and painting would anyway triumph through its ability to demonstrate two viewpoints in one frame. However, the relationship may be less antagonistic than reciprocal: the sitter is unembarrassed by the alter image which she fingers, perhaps beckoning the sense of touch. Even the most partisan champions of painting allowed that it exploits only one sense, sight, while sculpture offers two; conversely, painting has 'captured' the appearance of sculpture and sealed it below its surface. All in all, we cannot be sure that the young Titian's intention was a challenge so much as a claim to fraternity in an artistic élite. For it has been argued that, in choosing to portray this sort of relief, Titian was consciously matching himself against Tullio Lombardo (1455–1532), the pre-eminent Venetian sculptor of his day and a virtuoso carver, in the round, in relief high or low, and classicising portraiture of all kinds.[2]

2. L. Freedman, '"The Schiavona": Titian's Response to the Paragone between Painting and Sculpture', *Arte Veneta*, 1987, vol. 41, pp. 31-40.

Lombardo himself was *au fait* with the commonplaces of the paragone, as revealed in a letter of 1526 where he commends to a patron the durability of sculpture over painting, citing as proof the abundant survival of ancient sculpture over the relative paucity of ancient painting. And it can hardly be coincidence that he also began carving, only to abandon, a low relief that copied Leonardo's renowned 'Last Supper' in Milan.[3] Tullio's own engagement with the paragone, and that of his brother Antonio (1458–1516), involved not only the virtuoso execution of bas-reliefs, but the bold injection of colour in the shape of porphyry or even agate inlays—quite probably influenced by wood marquetry. Bolder still were the large reliefs that the brothers executed on the façade of the Scuola Grande di S. Marco (1489–95) (fig. 1.a) and within the Cappella di Sant'Antonio (1500–1) in the Basilica del Santo in Padua. These combined all degrees of relief, from the virtually freestanding, through shallow bas-relief (Leonardo's 'mixture of painting and sculpture'), to the virtually engraved, the last purposefully more like drawing than carving (fig. 1.b). Finally, streaky marble panels were used as background inlays to suggest skies riven with cloud, and the whole ensemble is contained by illusionist passageways in false perspective that not only reconcile sculpture to architecture but provide another link with painting. As Leonardo had said, 'low relief is a form of painting…as far as drawing is concerned, because it participates in perspective'.

The material tactics of the Lombardo brothers were illusionistically shared by a painter never far from their imaginations, Andrea Mantegna (*c*.1431–1506). At the close of the fifteenth century, in just the same years, Mantegna devised a completely new genre of painting in which fictive low-reliefs of gilt bronze or marble are silhouetted against richly veined, but again feigned, marble backgrounds.[4] Mantegna

3. A Sarchi, *Antonio Lombardo*, Venice, 2008, pp. 120-124.

4. R. W. Lightbown, *Mantegna: With a Complete Catalogue of the Paintings, Drawings and Prints*, Oxford, 1986, pp. 210-218, K. Christiansen, 'Paintings in Grisaille', in *Andrea Mantegna*, ed. J. Martineau, London, 1992, pp. 394-417.

fig. 1.a. Pietro, Tullio and Antonio Lombardo, detail of the façade of the Scuola Grande di S. Marco, Venice, 1489–95

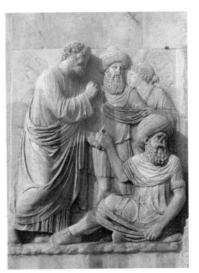

fig. 1.b. Tullio and Antonio Lombardo, *The Healing of Anianus*, Scuola Grande di S. Marco

15

had been criticised from the outset of his career for painting figures that were more statuesque than vital, but here he devised an art form of 'substitute reliefs' that married the depth of painting with the illusion of a two-layer relief. This marriage is a complete fiction, and in some cases the carving would have tested the skill of any sculptor (fig. 2). More notable still, however, is that in these fictive confections Mantegna chose to simulate coloured marble in the backing slab, a medium that had long been hailed as a natural form of painting because of its brushy veining, its venue for images made by chance and its variegated palette, sometimes all within the same slab. Just like cameos, the marble medium—a sort of frozen painting by Nature (or God) the Artist—posited a loop-hole in the rules of the paragone.

By 1550, even an avid interlocutor of artistic theory like Giorgio Vasari (1511–74) regarded the paragone debate as sterile, and Michelangelo simply said '*basta!*'. Yet Mantegna's fictions would become fact in that genre of sixteenth-century reliefs where gilded bronze reliefs are mounted on marble supports (fig. 3), especially the black variety coincidentally known as *pietra di paragone* (in English, 'touchstone').[5]

Other ingredients, now supplied by practice rather than debate, also entered the mix. From Sebastiano del Piombo onwards (1530), painters had countered the charge that painting was not 'eternal' by painting directly onto marble slabs. The added attraction, as more than one observer remarked, was that when the painter attempted to adapt his composition to the veining of the slab then 'the skill of the artist played with the art of nature'. By the late sixteenth century, this painting *on* stone had turned to painting *in* stone, in the shape of the elaborate table-tops and easel-pieces produced by workshops from Prague to Naples, assembled from

5. It was common for any black stone to be called *pietra di paragone* from at least the sixteenth century. The term was borrowed from the dark basalts used to assay precious alloys, especially coins. By rubbing the metal to be assayed across the stone, adjacent to a streak of a metal of known purity, and then treating both with nitric acid to dissolve impurities, the contrast between pure and impure metal, between true and debased coins, became obvious. This assaying by 'touch' is why *pietra di paragone* is called 'touchstone' in English and because of the 'proving' *Prüfstein* in German. In all languages the figurative use of the term also carries the same meaning, i.e. the standard by which something may be judged.

fig. 3. Pompeo Targone, to the designs of Giacomo della Porta and Gaspare Guerra, relief of St Cecilia between Sts Valerianus and Tyburtius, 1599–1603, gilt bronze on black marble, S. Cecilia, Rome

16

tesserae of judiciously selected hardstones jig-sawed into ensembles copied directly from painted cartoons (fig. 4).

These various innovations in technique, and the continuing interest in the role of painting versus sculpture as the locus of the *metatechne*, the art of art, would reach sophisticated fruition during the seventeenth century, particularly in the work of Gianlorenzo Bernini (1598–1680). Bernini had inherited not only his extraordinary facility in carving from his father, Pietro, but also his personal engagement with the paragone. Pietro used paintings as models for his sculpture, indeed virtually 'translated' them into relief, and he overtly sought to rival painting in a *tour de force* such as the massive 'Assumption', carved in 1606–10 (fig. 5). In works of such ambition, Pietro meant the multiplicity of planes, degrees of polish and variety of texture, chiaroscuro, anamorphic illusionism, exploitation of the oblique, and impression of movement to capture both visible and tangible nature, in other words to fuse sculpture's capacity for materialisation (to manifest things 'as they are') with painting's capacity for illusionism (to represent things 'as they seem').[6]

Eventually Gianlorenzo too would combat the proscriptions of the paragone by creating his own brand of 'sculpted painting' in youthful works like the 'St Lawrence on the Grille' (1617) or the famous 'Apollo and Daphne' (1622–5), works that defy the unrelenting stone by producing effects that were supposedly the prerogative of painting: supple flesh, the sheen of hair, the delicate tracery of a sapling, even smoke, transparency, shifting light, movement, but also transformation.[7] And the paragone continued to weigh on Gianlorenzo's mind sufficiently

6. S. F. Ostrow, 'Playing with the Paragone: The Reliefs of Pietro Bernini', *Zeitschrift für Kunstgeschichte*, 2004, vol. 67, pp. 329-64.

7. R. Preimesbergher, 'Themes from Art Theory in the Early Works of Bernini', in *Gianlorenzo Bernini. New Aspects of His Art and Thought: A Commemorative Volume*, ed. I. Lavin, University Park, 1985, pp. 1-24.

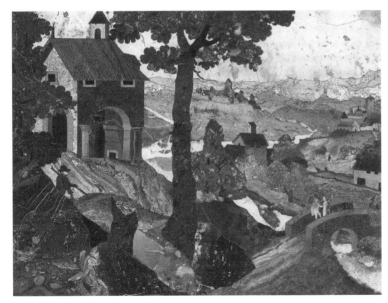

fig. 4. Cosimo Castrucci, *Landscape with bridge and chapel*, 1596, Kunsthistorisches Museum, Vienna, Kunstkammer

fig. 5. Pietro Bernini, *Assumption*, 1606–10, Baptistery, S. Maria Maggiore, Rome

8. T. Montanari, '"Theatralia", di Giovan Battista Doni: una nuova fonte per il teatro di Bernini', in *Estetica Barocca*, ed. S. Schütze, Rome, 2004, pp. 305-8. See also S. F. Ostrow, 'Bernini e il Paragone', in *Bernini Pittore*, ed. T. Montanari, Cinisello Balsamo, 2007, pp. 223-33.

for him to write a comedy (1635) in which a painter's studio and a sculptor's appeared on stage side-by-side, with the actors his own studio-hands.[8]

The Cornaro Chapel that Bernini designed in mid-career (1647–53) was a step towards a definitive solution (fig. 6). His preoccupation with the paragone is immediately betrayed by his calculated use of relief. On the side walls the Cornaro cardinals, actually their souls, are carved in white silhouette against a tinted stucco background to demonstrate, as a contemporary poet commented, Bernini's ability 'to carve colour,' and they are also enclosed in fugitive false-perspectives surprisingly reminiscent of the Lombardos' earlier formulations (fig. 7). The altar frontal (another 'Last Supper') also rehearses the genre of bronze relief on a marble ground, this time Lapis Lazuli. But these are merely supplements to the main event, the central effigy of 'St Theresa in Ecstasy', in which all the effects are extorted from a colour-less block that is unnecessarily, almost perversely, one piece of stone (the 'art of subtraction'). This effigy is indefinable within the criteria of the time and the strictures of the paragone. Theresa and her accompanying angel are in a sense a relief, indeed only what is necessary for appearances is carved. Theresa has, for example, no right arm and the figure group is hollowed out to lighten its load. More significant still—and most obviously in debt to the painterly imagination—this floating statue is the first baseless statue ever made. It is as though Bernini had taken Michelangelo's 'Pietà' and made it fly. Moreover, the Theresa occupies her own mini-building and is lit by her own sun. Effectively, Bernini has taken the back off the relief and folded it into a volume, and the idea of the 'sculpted painting' has now ballooned into that of the *built painting*. His pupil, the brilliant but short-lived Melchiorre Cafà (1636–67) seems to have acknowledged this achievement in his 'St

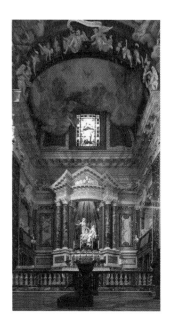
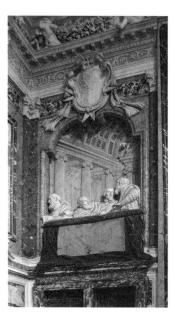

fig. 6. Gianlorenzo Bernini, Cornaro Chapel, 1647–53, S. Maria della Vittoria, Rome

fig. 7. Cornaro cardinals, lateral relief, Cornaro Chapel

fig. 8. Melchiorre Cafà, *St Catherine in Glory*, c.1662–4, High Altar, S. Caterina da Siena a Largo Magnanapoli, Rome

Catherine in Glory' (*c.* 1662–4), where he re-embedded the effigy into an intarsia background that obviously re-evoked the 'eternal painting' (fig. 8).

Bernini also subsumed the dialectic between painting and sculpture into the colourful world of polychrome marble architecture that frames and fields all the figurative sculpture.[9] Until now, architecture had generally stood on the sidelines of the paragone debate, disqualified by its inability—with the exception of the Renaissance grotto—to imitate from nature or life, with observers wavering between regarding it as the mother of the arts or a poor sister.[10] However, already in the 1540s the latest protagonists of the paragone had broached the question by arguing that because architecture is 'necessary' (unlike painting and sculpture), 'sculptures and paintings are made to decorate buildings rather than the reverse' (Benedetto Varchi) and, conversely, that the fine arts were necessary to architecture because they 'mix in a little delicacy to its essence, which is in truth mechanical' (Vincenzo Borghini). By the 1580s, the issue was short-circuited by the painter turned treatise writer Gian Paolo Lomazzo, who discussed architecture in equal terms and identical categories to painting, and in whose *Idea of a Temple of Painting,* as the title suggests, the criteria of painting become the metaphorical building blocks of a conceptual building, the Temple of Painting.

Bernini, for his part, was predisposed to see architecture as sculptural, not only because it was carved and plastic, with façades particularly akin to reliefs, but also because body metaphors had long underpinned architectural design. Yet he was able to assimilate architecture to painting via sculpture, and make peace between the arts so to speak, by using coloured marble as a medium rather than an ornament. This material lay half-way between the pictorial and the plastic arts, and overcame any distinction between the art of addition and the art of subtraction, because colour was part of its very substance. In this sense the marble became as much a medium as any other binder used for pigment, and seemingly as mobile too. What was a dormant background in Mantegna's fictions is now an active environment, with a palette spanning from the shadow of the tomb at the chapel's base (the Cornaro Chapel is a mortuary chapel) to the glaring light of the resurrection painted in its vault. Bernini effectively paints with the stones, exploiting their veining as though they were brush trails. The ultimate unity of the ensemble is not a conjunction of the arts but an elision, because the ability of one art to perform as another deregulated and even confounded the boundaries between sculpture and painting, ultimately subsuming them into mother architecture. We can no longer decide whether sculpture is engulfed by painting or emerges from it. In fact, distinction itself has become an idle question, giving way to that 'intervisuality' that guarantees the autonomy of the representation, and nullifies any issue of truth or deception.

9. An early approach to this question is in F. Barry, '"*I Marmi Loquaci*": Painting in Stone', *Daidalos*, 1995, vol. 56, pp. 106-21.

10. A. Payne, 'Alberti and the Origins of the Paragone between Architecture and the Figurative Arts', in *Leon Battista Alberti: teorico delle arti e gli impegni civili del 'De Re Aedificatoria'*, ed. A. Calzona, F. P. Fiore, A. Tenenti and C. Vasoli, Florence, 2007, pp. 347-68.

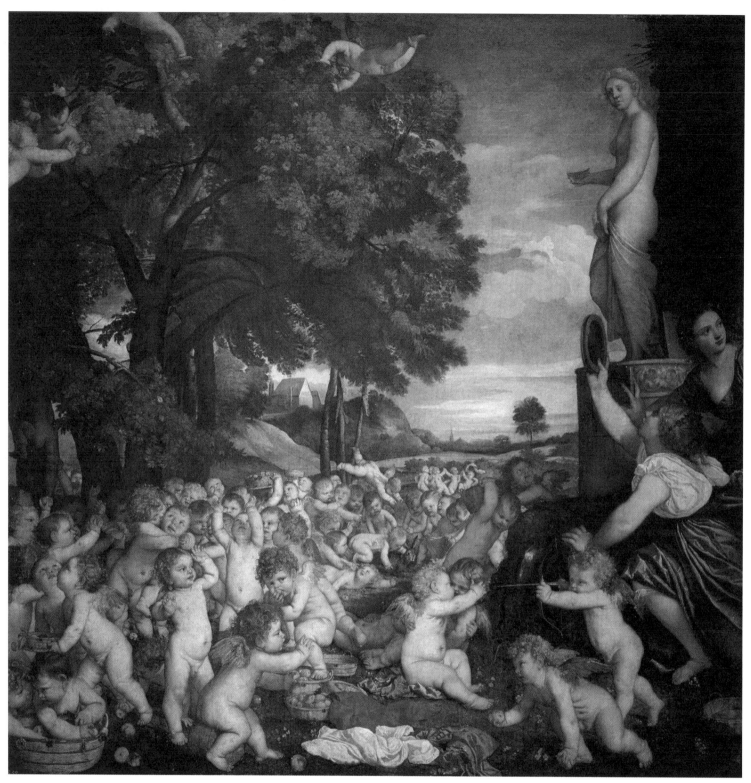

fig. 1. Titian, *The Worship of Venus*, 1519, Museo del Prado, Madrid

Etienne Jollet

SCULPTURE IN PAINTING: FUNCTION, TIME AND REFLEXIVITY (FRANCE, *c*.1630–1750)

Sculpture, painting: a comparison between the arts? In the many years in which the paragone has been studied there has been a particular emphasis on its theoretical aspects.[1] In studies of actual production, the accent has been put on the relationship between techniques and material, or the play between the arts.[2] Rare are the studies dealing with the actual presence of sculptural motifs.[3] The novelty and richness of the present approach prevent us in this essay from going further than outlining its key features, from the Renaissance to the end of the eighteenth century. I should like to deal first with sculpture as motif, taking account of the special role played by the statue. Then we shall take account of the specific temporal value which sculpture can impart to a painting. Finally we shall turn our attention to the way painting can deal with the needs of verisimilitude: sculpture, painting and reflexivity are here combined.

Sculpture in painting: function

Sculpture in painting is traditionally linked to its well-known use, especially in the form of the statue, as a model for painters.[4] Let us immediately put to one side an important connection: the use of the relief, drawn particularly from sarcophagi, as the basis of a pictorial composition, for example by Poussin, in works such as 'The Empire of Flora' (Paris, Musée du Louvre).[5] Sculptural borrowing is mainly concentrated on the statue. The presence in paintings of certain famous statues or groups, as based on a narrow understanding of mimesis, is also obvious—see for example the fortune of the 'Laocoon'.[6] But a thorough study shows a more complex situation: in the case of Poussin, for example, not one of the statues represented is a direct copy of an actual one.[7] Two functions predominate. The first is when the statue plays a pre-eminent role in the story, or *historia*; the second is the use of sculptural elements as part of the environment, notably the architectural one.

Alberti, in his treatise *On Painting*, opposes the colossal statue to the *historia*:[8] what is at stake is the choice between two ways of creating an impact on the beholder, by means of scale and the material on the one hand, by the complexity of the relationships between the motifs on the other. In a certain number of works of art a combination of the two, ie the statue, if not the colossus, plays a central role in the narration. Reciprocally, narrative scenes animate the small bronzes of the seventeenth and eighteenth century:[9] they are, in a way, more sophisticated

1. Cf. for a recent synthesis on the relationships between sculpture and painting during the early modern period, E. Mai et al (ed.), *Wettstreit der Künste: Malerei und Skuptur von Dürer bis Daumier*, Wolfratshausen, 2002, cf. also J. White, 'Paragone; Aspects of the Relationship between Sculpture and Painting', in *Art, Science and History in the Renaissance*, C.S. Singleton ed., Baltimore, 1967, pp. 43-108, H. Körner, 'Paragone der Sinne: der Vergleich von Malerei und Skulptur im Zeitalter der Aufklärung' in Herbert Beck (ed.), *Mehr Licht*, 1999, pp. 365-78.

2. Cf. J. Pope-Hennessy, 'The interaction of Painting and Sculpture in Florence in the Fifteenth Century', *Journal of the Royal Society of Arts* vol. 117, 1969, pp. 406-424.

3. H. Holländer, 'Steinerne Gäste der Malerei', *Giessener Beiträge zur Kunstgeschichte*, 1973, 2, p. 103–51, T. Hetzer, 'Vom Plastischen in der Malerei' in Andrew Ladis (ed.), *Giotto, Master Painter and Architect*, New York and London, 1998, p. 235-48.

4. Cf. L.S. Fusco, 'The use of sculptural models by painters in the fifteenth century', *Art Bulletin*, LXIV, 1982, p. 175-94.

5. It is a truism for the art theory of the early modern period that relief is an intermediate type between sculpture and painting: it intervenes at two levels. In Poussin's work, the relief determines a recurrent bi-dimensional treatment of the composition and a lateral orientation of the action, as in the 'The Empire of Flora' and above all in the 'Judgement of Solomon'. We notice a frequent contrast between the type and its connotations and the iconography: the success of the putti copied from Duquesnoy leads to an iconography of infancy which functions as a valuation of perpetual youth. But relief can be also present as a motif in the representation, as when it appears on a vase in Watteau's 'Pour garder l'honneur d'une belle' (print by Cochin *le père*). As an image fixed forever, and as a

21

commentary on the principal scene, it makes obvious the role played by the values of eternity associated with sculpture and, more generally speaking, to time.

6. Cf. S. Settis, *Laocoonte, fama e stile*, Rome, 1999.

7. We refer to the work in progress of Elsa Biguet, *Les statues anciennes dans l'œuvre de Nicolas Poussin*, MA thesis, Université de Paris Ouest.

8. L.B. Alberti, *On Painting*, J.R. Spencer ed., New Haven and London, 1966, p. 72.

9. Cf. for example François Lespingola, 'Hercules delivers Prometheus' (around 1670, Dresden, Staatliche Kunstsammlungen, or Giuseppe Piamontoni, 'Jupiter on his eagle' (around 1670, Oxford, Ashmolean Museum).

10. Cf. Giambologna, 'The Rape of the Sabine Women', 1583, Florence, Loggia dei Lanzi.

11. Cf. *Dürers Verwandlung in der Skulptur zwischen Renaissance und Barock*, Frankfurt am Main, Liebighaus, Museum alter Plastik, November 1 1981–January 17 1982.

12. Cf. K. Dobai, *Studien zu Tintoretto und die florentinische Skuptur der Michelangleo-Nachfolge*, Berne, 1991, R. Krischel, *Tintoretto und die Skulptur der Renaissance in Venedig*, Weimar, 1994.

versions of what we see in the public sculpture of the sixteenth century, especially in the work of Giambologna.[10] The link is also forged through the fact that many sculptors used the motifs and compositions of painters such as Dürer.[11]

The habit of using statues as models in the training of painters is of course at the origin of a recurrent feature, the presence of famous antiques as the source of various figures. What makes the relationship more complex—and more interesting—is when the quotation is obvious: that is when the borrowed model is presented as such, with an attempt to integrate it into the scene: in Poussin's work see for example the quadriga in 'Summer' (Paris, Musée du Louvre) or the main figure in the 'Landscape with a Man killed by a Snake' (London, The National Gallery). What is at stake here is the artist's decision either to hide or to reveal the reference.

More generally speaking, it is the sculpturality of sculpture in painting which is associated with different features: the effects of volume, of monumentality, of power, and also—notably with reference to Michelangelo—to the empathetic impact of a powerful body. This concerns certain artists more than others; Tintoretto, for example, appears to be difficult to study without reference to the Florentine polymath.[12] This question of impact (or, to refer once again to Alberti, the integration of the colossus in the *historia*) brings with it fundamental religious questions as to the effective depiction of the idol. In sixteenth-century painting one can find scenes of pagan cult, such as Titian's 'The Worship of Venus' (Madrid, Museo del Prado). (fig. 1) In Poussin's work, the idol appears in an ambivalent manner. In a Christian context, as in 'The Adoration of the Golden Calf' (London, The National Gallery) (fig. 2) the evocation is negative; this is also the case when the statue is pagan, as in the 'Martyrdom of St Erasmus' (Vatican Museums). But in

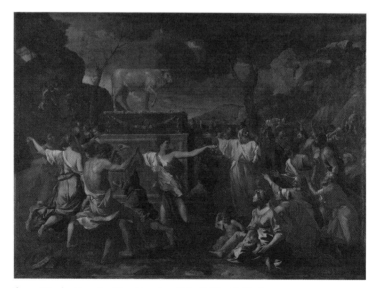

fig. 2. Nicolas Poussin, *The Adoration of the Golden Calf*, 1633–4, The National Gallery, London

the mythological context, the idol is associated with positive values; see for example 'A Bacchanalian Revel before a Term' (London, The National Gallery) (fig. 3), or 'A Dance to the Music of Time' (London, The Wallace Collection).[13] Such questioning is still present during the eighteenth century but takes a more anthropological perspective, as illustrated, for example, by Charles de Brosses' book, *Du culte des dieux fétiches* (*On the cult of fetish gods*).[14] The series of works by Vien and Greuze in the 1760s and by Fragonard in the 1780s—Vien's 'The Virtuous Athenian Maiden' (Strasbourg, Musée des Beaux-Arts), Greuze's 'Votive Offering to Cupid' (London, The Wallace Collection) (fig. 4) and Fragonard's 'The Vow to Love' (Orléans, Musée des Beaux-Arts)—are testimony to a new interest in the question of pagan worship.

So far we have been looking at examples where the sculpture is central to the *historia*: we now have to take account of the fact that, very often, it takes part in the decorum, or the conformity to status. Sculpture appears in the form of what the western tradition calls *parerga*; secondary elements of representation. We have to take account of such elements within paintings as characteristics of place, notably because sculpted elements are frequent in noble architecture of the time. This will become particularly important during the eighteenth century with its play on 'hybridisation', or the mixing of genres; when Lancret paints his 'The Oyster Lunch'

13. See also 'The Departure for the Hunt', Madrid, Prado, 'Bacchanal of Children', Rome, Palazzo Barberini.

14. C. de Brosses, *Du culte des dieux fétiches*, s.l., 1760.

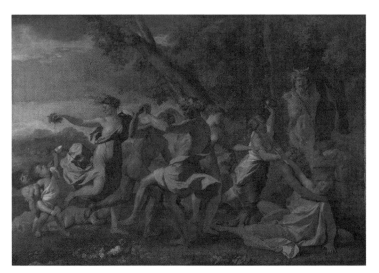

fig. 3. Nicolas Poussin, *A Bacchanalian Revel before a Term*, 1632–3, The National Gallery, London

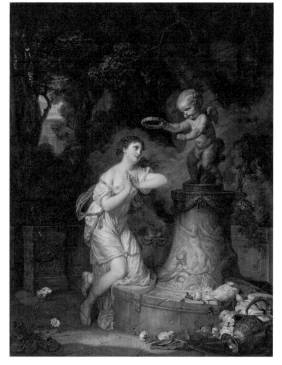

fig. 4. Jean-Baptiste Greuze, *Votive offering to Cupid*, 1767, The Wallace Collection, London

Etienne Jollet

(Chantilly, Musée Condé) with statues in the niche behind, he creates a strong contrast between the two registers and thus provides a source of artistic pleasure.

Third, the painters use geometrical motifs—tombs, pyramids, columns or spheres—like the one on top of a pillar in Poussin's 'Eliezer and Rebecca' (Paris, Musée du Louvre): here it is difficult to really differentiate between sculpture and architecture. But the most important feature is the use of detail; the sculpted motif, even if not very noticeable, can nevertheless impart new information about the scene and transform its meaning. In Poussin's 'The Death of Germanicus' (Paris, Musée du Louvre) (fig. 5) a bust at one end of the gallery may refer to Tiberius, the emperor responsible for the death of the young patrician. Even more interesting is the figure hidden under the veil: is it a human being or a statue? Many eighteenth-century artists—or at least the subtlest, and notably Watteau or Fragonard—used this device, thereby integrating very small sculpted elements, especially reliefs.[15]

15. Cf. in Watteau's 'Pilgrimage to Cythera', Berlin, Charlottenburg Palace, the figures of Eros and Anteros at Venus' feet; the same group is to be found in 'Plaisirs d'amour', Dresden, Gemäldegalerie. Fragonard's 'Coresus and Callirhoé', Paris, Louvre, includes the basis of a column at the right inferior angle with sphinx and rams.

Sculpture in painting: time

The sculpture of the early modern period can be either antique or contemporary, and each accordingly comes with different connotations. If associated with antiquity, it refers in a complex way to the opposition between Paganism and Christianity: the Hercules of Poussin's 'The Martyrdom of Saint Erasmus' is underlined by the deictic

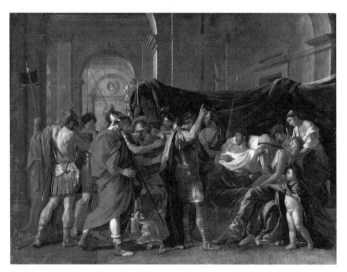

fig. 5. Nicolas Poussin, *The Death of Germanicus*, 1627
Minneapolis Institute of Arts

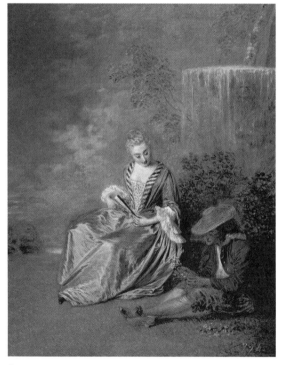

fig. 6. Jean-Antoine Watteau, *The Shy Lover*, 1718
Palacio Real, Madrid

24

gesture of one of the characters. The antique statue can be one element in the scene's characterisation, as in Louis Lagrenée the elder's 'Preparations for the Battle between Paris and Menelaus' (Paris, Musée du Louvre) with its statue of Zeus. We can also find in Poussin a surprisingly historicised vision of sculpture, showing the traces of the restoration of the antique. This may be a way of explaining the astonishing fact that in his 'The Rape of the Sabine Women' (Paris, Musée du Louvre) one of the major characters in the centre of the composition is represented with strange red arms, which were indeed additions to the figure at this time.[16] This temporal evaluation of sculpture can be also associated with the representation of collections, as in Michel-Ange Houasse's 'Clock and Statuettes' (Madrid, Palacio Real).

Metamorphosis proposes a less impressive idea of evolution. There are numerous myths which take us from animate to inanimate and back again. On the one hand, there is petrification, as in the myth of Echo and Narcissus, which we see in Poussin's version. On the other, two states of being are represented, whether, as in the myth of Deucalion and Pyrrha, where stones are transformed into human beings, or, as in Galatea and Pygmalion, where statues become human.

The play between eternal and transient values might be the cause of the recurrent association of water with sculpture. At its most basic their actual combination in the form of fountains can lie behind this phenomenon, and one can trace this throughout the production of ornamental projects.[17] Water can stress the idea of nature's constant movement, as opposed to sculpture's eternal values. But water can also bring a certain fuzziness: the powerful effect of the apparition of the feminine figure playing the mandolin in Watteau's 'The Shy Lover' (Madrid, Palacio Real) (fig. 6) functions to reveal the actual relationship between the blushing young man and the woman.

Such effects define a very intimate relationship with the beholder, with whom a link more empathetic than visual exists with the figures represented. Here, the long-term association between sculpture and death is central. The dying or dead body is represented with a colour close to that of the statue; usually a green-grey hue, as in Poussin's 'The Massacre of the Innocents' (Chantilly, Musée Condé). But it can have a more ambiguous meaning, especially in still lives, a genre which often uses sculpture to refer simultaneously to eternity and to transience. Desportes' 'Dog guarding Game' (Paris, Galerie Cailleux) shows a relief by François Duquesnoy, 'Children playing with a Goat'. Discrete evocations of death can be found in Poussin's 'Et in Arcadia ego' (Paris, Musée du Louvre) if we associate the four figures with those which traditionally flank the tomb, in line with a tradition which goes back to the Renaissance.

This is even more obvious in the corpus of genre painting. Watteau's use of statues has been thoroughly studied,[18] mainly in relation to its iconography. Also important is the nature of the link thus created with the actual characters. The faun and the various figures of commentator which are placed in the margins

16. Cf. Biguet, op. cit.

17. Cf. for example F. Boucher, *Recueil de fontaines inventées par F. Boucher peintre du roi*, engravings by Huquier and P. Aveline.

18. C. Seerveld, 'Telltale Statues in Watteau's Painting', *Eighteenth Century*, Winter 1980/81, pp. 151-80, A.P. Mirimonde, 'Statues et emblèmes dans l'oeuvre d'Antoine Watteau', *Revue du Louvre*, n° 12, 1962, pp. 11-20, F. Souchal, 'Watteau et la sculpture', Actes du colloque 'Style et technique dans l'œuvre de Watteau', 22 novembre 1986, in *Annales d'histoire et d'archéologie*, IX, 1987, p. 175-85.

19. Cf. in Watteau's works: 'Sous un habit de Mezetin', London, Wallace Collection, 'La Gamme d'amour', London, National Gallery, 'Gilles', Paris, Louvre, 'Les Jaloux', Melbourne, National Gallery of Victoria, 'Voulez-vous triompher des belles?', London, Wallace Collection.

20. Cf. 'Amusements champêtres', Paris, private collection, 'Récréation galante', Berlin, Staatliche Museen, 'La Famille Bouc-Santussan', Switzerland, private collection. Sarazin's group was in the gardens of Marly at this time.

21. Cf. 'Rinaldo and Armida', Paris, Louvre, 'Vertumnus and Pomona', Columbus (Ohio), Museum of Art, 'The Toilet of Psyche', Roma, Palazzo del Quirinale.

22. Cf. V. Stoichita, *L'instauration du tableau. Métapeinture à l'aube des temps modernes*, Genève, 1993.

23. S. Sontag, 'Im Wettstreit der Künste: Fensterbilder der Leidener Feinmaler und der "paragone" mit der Bildhauerkunst', *Dresdener Kunstblätter*, 50, 2006, n° 5, p. 279-87.

24. They had to portray two of their colleagues. Cf. for example, for the seventeenth century, Jean Lemaire 'Jacques Sarazin', Versailles, musée national du château, Jacques d'Agar, 'Michel Anguier', Antoine Benoit, 'Jacques Buirette', all at Versailles, musée national du château, for the eighteenth century, J.-B. Drouais, 'Robert Le Lorrain', Paris, Louvre, J.-S. Duplessis, 'Christophe Gabriel Allegrain', Paris, Louvre, S. Labille-Guiard, 'A. Pajou', Paris, Louvre.

25. Cf. P. Subleyras, 'The Painter's Workshop', Vienna, Akademie der schönen Künste, J.-B.-S. Chardin, 'The ape painter', Paris, Louvre, H.Robert, 'The Painter in his Workshop', Paris, coll. Jules Féral.

26. Cf. Jacques Buirette, 'L'Union de la Peinture et de la Sculpture', 1663, Paris, Louvre, Jacques Prou, 'La Sculpture présentant à la peinture le médaillon du Roy', 1682, Paris, Louvre. The relationship is still present during the eighteenth century (cf. C.-M. Challe, 'Union de la peinture et de la sculpture', 1751, Fontainebleau, musée national du château).

27. Cf. the versions of 1765, Paris, Louvre and 1766, Saint-Petersburg, Hermitage and Minneapolis, Institute of Arts.

28. We refer to John Onians' phrase used as the title for his important book on the column in western architecture,

of the image[19] have a different meaning to that of the he-goat which refers to Sarazin's sculptural group and hints far more directly at passion.[20] The various sculpted putti painted by Boucher refer to love's eternal recurrence;[21] they appear at different scales, sometimes very tiny, giving the eye the pleasure of discovering these details at an intimate level. Thereafter the iconography in either Vien's or in Fragonard's paintings can be interpreted as more than a simple reference to an idol; it also questions the power of the image in terms of a moral reflection, effectively doing this by examining the various arts, determining a reflexive approach to the link between sculpture and painting.

Sculpture in painting: reflexivity

Such reflexivity obviously refers to the tradition of the paragone.[22] The painted reliefs which are the apotheosis of the *trompe l'oeil* tradition and so frequent in seventeenth and eighteenth-century painting must be associated with this kind of questioning.[23] Another good example of this train of thought is to be found in the corpus constituted by the painted portrait of the sculptor, a tradition at the Académie royale de peinture et de sculpture for the '*agrément*' or '*réception*' of portraitists.[24] The classic pose includes a sculpted hand, almost always that of a statue. But sculpture is also present in the portraits of painters and their studios; it is there as a model and reflects the conventions of their training.[25] Patrons and connoisseurs also liked to be represented with a statue, as in the example of Madame de Pompadour, whose portrait by Boucher shows her in front of Pigalle's statue of 'Friendship', which had been ordered for the gardens of her castle at Bellevue (London, The Wallace Collection).

The statue can be also part of a decorum which characterises a certain atmosphere, as in Largillière's allegorical portrait of the *Régent* (Paris, Musée du Louvre). This production has close links with the '*morceaux de réception*' (or submissions for entry into the Academy), reliefs which bring painting and sculpture together.[26] The numerous 'Attributes of the Arts' (fig. 7), which often include a statue, are also part of this tendency.[27] This play on the relationships between the two genres gives a special value not only to sculpture but also to its topographical marker: its pedestals, 'bearers of meaning'.[28]

Within paintings it was possible to add the logic of opposition. Sculpture is often integrated in paintings which emphasise contrary characteristics: they might stress the value of bi-dimensionality by means of the legibility of touch, the importance of the composition, or of the *historia* on the sculptural figure. They contest the materiality of things; the difficulty of seeing the contours very precisely; they choose an iconography of transience. This kind of oppositional logic appears very early, as in Mantegna's 'St Sebastian' (Vienna, Kunsthistorisches Museum). But the artist who seems to have been most interested in such a contrast was Fragonard with his various pictures from the 1780s depicting the integration

26

of a statue: in 'The Love Vow' (London, private collection), 'The Waking up of Nature' (lost), 'The Fountain of Love' (London, The Wallace Collection) or 'The Vow to Love' (Orléans, Musée des Beaux-arts) (fig. 8) the statue is as blurred as the rest of the image and 'sculpturality' is challenged by the dominance of pictorialism. The myth of Pygmalion is central.[29] Its strength is to bring in reflexivity on three levels at once: the first is oriented towards the question of imitation, this is at the core of western aesthetics and involves the contrast between inanimate and animate figures; the second associates the two major arts, sculpture and painting; the third concerns the process of creation, at a period during which the status of the artist was always compared to that of Creation. Themes can overlap, as in the 'The Monkey Painter,'[30] and essentially they question the limits of humanity: Mary Shelley's Frankenstein is not so far from Vaucanson's automats.[31]

On a deeper level, the relationship between the various senses is challenged. Sculpture in painting reminds us that we don't only appreciate painting with our eyes, but with all our senses.[32] The sense of touch is especially valued: it accounts for the recurrent gesture of the artist's hand on a sculpture, as in the sculptors' portraits mentioned above.[33] The representation of a blind man is simply a more explicit reference in the allegories of sculpture.[34] Such a play on the senses is not without consequences for the beholder's relationship with the picture. The sculpted figures which take up a position of commentary—as with the faun in Poussin's 'Bacchanals' but also in Watteau's 'Fêtes galantes'—are ways of inviting the beholder to regard the spectacle with greater objectivity.[35]

This play on a second degree effectively diminishes painting's fundamental premise: the respect of the norms which govern verisimilitude. In paintings

Bearers of meaning, Princeton, 1988. Cf. the play on the limits of the statue: in Watteau's 'Champs-Elysées', London, Wallace Collection, the arm of the feminine figure falls down along the pedestal.

29. Cf. V. Stoichita, *L'Effet Pygmalion. Pour une anthropologie historique des simulacres*, Geneva, 2008, Andreas Blühm, *Vom Leben zum Bild- vom Bild zum Leben. Pygmalion im Streit der Künstler*, p. 142-51

30. Cf. J.-B.-S. Chardin, 'The Monkey Painter', Chartres, Musée des Beaux-arts.

31. Cf. Klaus Völker (ed.), *Künstliche Menschen, Dichtungen und Dokumente über Golems, Homunculi, Androiden und liebende Statuen*, Munich, 1971.

32. Cf. H. Baader (ed.), *Im Agon der Künste: paragonales Denken, ästhetische Praxis und die Diversität der Sinne*, Munich, 2007.

33. On touch see J. Lichtenstein, *La Tâche aveugle. Essai sur les relations de la peinture et de la sculpture à l'âge moderne*, Paris, 2003, H. Körner, 'Der fünfte Bruder: zur Tastwahrnehmung plastischer Bildwerke von der Renaissance bis zum frühen 19. Jahrhundert', *Artibus et historiae*, 21.2000, n° 42, p. 165-96, H. Körner, 'Die enttäuschte und die getäuschte Hand: der Tatsinn im Paragone der Künste', in Valeska von Rosen (ed.), *Der stumme Diskurs der Bilder: Reflexions- formen des Ästhetischen in der Kunst der Frühen Neuzeit*, Munich, 2003.

34. Cf. Mattia Preti, 'Allegory of Painting, Architecture and Sculpture', Naples, private collection, Jusepe de Ribera, 'The Touch', 1611/13-1616 , Pasadena, Norton Simon Museum.

35. Cf in 'Bacchanal in front of a term', London, National Gallery, 'The Empire of Flora', Paris, Louvre, 'The Dance to the Music of Time', London, Wallace Collection.

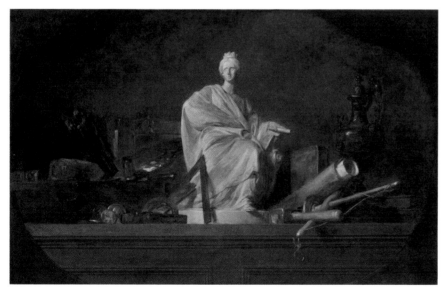

fig. 7. Jean-Siméon Chardin, *Attributes of the Arts*, 1765, Musée du Louvre, Paris

sculpture can represent the image of immobility, in a context where the depiction of movement is considered the most difficult and thus the noblest task for a painter. At the end of the seventeenth century, the convention whereby movement should be put back into painting was apparently challenged in a text by the historian Saint-Réal which denounced the paradox of movement in a static work.[36] In Saint-Réal's text, the 'good' painting is exemplified by a representation of Diogenes asking statues for alms, a comment on the lack of charity at court, a theme which would be illustrated much later by J.-B. Restout (Toulouse, Musée des Augustins). Such a text can be considered as a departure point for a new type of relationship to the work of art, which is now more felt than viewed.[37] But this can create problems of interpretation, as when Diderot criticises the representation of a statue in a painting alongside a living woman: for no other reason than 'it is the way I feel it'.[38]

This new approach based on feeling corresponds in fact to an older type of relationship between sculpture and painting—where sculpture can't simply be reduced to a motif in the painted work. This is the case with the altarpiece (or *pala*), a more popular form which combines the two practices.[39] We should also remember the tradition of the sculpted frame.[40] This exterior presence can be traced within painting itself: it is the case with the representations of statues as monuments. Titian's 'La Schiavona' (London, The National Gallery, see p. 80), with its contrast between the living figure viewed frontally and the profile in relief, eternalised in the marble, already betrays an early awareness of such a value.[41] The various medallions represented in seventeenth-century still-lives are further testimonies of such a sensibility.[42] But what comes later is the additional association with the notion of site, as with the paintings executed for the patrons of the Grand Tour, where the representation is either faithful to reality or shows a caprice. The whole genre of 'ruins', with the success of Panini and Hubert Robert, bears witness to this use of statuary in creating the disjunction between history and story, between the traces of a noble past and the anecdotal present.[43] Moreover, Hubert Robert not only put sculpture in his painting but was also the curator of the Louvre who dealt with the actual placement of the works in the Grande Galerie and with the groups of Apollo and the muses or the horses of the Sun in the '*bosquet des bains*' at Versailles. And the various representations of monuments, for example the statue of Marcus Aurelius, betray the interaction between history, as recalled by the statue, and the souvenir which is also a reminder of its transience.

This sensibility to the fragility of statues and their history can be associated with an interest, especially in the eighteenth century, in sculpture as artefact. But, in fact, the interrogation of the link between the rock and the statue is at least as old as the myth of Dinocrates, the architect who wanted to transform Mount Athos into a colossus. But even more discreet effects, such as the split rock in Poussin's 'Israelites Gathering the Manna' (Paris, Musée du Louvre) which recalls

36. 'Car il n'en est pas de ce Tableau, continua-t-il, comme de la plupart de ceux qui représentent des Histoires. Les Peintres, qui n'ont pas d'ordinaire l'esprit aussi juste que les yeux, croient qu'elles sont toutes également propres à être peintes. Cependant, il y a en très-peu qui le soient, parce que le pinceau ne pouvant faire mouvoir les figures sur la toile, ne peut représenter qu'imparfaitement les sujets qui consistent en mouvement, comme les Combats, les Exercices du Corps, les Tempêtes, les Embrasements, & presque tout ce que les Peintres aiment le plus. Je ne sçais si personne n'a jamais senti la même peine que moi, en considérant ces sortes de peintures: mais il me semble toujours, que les figures doivent se remuer; et l'attitude agissante, où elles sont représentées, tout immobiles qu'elles sont en effet, enferme une espèce de contradiction dont mon imagination ne sçauroit s'empêcher d'être blessée', César Vichard, abbé de Saint-Réal, 'Césarion' in *Oeuvres*, Paris, 1745, t. I, p. 441.

37. Several authors would refer to Saint-Réal's text during the eighteenth century cf. the author's 'Saint-Réal et la temporalité du discours critique au XVIIe siècle en France' in *La naissance de la théorie de l'art en France*, Paris, *Revue d'esthétique*, numéro spécial, 1997, pp. 173-85.

38. D. Diderot on Greuze's 'The Votive Offering to Cupid', op. cit.: '*Pour moi, il me déplaira toujours dans cette composition de voir une statue en scène avec une femme vivante… Je suis peut-être pointilleux, mais c'est ainsi que je sens; tant pis pour l'artiste ou pour moi*', lettre à Falconet, juillet 1767, *Œuvres complètes*, éd. Assézat t. XVIII, p. 250.

39. Cf. I. Wenderholm, *Bild und Berührung. Skuptur und Malerei auf dem Altar der italienischen Frührenaissance*, Berlin, 2006.

40. Cf. C. Grimm, *Alter Bilderrahmen*, Munich, 1978.

41. Cf. L. Freedman, '"The Schiavona": Titian's Response to the Paragone Between Painting and Sculpture', *Arte Veneta*, 41, 1989, p. 31-40.

42. Cf. Jean Garnier, 'Still life with portrait of King Louis XIV', 1672, Versailles, musée national du château.

43. G. Herzog, *Hubert Robert und das bild im Garten*, Worms, 1989.

28

the metaphor of the 'narrow door', are part of a general interest in this rapport, the petrification in Mantegna's works being an early example. During the first half of the eighteenth century, the art of the *'rocaille'* (or Rococo) popularises such an interest, inside and outside the painting: it appeals to a study of the relationship between painting and sculpture that goes outside of the picture itself.

Sculpture in painting appears during the early modern period to support various narrative or decorative functions, to play an important part in the temporal characterisation of the scene, to question the specificity of painting as a technique and also as a representation. What may be central is the way it creates a tension, in the representation, between the whole and the part, between the overall composition and the motif. It suggests a bedding-down of a certain culture (notably humanist) and the ways in which it could be inflected. Finally, and perhaps most importantly, sculpture in painting allows for a conception of art history which deals not only with the motif but also with what can be described as the interplay amongst various states of representation: as a motif; as a work; as a monument present in the world, in a context where the work of art is increasingly asked to play a public role; where the perennial aspects of the psyche as evoked through sculpture are simultaneously challenged by its reference to our shared cultural heritage.

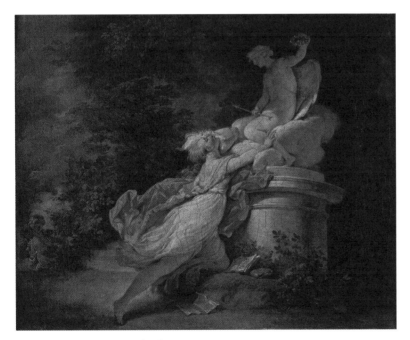

fig. 8. Jean-Honoré Fragonard, *The Vow to Love*, *c.*1780, Musée des Beaux-Arts, Orléans

29

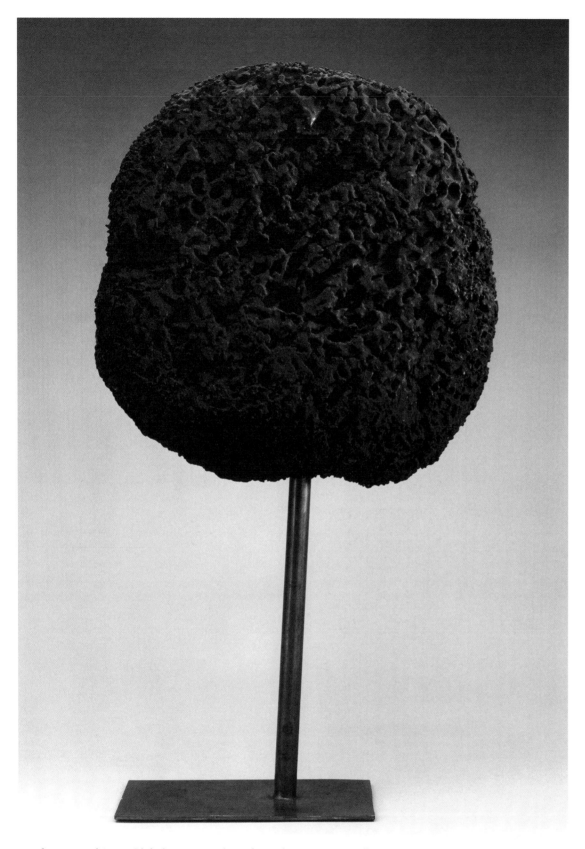

fig. 1. Yves Klein, *Untitled Blue Sponge Sculpture (SE 245)*, c.1960, private collection

David Batchelor

THE 'IN' IN SCULPTURE
IN PAINTING (*c*.1960)

Unlike the other contributors, I am not going to discuss paintings that contain representations of sculptures. But the three works I want to discuss, by Yves Klein, Hélio Oiticica and Dan Flavin, though paintings of a sort, are paintings that, in one way or another, contain something sculptural, or something three-dimensional that can't easily be classed as painting. If it sounds like I'm being a bit picky about terminology it may be because, at the time when these works were made—the early 1960s—whether something could be described as a painting or a sculpture—or something else entirely—seemed to matter quite a lot to a good many artists. It was a time, as everyone knows, when the question of medium acquired a great deal of creative uncertainty, and when many artists found that the activity of stretching a medium beyond its conventional limits, or corrupting or contaminating a medium, was pretty much the only way of continuing to make work.

If the subject is sculpture in painting, how many different ways can I interpret the preposition 'in'?

By the mid-1950s Robert Rauschenberg had embarked on his extraordinary series of 'Combines', works that acknowledged in their titles and explored on their surfaces and at their edges what materials and forms could or could not be contained within the format of painting. By the early 1960s many artists in the Americas and parts of Europe had begun independently to pull painting so far out of shape that it could no longer be called painting, and yet for many it wasn't sculpture either.

Yves Klein's 'Blue Sponge Sculpture' (42.3 x 24 cm) is, in one sense at least, a sculpture that probably *was* in a painting. (fig. 1) Klein had begun to apply customised IKB (International Klein Blue) ultramarine pigment in the studio by dipping a sponge in the liquid colour and smearing it across the surface of a rigid panel. In the process he obviously noticed there was something about these drenched sponges that was compelling in themselves and made them more than just a means to an end. I'm guessing that it happened over time in the course of how things tend to happen in the studio: if not exactly by accident then certainly in an unpremeditated way, by slow realisation. Although Klein's dating of his works can be a little unreliable, it appears that first there were the more-or-less flat monochrome paintings; then there were paintings with sponge-growths on the surfaces; and then there were sponges-on-sticks: free-standing sponge sculptures that had emerged from painting as if, for Klein, painting was pregnant with sculpture. If that sounds

worryingly anthropomorphic, well, too bad, and anyway there's more to come. 'The monochrome propositions…secure the sculptural destiny of pure pigment today', said Klein in an uncharacteristically materialist moment.[1]

1. Quoted in Sidra Stich, *Yves Klein*, London, 1995, p. 91.

If the wall is the natural habitat of painting, and perhaps a defining condition of the medium, and the floor is where works become sculptures, then it may be possible to tell which is which by checking the plane on which it sits. That may sound simplistic beyond belief, and there are obvious exceptions, but bear with me. The 'Spatial Relief' (62.5 x 148 x 15.3 cm) by Hélio Oiticica, one of many made at much the same time as Klein's work, enacts the transition between painting and sculpture, or between two and three dimensions, or between the vertical and the horizontal plane, in a rather different way. (fig. 2) It has left the wall but has yet to land on the floor. It is suspended, literally, but also perhaps metaphorically. It is in transition (but it is not necessarily a transitional work). It belongs neither to the wall nor the floor—and nor, by the way, does it belong to the ceiling. Its relationship with the wall is more pronounced—both because that is where the earlier work came from and because as viewers we still see it in relation to that plane.

If the dubious metaphor I used for Klein's work was one of gestation, the equally dubious metaphor here is that of migration. The work appears to be travelling away from the wall and, in leaving the wall (we know in retrospect) Oiticica's work would never return to that place in the same way. It would never return as painting. The work itself—several overlapping painted panels that appear to have sprung out of a flat two-dimensional plane—is not fully in-the-round; it still appears to have a strongly frontal element, as do Klein's sponge works.

Unlike Klein's and Oiticica's work, Dan Flavin's 'Icon VI' (63.8 x 63.8 x 26.4 cm) remains attached to the wall, and resolutely frontal, as did much but not all of his later work. (fig. 3) It's a little difficult to talk about this square, box-like, construction as a painting—although it is painted and hanging on a wall. It is also difficult to talk of it as having something sculptural within it, as the additional three-dimensional element—a flashing light bought in a hardware store—emphatically sits *on* the chamfered side of the green structure. It sits on the face like a growth (yet more anthropomorphism), like something that is not meant to be there, and it looks like something has to give. Donald Judd described these works as 'blunt', 'awkward' and 'interesting', which seems about right.[2] This probably could be called a transitional work (although I don't trust the term), as there were only eight 'Icons' and, shortly after these were made, and probably because of them, Flavin abandoned all other materials in favour of illuminated fluorescent lights.

2. Donald Judd, 'In the Galleries', *Arts Magazine*, April 1964. Quoted in Judd, *Complete Writings 1959–1975*, New York, 1975, p. 124.

In both Klein's and Oiticica's work there is, or there appears to be, a relatively fluid transition between the two-dimensional, wall-based work, and three-dimensional, floor or table-based work. Much less so in the case of Flavin, who seemed less comfortable with painting to begin with, although perhaps more attached to its effects. Yet for all their differences, these works occupy a space right at the

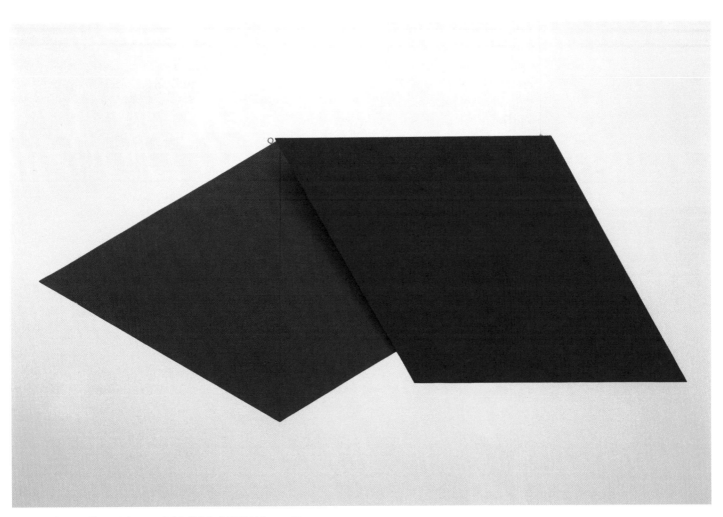

fig. 2. Hélio Oiticica, *Spatial Relief (red) REL036*, 1959, Tate

edge of what painting could have been at the time, and none of them look like they were going to stay there for long—or perhaps that is just the easy certainty of hindsight.

These works also inhabit the ambiguous space of abstract art. Ambiguous because, for all the rhetoric of absolutes and purity that often accompanied it, abstract art carried within it the paradoxical possibility of being tantalisingly immaterial and emphatically material at the same time. And no form of abstraction embodied these paradoxes more than the monochrome, the abstraction of choice for Klein and Oiticica and, to a certain extent, Flavin. That is to say the monochrome—painting as an uninterrupted plane of a single uninflected colour—is at once the most optical and the most literal form of painting: as optical as a disembodied void and as literal as a painted door. And this is perhaps something to do with why each of these artist's works were able, in their different ways and for different lengths of time, to occupy a highly ambiguous space between painting and sculpture, to find the sculptural within the painterly and the painterly within the sculptural. At the time this was not merely an absorbing technical question for advanced painting; on the contrary, it was a fundamental question of art's relationship with the world it inhabits. It seemed that, for many, the optical and the literal were mutually exclusively alternatives, and that what was at stake in one or the other was the very survival of art. It also seems that, for some, what might have been mutually exclusive alternatives in theory, could in practice become the basis for a vivid creative tension.

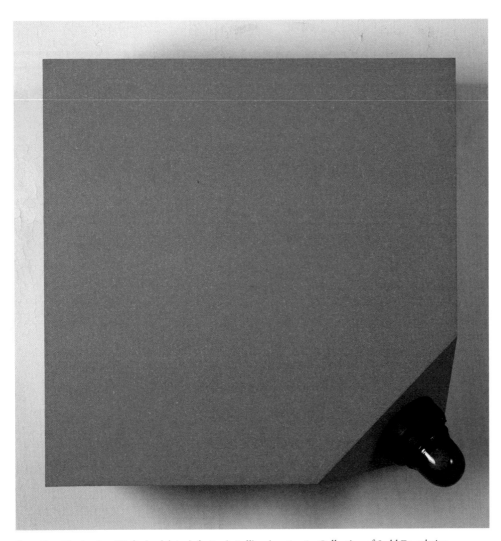

fig. 3. Dan Flavin, *Icon VI (Ireland dying) (to Louis Sullivan)*, 1962–63. Collection of Judd Foundation

Ann Sproat
SELECT BIBLIOGRAPHY

In compiling this bibliography it was helpful to think in terms of themes which have prompted representations of sculpture. The more obvious ones are: portraits of sculptors and collectors of sculpture, descriptions of sculpture collections, the studio, the academy and the myth of Pygmalion. The bibliography also includes texts on the forms of art which invite a dialogue between sculpture and painting: *trompe l'oeil* and grisaille painting, polychrome and relief sculpture. A few articles which deal with the paragone in relationship to specific paintings are included but the general literature on the competition between the arts is beyond the scope of this bibliography.

Some volumes have been chosen purely for the abundance of illustrations on the theme such as *Citizens and Kings* while others include chapters which deal with specific historical periods, such as *A God or a Bench*, a discussion of the representation of sculpture in seventeenth and eighteenth-century France. *Wettstreit der Künste: Malerei und Skulptur von Dürer bis Daumier*, the catalogue produced to accompany the exhibition held in Munich and Cologne in 2002, offers a good survey of the subject.

The titles within each section of the bibliography are organised by date.

GENERAL WORKS

Gross, Kenneth, *The Dream of the Moving Statue*, Ithaca, 1992

Hall, James, *The World as Sculpture: The Changing Face of Sculpture from the Renaissance to the Present Day*, London, 1999

Mai, Ekkehard, and Wettengl, Kurt (eds), *Wettstreit der Künste: Malerei und Skulptur von Dürer bis Daumier*, Wolfratshausen, 2002

Lichtenstein, Jacqueline, *The Blind Spot: An Essay on the Relations between Painting and Sculpture in the Modern Age*, trans. Chris Miller, Los Angeles, 2008. First published as *La tache aveugle*, Paris, 2003

Weinshenker, Anne Betty, *A God or a Bench: Sculpture as a Problematic Art during the Ancien Régime*, Oxford, 2008

PYGMALION

Carr, J. L., 'Pygmalion and the Philosophers. The Animated Statue in Eighteenth-Century France', *Journal of the Warburg and Courtauld Institutes* Vol. 23, (1960), 239-255

Blühm, Andreas, *Pygmalion: Die Ikonographie eines Künstlermythos zwischen 1500 und 1900*, Frankfurt am Main, 1988

Pointon, Marcia, *Naked Authority: The Body in Western Painting, 1830–1908*, Cambridge, 1991

Read, Benedict, and Barnes, Joanna (eds), *Pre-Raphaelite Sculpture: Nature and Imagination in British Sculpture 1848–1914*, London, 1991

Arscott, Caroline, and Scott, Katie (eds), *Manifestations of Venus: Art and Sexuality*, Manchester, 2000

Smith, Alison (ed.), *Exposed: the Victorian Nude*, exh. cat., London, Tate Gallery, 2001

Barry, Rosemary Julia, *The Use of Classical Art and Literature by Victorian Painters, 1860–1912: Creating Continuity with the Traditions of High Art*, Lewiston, N.Y., 2007

Stoichita, Victor I., *The Pygmalion Effect: From Ovid to Hitchcock*, trans. Alison Anderson, Chicago, 2008. Trans. of *L'effet Pygmalion*, Geneva, 2008

PARAGONE

Paragone: A Comparison of the Arts by Leonardo da Vinci, introduced and translated by Irma A. Richter, London, 1949

White, John, '*Paragone*; Aspects of the Relationship between Sculpture and Painting', *Art, Science and History in the Renaissance*, Charles S. Singleton (ed.), Baltimore, 1968

Hecht, Peter, 'The *Paragone* Debate: Ten Illustrations and a Comment.' *Simiolus: Netherlands Quarterly for the History of Art* Vol.14, No 2, 1984, 125-136

Freedman, L., '"The Schiavona": Titian's response to the Paragone between Painting and Sculpture', *Arte Veneta* Bd. 41, 1987, 31-39

Hecht, Peter, 'Art Beats Nature, and Painting Does so Best of All: The *Paragone* Competition' in Duquesnoy, Dou and Schalcken, *Simiolus: Netherlands Quarterly for the History of Art* Vol. 29, No, 3/4, 2002, 184-201

Brown, Beverly, 'Titian's Marble Muse: Ravenna, Padua and The Miracle of the Speaking Babe', *Studi Tizianeschi. Annuario della Fondazione Centro Studi Tiziano e Cadore* Vol. 3, 2005

Farago, Claire J., *Leonardo da Vinci's Paragone: a critical interpretation with a new edition of the text in the Codex Urbinas*, Leiden, 1992

COLLECTORS AND COLLECTIONS

Haskell, Francis, and Penny, Nicholas, *The Most Beautiful Statues: The Taste for Antique Sculpture 1500-1900*, exh. cat., Oxford, Ashmolean Museum, 1981

Haskell, Francis, and Penny, Nicholas, *Taste and the Antique: The Lure of Classical Sculpture 1500–1900*, New Haven, 1981

Hibbert, Christopher, *The Grand Tour*, London, 1987

Jenkins, Ian, *Archaeologists & Aesthetes in the Sculpture Galleries of the British Museum 1800–1939*, London, 1992

Bignamini, Ilaria, and Wilton, Andrew (eds), *Grand Tour: The Lure of Italy in the Eighteenth Century*, exh. cat., London, Tate Gallery, 1996

Baker, Malcolm, *Figured in Marble: The Making and Viewing of Eighteenth-Century Sculpture*, London, 2000

Guilding, Ruth, *Marble Mania: Sculpture Galleries in England 1640–1840*, exh. cat., London, Sir John Soane's Museum, 2001

Coltman, Viccy, *Fabricating the Antique: Neoclassicism in Britain, 1760–1800*, Chicago, 2006

Scott, Jonathan, *The Pleasure of Antiquity: British Collectors of Greece and Rome*, New Haven, 2003

Penny, Nicholas, and Schmidt, Eike D. (eds), *Collecting Sculpture in Early Modern Europe*, Studies in the History of Art; 70. Symposium Papers / Center for Advanced Study in the Visual Arts, 47, Washington, 2008

Marvin, Miranda, *The Language of the Muses: the Dialogue between Roman and Greek Sculpture*, Los Angeles, 2008

STUDIO AND ACADEMY

Bignamini, Ilaria, and Postle, Martin, *The Artist's Model: Its Role in British Art from Lely to Etty*, exh. cat., Nottingham, University Art Gallery, 1991

Perry, Gill, and Cunningham, Colin (eds), *Academies, Museums and Canons of Art*, New Haven, 1998

Postle, Martin, and Vaughan, William, *The Artist's Model: From Etty to Spencer*, London, 1999

Fenton, James, *School of Genius: A History of the Royal Academy of Arts*, London, 2006

PORTRAITS

Bowron, Edgar Peters, and Kerber, Peter Björn, *Pompeo Batoni: Prince of Painters in Eighteenth-Century Rome*, New Haven, 2007. Catalogue of an exhibition held at the Museum of Fine Arts Houston and the National Gallery, London

Citizens and Kings: Portraits in the Age of Revolution, 1760–1830, exh. cat., London, Royal Academy, 2007

Simon, Robin, *Hogarth, France and British Art: The Rise of the Arts in 18th-Century Britain*, London, 2007

PAINTING IN SCULPTURE IN THE 20ᵀᴴ CENTURY

Mezzatesta, Michael P., *Henri Matisse: Sculptor/Painter*, exh. cat., Fort Worth, Kimbell Art Museum, 1984

In Tandem: The Painter-Sculptor in the Twentieth Century, exh. cat., London, Whitechapel Art Gallery, 1986

Cowling, Elizabeth, and Golding, John, *Picasso: Sculptor/Painter*, exh. cat., London, Tate Gallery, 1994

Prat, Jean-Louis, *Die Skulpturen der Maler: Malerei und Plastik im Dialog*, Ostfildern, 2008. Catalogue of an exhibition held at Museum Sammlung Frieder Burda, Baden-Baden.

POLYCHROME SCULPTURE

Blühm, Andreas, and Curtis, Penelope (eds), *The Colour of Sculpture 1840–1910*, exh. cat., Amsterdam, Van Gogh Museum, Leeds, Henry Moore Institute, 1996

Panzanelli, Roberta, et al. (ed.), *The Color of Life: Polychromy in Sculpture from Antiquity to the Present*, Los Angeles, 2008

TROMPE L'OEIL PAINTING

Battersby, Martin, *Trompe l'Oeil: The Eye Deceived*, London, 1974

Mauriès, Patrick, *Le Trompe l'Oeil: de l'Antiquité au XXe Siècle*, Paris, 1996

Ebert-Schifferer, Sybille, et al., *Deception and Illusions: Five Centuries of Trompe l'Oeil Painting*, exh. cat., Washington, National Gallery of Art, 2002

GRISAILLE PAINTING

Gray is the Color: An Exhibition of Grisaille Painting, XIIIth-XXth Centuries, Houston, 1974

Christiansen, Keith, 'Paintings in Grisaille', *Andrea Mantegna*, Jane Martineau (ed.), London, 1992

Blumenröder, Sabine, 'Andrea Mantegna's Grisaille Paintings: Colour Metamorphosis as a Metaphor for History', *Symbols of Time in the History of Art*, Christine Heck and Kristen Lippincott (eds), Turnout, 2002

RELIEF SCULPTURE

Rogers, L.R., *Relief Sculpture*, London, 1974

Güse, Ernst-Gerhard, *Reliefs: Formprobleme zwischen Malerei und Skulptur im 20.Jahrhundert*, Münster, 1980

Curtis, Penelope (ed.), *Depth of Field: The Place of Relief in the Time of Donatello*, exh. cat., Leeds, Henry Moore Institute, 2004

CATALOGUE

I BETWEEN SUBJECT AND OBJECT

The first section sets up the topic by way of introducing us to the founding myth of artistic creation. Pygmalion—or pygmalionism—is here represented in four different forms, more or less faithful to Ovid's original 'Metamorphosis' in which a royal sculptor gives life to his new creation by means of prayer. The animating presence of attentive devotion—whether it be before a sculpture of a beautiful woman or of the Virgin Mary—is clearly conveyed. Whereas we may only guess at the import of Marguerite's prayers at a wayside shrine, Titian's reflections in front of the monochromatic sculpture which sits before him speak of the impetus of painting and of its imminent and life-giving ability.

The series of portraits conveys the range of subtle variations within the portrayal of a single sitter with a sculpture. Some are portrayed in the act of creating their own artwork, piercing it with an active gaze, handling it more or less possessively, or gazing impassively past the work of others. The work of Georg Scholz, which shows a 'living' nude beside an antique bust, in plaster, might be seen to epitomise the contrast between the life-class and the antique cast, between the present and the past, between painting and sculpture.

Other portraits use sculpture in its shallowest form to speak of another time, past or future, and of the highest artistic achievements. Relief sculpture releases us from the statue. Leighton poses himself in front of the Parthenon frieze, Gavin Hamilton represents his sitter's art in the form of a relief. This threshold, between reality and fiction, the painted 'living' sitter and the sculpted story, is brought vividly to the fore by de Chirico, in a self-portrait in which painting becomes sculpture, and the artist a sculpture. Here de Chirico, as so often, successfully merges history with the here and now.

Franz von Stuck (1863 – 1928)
*Pygmalion, c.*1926
Oil and syntonos colours on canvas, 60.5 × 50 cm
Museum Villa Stuck, Munich (permanent loan from the Federal
Republic of Germany), G-L 91 1-6

1. Maria Makela, *The Munich Secession: art and artists in turn-of-the-century Munich*, New Jersey, 1990, pp. 104-5.
2. Ibid. p. 105.
3. Their quality indicated by the fact the furniture received a gold medal at the *Paris International Exposition* of 1900. Eva Mendgen, *Franz von Stuck, 1863–1928: 'A Prince of Art'*, Cologne, 1995, p. 34.
4. Including a nomination to the *Pour le Mérite* order by the Director of the Master Studio for Sculpture in Berlin in recognition of his work in architecture and sculpture. Mendgen, p. 84.

Stuck received a broad artistic training. His father, a miller, only permitted the young Franz to study art in a practical context: Stuck therefore began his artistic studies at the Munich Arts and Crafts School, where he was trained from 1878–81 in the applied arts, design and architectural drawing.[1] After this Stuck moved to the Academy of Fine Arts in Munich 1881–5, but his early interaction with the applied arts was to have great consequences for the development of his distinctive painterly style.

Stuck's knowledge of the applied arts continued alongside the development of his career as a painter. Whilst a student at the Academy, he earned money making and selling decorative objects.[2] In 1897–8 he designed and built his own home, including the interior decorations and furniture.[3] And gradually, in the 1890s, Stuck began to produce small-scale sculptures as well as paintings: his most important sculptural work, 'Riding Amazon', was made in 1897. Indeed, from 1913 his interest in sculpture grew to rival or at least match his painterly output and in this, his last decade, Stuck received more recognition for his work in the plastic medium than for his paintings.[4]

Sculpture and the applied arts were not simply an extra string to this painter's bow, but were fundamental to his conception of art; responses to Stuck's earliest works noted 'sculptural' elements to his style. In his late period of *c.*1913–27 that influence came to lead his painterly practice: the sculptural elements of his paintings become more exaggerated and he increasingly produced 'double works', compositions on the same topic in both painted and sculpted media.

The late painting 'Pygmalion' (*c.*1926), is exemplary of the importance of sculpture to Stuck's painting in these years. 'Pygmalion' is primarily a composition around two figures: the sculptor on his knees in awe, extending his arms towards the newly vivified Galatea who in turn extends her arms downwards towards him from her elevated position. The bodies are contrasted through colour: Galatea's white flesh still retaining the suggestion of marble in comparison to the sunburned, earthy tones of Pygmalion's skin.

Stuck's preoccupation with, and depiction of, the human body in his painting was one aspect of his work that was deemed sculptural by his contemporaries. Not only are Stuck's figures typically symbolic or iconic rather than engaged in a narrative scene (and in this resemble figurative sculptures) but he also attempts to overcome the flat plane of his painted surface in order to present fully-rounded depictions of the human form. The use of strong colour contrast is one method employed and in 'Pygmalion' the physicality of Galatea, the statue now made

44

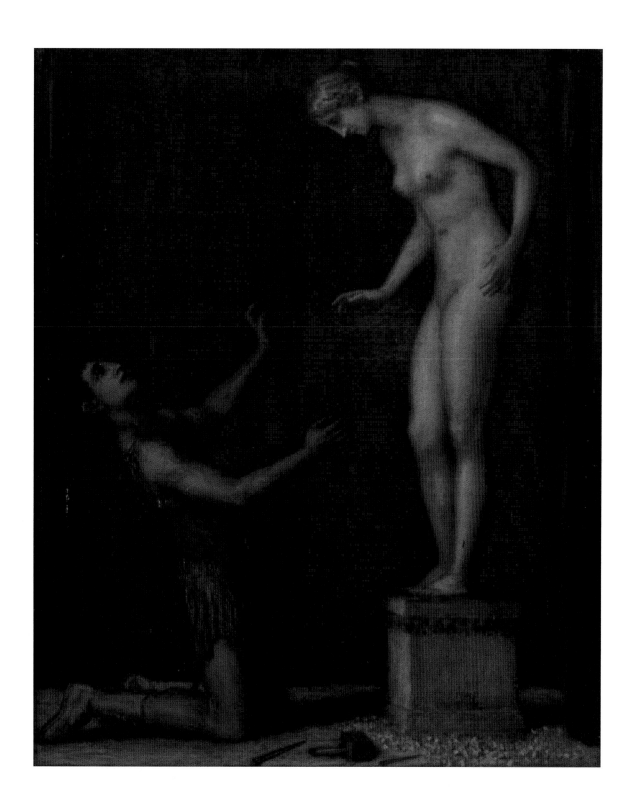

Franz von Stuck
Pygmalion

flesh, is a major focus. The painter emphasises the roundness of her limbs and fullness of her flesh through setting the light tones of her skin against the flat tones of the vivid red screen behind.

Stuck's use of line is another sculptural feature of his work. Although he was an excellent draughtsman, his stylised drawing favours a simplistic outline rather than extensive detail. The concentration on shape (seen in the mirrored positioning of Pygmalion and Galatea's poses) is distinctly sculptural.

The spatial organisation of Stuck's paintings as a whole also rests on lines, bringing them an architectural quality. They are typically composed of starkly opposed horizontal and vertical lines: in 'Pygmalion' it is the vertical line in particular that predominates, provided across the centre-right of the painting in the echoing verticals of the red screen, the black screen support and the edge of wooden furniture, and centrally in the vertical lines of Galatea's plinth. Indeed, Stuck's use of the vertical line in other works has been associated with a desire to invoke the 'monumentality' of sculpture in his painting.[5] This judgement certainly holds true for 'Pygmalion'; as she comes into life Galatea is depicted as moving away from her previous vertical position. The vertical lines in the painting all serve to show, by negative inference, the position which Galatea formerly adopted and impress that now she is pliant flesh.

The supple body of Galatea only serves to enhance the ways in which the rest of the painting is rigidly organised along sculptural lines. It must be remembered that the painting is named simply 'Pygmalion': the painting and its painter are explicitly associated with the sculptural principles that Pygmalion represents. Stuck's treatment of the myth centres on the sculptor's role: the viewer is engaged by Pygmalion's animated response to Galatea's transformation rather than encouraged to focus on the transformation itself (other paintings on this subject, including Edward Burne-Jones' 1875–8 series on the topic, have tended to show Galatea in the process of transformation, with feet or legs still in stone). Stuck instead presents the moment at which an artist, inspired and motivated by the beauty of sculpture, comes into full possession of his art. It is no coincidence that Stuck produced this painting during this Indian summer of his career. This painting is an affirmation by the painter of the centrality of sculpture to his inspiration and production, and to his feeling that, like Pygmalion, he had come to a full possession of his art through its means.

Vicky Greenaway

5. See Mendgen's analysis of 'Pallas Athena', 1898, Mendgen, p. 30.

46

William Dyce (1806–64)
Titian Preparing to make his First Essay in Colouring, 1856–7
Oil on canvas, 91.6 × 71 cm
Aberdeen Art Gallery & Museums Collection, ABDAG003211

Born in Aberdeen, William Dyce studied medicine and theology before turning to painting and design. Having attended the Royal Academy schools for only a few months (1825), he abandoned his formal training to travel in Italy. There he developed an interest in Italian art, particularly of the fourteenth and fifteenth centuries, which would influence his own work throughout his career. Intensely religious, he regularly produced pictures on Biblical themes in the manner of Perugino and the young Raphael. From the beginning he was drawn to Titian.[1]

While Dyce's paintings have often been commended for their sculptural qualities his 'Titian' is the only work featuring an actual sculpture. It illustrates an anecdote in Carlo Ridolfi's *Life of Titian* (1648) in which the young painter is said to have squeezed the juice from flowers to provide colours with which to paint.[2] Stories from the lives of the Old Masters were popular in nineteenth-century art.[3] Artists represented as child prodigies appealed to the Victorian idea of genius as something innate. Dyce's Titian evinces his early artistic leanings. The boy considers a statue of the Virgin and Child on a tree stump in a wooded garden. His right hand, holding flowers and a *porte-crayons*, rests on the blank pages of his open sketchbook. At his feet is a wicker basket with the flowers and berries he has gathered to make his rudimentary pigments. Other paraphernalia of the painter's craft are set on the grass nearby. As Ruskin and others remarked, of all Dyce's pictures this comes closest to the Pre-Raphaelite ideal in the almost photographic precision of its natural detail; in the gnarled oaks, for example, and the flowers all simultaneously in bloom.[4]

The statue which the young painter admires is a pastiche in the style of mid-fourteenth century Tuscan sculpture which approximates the appearance of various statues of the Virgin and Child by Nino Pisano in Pisa.[5] Dyce would have seen these when he was in Pisa in 1845.[6] It is highly improbable that the young Titian ever did. Besides this historical inaccuracy, Dyce has also taken liberties with the text that supposedly inspired his picture. When the painting was exhibited at the Royal Academy in 1857 the catalogue entry noted: 'Ridolfi states that Titian, when a little boy, gave the earliest indication of his future eminence as a colourist by drawing a Madonna which he coloured with the juice of flowers'.[7] There is no mention of a statue and indeed the idea that an uncoloured stone figure might in some way have inspired Titian the colourist puzzled even Ruskin who, apart from this, pronounced the picture 'wonderful',[8] ' … it [would not] have been a statue such as this which first made him dream of the Madonna but rather some fresco of a wayside chapel'.[9]

Ruskin, however, missed the point. It is precisely the statue's colourlessness which inspired the young painter to complete it, in his mind's eye, with the enli-

1. Two early works clearly reveal Dyce's debt to the painterly style of Titian and in 1840 he exhibited at the Royal Academy the now lost 'Titian and Irene di Spilimbergo', see M. Pointon, *William Dyce 1806–1864. A Critical Biography*, Oxford, 1979, pp. 8, 10, 138, 198 and J. Melville ed., *William Dyce and the Pre-Raphaelite Vision*, Aberdeen, 2006, pp. 78–9.
2. C. Ridolfi, *Le Maraviglie dell'Arte*, Venice, 1648, I, p. 136. See also F. Irwin, 'William Dyce's "Titian's First Essay in Colour"', *Apollo*, 1978, vol. 108, pp. 251–5 and the catalogue entry by Ann Steed, in Melville 2006, pp. 160–3.
3. F. Haskell, 'The Old Masters in Nineteenth-Century French Painting', *Art Quarterly*, 1971, vol. 34, pp. 55–85, reprinted in F. Haskell, *Past and Present in Art and Taste: Selected Essays*, New Haven and London, 1987, pp. 90–115 and M. Levey, *The Painter Depicted: Painters as a Subject in Painting*, London, 1981.
4. It is thought that Dyce may have actually used photographs at this time in composing paintings such as 'The Ferryman' (1857), which may have derived from a photograph by the Aberdeen photographer George Washington Wilson, see C. Willsdon, 'Dyce "in Camera": New Evidence of his Working Methods', *Burlington Magazine*, 1990, vol. 132, pp. 760–5 and Melville ed., pp. 164–5. As Ann Steed of Aberdeen Art Gallery pointed out to me, the split and gnarled oaks in the 'Titian' resemble the line of trees in a photograph attributed to the pioneer photographers D.O. Hill—with whom Dyce corresponded—and R. Adamson now in the collection of Glasgow University (inv. HA0416). On the multi-seasonal mix of flowers see Irwin 1978, pp. 252–3.

5. See, for example, the Madonna on the Saltarelli tomb in S. Caterina, Pisa or the Virgin Annunciate in the same church and the marble Virgin, formerly in the little Gothic church of S. Maria della Spina, now in the Museo di S. Matteo, Pisa. G. Kreytenberg, *Andrea Pisano und die toskanische Skulptur des 14. Jahrhunderts*, Munich, 1984, figs. 158, 222-3, 248-9.

6. L. Errington, 'Ascetics and Sensualists, William Dyce's Views on Christian Art', *Burlington Magazine*, 1992, vol. 134, pp. 492-3.

7. Ridolfi (1648, I, p. 136) actually notes that Titian, '*ancor piccioletto col solo impulso della natura, fece co' sughi di fiori, entro ad un capitello sopra ad una strada della sua Patria, la figure della Vergine*', that is, he painted the figure of the Virgin with the juice from flowers on a capital (or piece of stone) on a road in his native town.

8. John Ruskin wrote to Dyce on 8 May 1857, 'to congratulate you on your wonderful picture' (Dyce Papers, Aberdeen Art Gallery).

9. J. Ruskin, *Academy Notes*, 1857, no. 107.

10. Errington 1992, p. 492.

11. Errington 1992, p. 493, Irwin 1978, p. 252.

12. Irwin 1978, pp. 253-4. Ruskin (*The Elements of Drawing*, 1857) was of the same opinion.

vening colour it lacks. While a richly-coloured fresco would have offered little to his imagination, the monochrome stone allowed it free rein. We are not to suppose, however, that Titian is tempted to colour the statue itself. Dyce would not have allowed it. He deplored the idea of polychromed sculpture, calling it 'barbaric'; although, ironically, fourteenth-century Madonnas like that in his painting would originally have been pigmented, at least in part.

But the presence of the statue in the picture may also be understood in other ways. Dyce was a committed Christian who believed that religion was a prime force in the development of art. In an unpublished lecture of 1844 he identified five periods in Christian art, the third of which he called the Ascetic, when art achieved its greatest excellence and which ended with the dawn of the Renaissance.[10] The late-medieval statue which the young Titian studies, is thus from art's most perfect era. That painters should learn from the past was one of the ideas to which Dyce as an educationalist was committed. Throughout his career he had been involved in the training of aspiring artists and designers and held strong views on the subject. He believed, for example, that modern painters did not spend enough time working from nature in the open air.[11] He was equally opinionated about the proper curriculum. The Royal Academy, with its old-fashioned emphasis on copying from the antique, from paintings and from the living model, was, in his view, insufficiently rigorous. Dyce instead proposed a two-stage programme for apprentice painters. In the first stage they would draw from uncoloured casts in order to learn about form and light and shade, and 'because…the crayon is more easily mastered than the…brush'. Only after becoming proficient in this were they to be allowed to colour.[12] Dyce's 'Titian' may be seen, therefore, as encapsulating his educational agenda. The young painter, working out of doors, studies the form and the play of light on the figure prior to drawing the Madonna in his book. Only afterwards will he colour in his sketch with the sap he has extracted from the flowers.

Brendan Cassidy

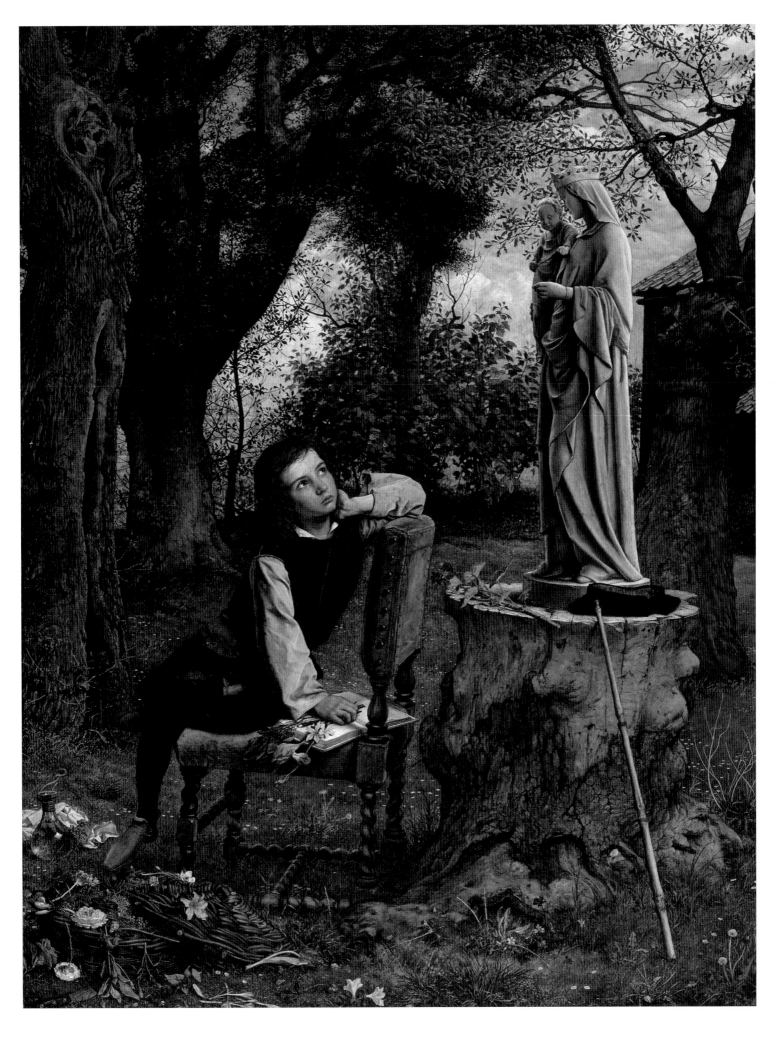

Guerman von Bohn (1812–99)
Marguerite (Woman in prayer before a Madonna), 1864
Oil on wood, 91 × 59 cm
Musée de la Roche-sur-Yon, 865 1 1

Guerman von Bohn was a German painter who also worked in France where he adopted the forename Auguste and had the greater success. Bohn took up painting after abandoning his law studies, moving to Paris in 1835 to train under the academic painters Ary Scheffer and Henry Lehmann. In the conventional manner he then moved to Rome in 1840–3 to complete his artistic education. His most successful compositions featured pensive young peasant women, firmly drawn and modelled, in fragmentary views of French regional landscapes. A similar format was adopted for paintings of female saints in commissions for Notre Dame de Paris, Tours and other major towns in France. Napoléon III admired Bohn's work and he was awarded the *Légion d'Honneur*. He later became court painter at Württemberg.

This painting is characteristic of the broad format of Bohn's work. The elegant young woman is characteristically lost in thought. The unusually strong sense of narrative brings the work closer to the painting of the German Nazarenes based in Rome, and perhaps even to some Pre-Raphaelites. The suggestion of narrative is crucial to the effect of the painted sculpture. By painting the young woman and the sculpture in similar ways, he makes them look equally alive, enabling the viewer, for a moment at least, to suspend disbelief and to think that the Virgin is able to reach down to her visitor. The painting may commemorate a gift or patronage to the convent visible in the painting.

However the most powerful sculptural form in this painting is the immemorial oak with enormous trunk, gnarled roots, and small twisted branches. By contrast the sculpture of the saint is small, broadly pyramidal, and precariously perched on a small shelf held in place with brackets. This sorrowful figure is sympathetic and composed. Her folded hands and tilted head establish a psychological contact with her supplicant visitor. Both are protagonists in the narrative.

The statue of the Madonna appears weightlessly immaterial. Her psychological contact suggests that she is alive, or that she is a vision, and, like a vision, insubstantial. At the foot of the oak a great, flat, stone slab testifies to the importance of this shrine as a place of prayer and offerings.

By contrast the young woman is stylishly dressed. Her profile suggests the freshness of youth echoed in the dewy landscape of early spring and by the flowers on her hem. She may be contemplating motherhood or, alternatively, a life withdrawn into the convent visible in the distance. The glowing landscape is tinged with an air of melancholy. The long lines of the young woman's clothes, and the pointed roofs of the distant buildings, recall medieval times, or medievalising modern times, of the kind sometimes evoked by the Pre-Raphaelites.

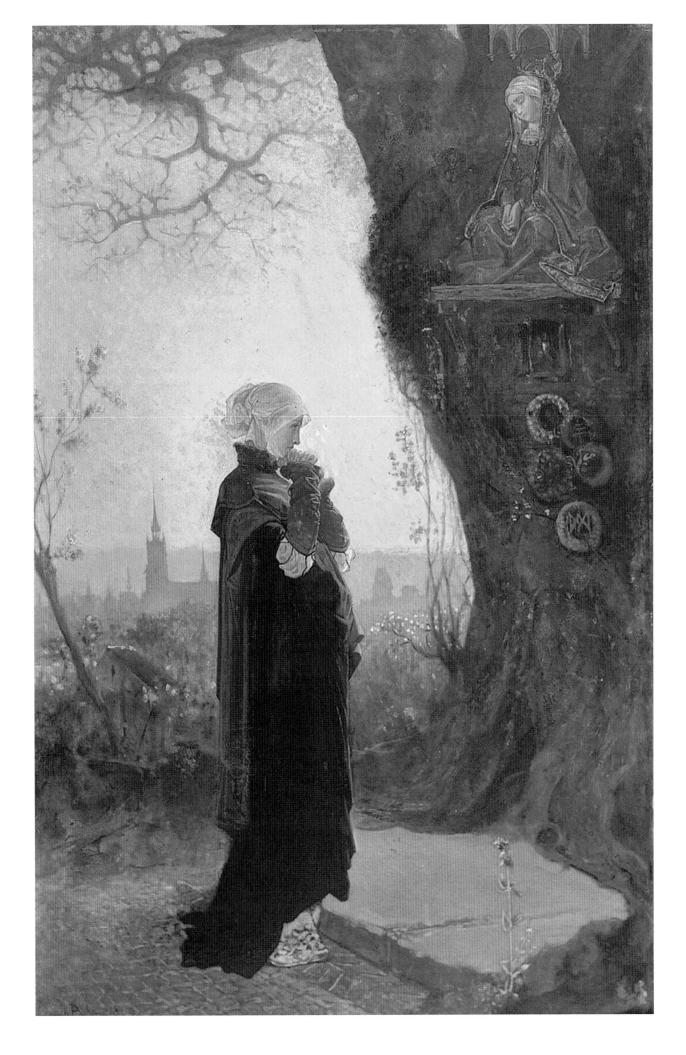

Guerman von Bohn
Marguerite (Woman in prayer before a Madonna)

The girl's stance and her intricately interlocked fingers are convincingly painted. If the painted sculpture of the Virgin might seem alive, so this figure resembles a finely crafted sculpture. One mystery remains. This is not a standard format for the image of the Virgin, but is closest to the shape of the *Pietà* in which the Virgin bears the body of her dead son. Here the Christ figure is absent, and this may be the key to the meaning of the painting: a gently affective meditation upon this world's intersection with belief.

The narrative richness and specificity of this painting are unusual and indicate the possiblity of a local commission. Guerman von Bohn has recorded the shrine and its Madonna, but also the sense of religious belief at a particular time and place, as Gauguin was to do in Brittany, so that this is a painting of a sculpture within a regional cult, and a totemic focus of mystical powers.

John Milner

Louis Gauffier (1762 – 1801)
Pygmalion and Galatea, 1797
Oil on canvas, 67.5 × 52.1 cm
Manchester City Galleries, 1979.546

Gauffier's painting illustrates the story of Pygmalion, a sculptor whose unrequited love for one of his statues, Galatea, prompted the goddess Aphrodite to intervene. Aphrodite transformed Galatea from an inanimate object made of ivory into a living being, and thereby enabled Pygmalion's love to be consummated. Gauffier's picture departs from its source in Ovid's *Metamorphoses*, Book X in two important ways. Firstly, in Ovid's story, the moment of transformation occurs once Pygmalion has taken his sculpture to his bed, blinded by his passion to the woman-object's unresponsiveness. Gauffier's version shows Galatea's body in the process of becoming animate as it stands on a plinth—the lower half of her body is grey, the upper parts are pinkish, especially her flushed cheeks. Secondly, Pygmalion's sculpture is described by Ovid as being of ivory, but in the painting appears to be made of stone. Gauffier shows Aphrodite floating on a cloud between Pygmalion and Galatea. Aphrodite places a butterfly on Galatea's head as a sign of her acquisition of a human soul, and gestures with her left hand to Cupid, who aims an arrow at Galatea to ensure she reciprocates the sculptor's love. Love, we observe, has the power to infuse life and desire into an inanimate object.

The picture conceals an ambiguous moral. On the one hand, Pygmalion's artistic virtuosity allows him to create an image so convincing that he, its creator, forgets that he is merely looking at a sculpture. This train of events seems like an analogy for the artist's ability to transform matter into something living. On the other hand, the artist's creative power, for all its magic, is shown to be divorced from his emotional being, such that he falls into the pathetic predicament of mistaking his sculpture for a woman. As shown by Gauffier, Pygmalion seems more astonished by the metamorphosis taking place before his eyes than transported by the rapturous prospect of what awaits him once Galatea finds a way to descend from her pedestal into his arms.

Galatea is surrounded by an array of tactile materials and objects—fragments of red coral, jewels, garlands—gifts and adornments from Pygmalion which the painter includes to create an enhanced 'reality effect'. There are also tokens of Pygmalion's adoration (we see a lyre for presumed serenades, a brazier for burning perfume), and, finally, the tools with which he has created his self-deceiving illusion. The scene takes place in a palatial setting, as if in the corner of a colonnaded courtyard, perhaps suggesting the monumentality attributed, not only to the ambitions, but also to the working conditions of antique sculptors, as much as corresponding to the fact that Pygmalion was a king.

Gauffier was an artist capable of history painting, portraiture and landscape. He gives this literary-mythological subject the scale and feel of a genre scene.

53

Louis Gauffier
Pygmalion and Galatea

Earlier paintings on this theme had been more operatic and sentimental, for example those by François Lemoyne (1688–1737) (1729) and Louis-Jean-François Lagrenée (1724–85) (1805). As the co-winner of the 1784 *Prix de Rome* he spent the years from 1785–9 in Rome. Although he returned to France in 1789, he was back in Rome later the same year. By 1793 he had moved to Florence, where he became a long-term resident. It was here that he made this picture, which might partly explain why Galatea's pose owes something to that of the famous antique sculpture, the 'Medici Venus', which was a celebrated item in the *Tribuna* of the Uffizi Gallery. We do not know for whom the picture was made, if, indeed, it was a commission (there is no provenance for it prior to its purchase by Manchester Art Gallery in 1979). A drawing (also in Manchester) shows an alternative horizontal format for the composition, with Aphrodite to the left, and Pygmalion clasping his hands to his breast.

Richard Wrigley

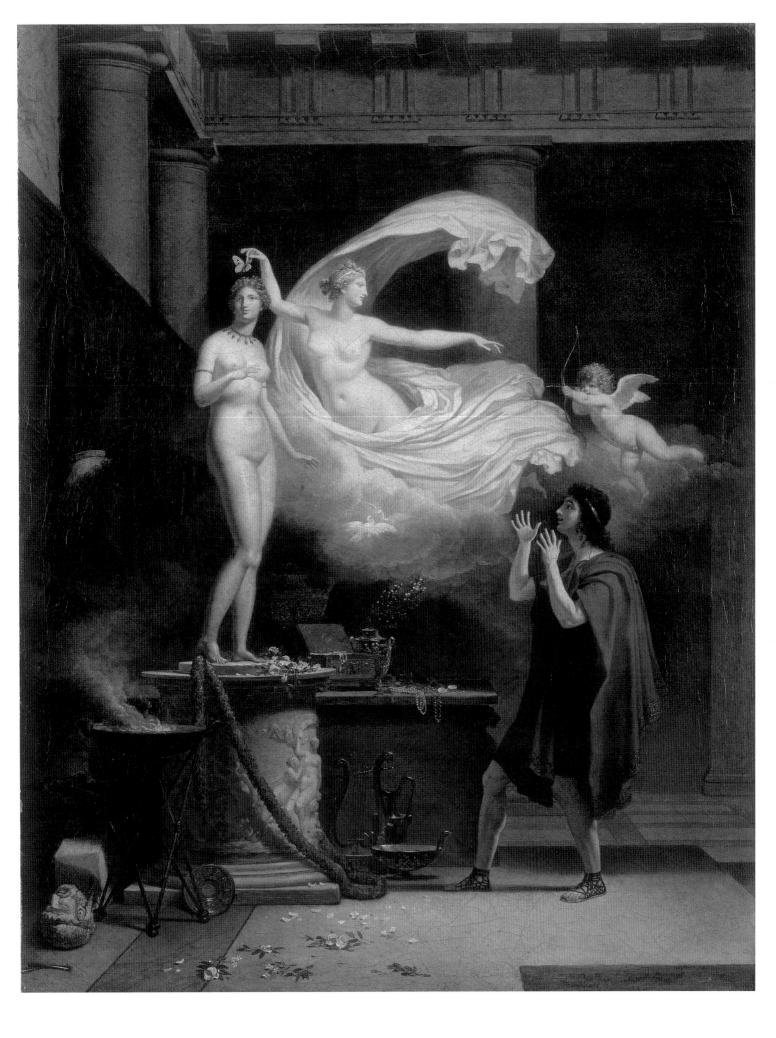

Georg Scholz (1890–1945)
Female Nude with Plaster Bust, 1927
Oil on canvas, 65.5 × 55 cm
Staatliche Kunsthalle Karlsruhe, 2799

Georg Scholz is commonly associated with the realist trend in German painting of the 1920s which goes under the name of the *Neue Sachlichkeit* (New Objectivity). There was no *Neue Sachlichkeit* manifesto or any significant collective programme but the term came into common use after it featured as the title of a 1925 exhibition, in which Scholz was included, and was seen as appropriate to characterise the work of those artists who took a sober and objective view of the world in contrast to the impassioned and idealistic outlook of their Expressionists predecessors. Cool and distanced attention to the world of things (*Sachen*) rather than submission to mystical visions typified the more cynical, materialistic outlook of the generation of artists who came to the fore in Germany at the end of the First World War. As was also the case with several of his contemporaries, artists such as Otto Dix and George Grosz, Scholz became involved at that point with the radical Dada groups in Germany who rejected Expressionism in favour of critically realist forms of practice, such as montage, through which they commented on everyday life and the current political turmoil. Scholz's satirical image of 'Industrialised Farmers', which combined painting with photomontage and collage, was shown at the *First International Dada Fair* in Berlin in 1920.

'Female Nude with Plaster Bust' has been described as a turning point in Scholz's career.[1] It was painted shortly after he took up a teaching position at the Karlsruhe Akademie, the very same art school where he had been trained from 1908–14. From that moment the nude became a dominant motif in his output, whereas his subject matter to that point had focussed primarily on urban life. It is clear that the painting provides a commentary on the teaching of art and is potentially highly didactic. The plaster bust, cast from a Greek marble dating from the fourth century BC known as the 'Brunnsche Kopf', was taken from the academy's collection, one of many such casts Scholz had been required to draw as part of his education. In 1927 Scholz became professor of a newly established life drawing class at the academy. The two models seem to refer directly to past and present educational practices, working from antique casts or from life, with realism triumphant. The nude, who is reported to have sat regularly for Scholz's students, is depicted in black stockings to emphasise her worldliness, the warmth of her flesh in direct contrast to the coldness of the antique bust.[2] The height of the bust, in line with the torso of the nude, makes us all the more conscious of the body it lacks. Nude and plaster cast occupy the same space but look in different directions and are in different worlds; Scholz may in fact have originally titled the painting 'The Old and the New Venus.'[3]

The theme of the new replacing the old is belied, however, by the interesting relationships drawn between the two figures. The blank gaze of the nude and her

1. Felicia H. Sternfeld, *Georg Scholz (1890–1945). Monographie und Werkverzeichnis*, Frankfurt am Main, 2004, p. 207.

2. Sternfeld, p. 208.

3. Sternfeld, p. 210.

56

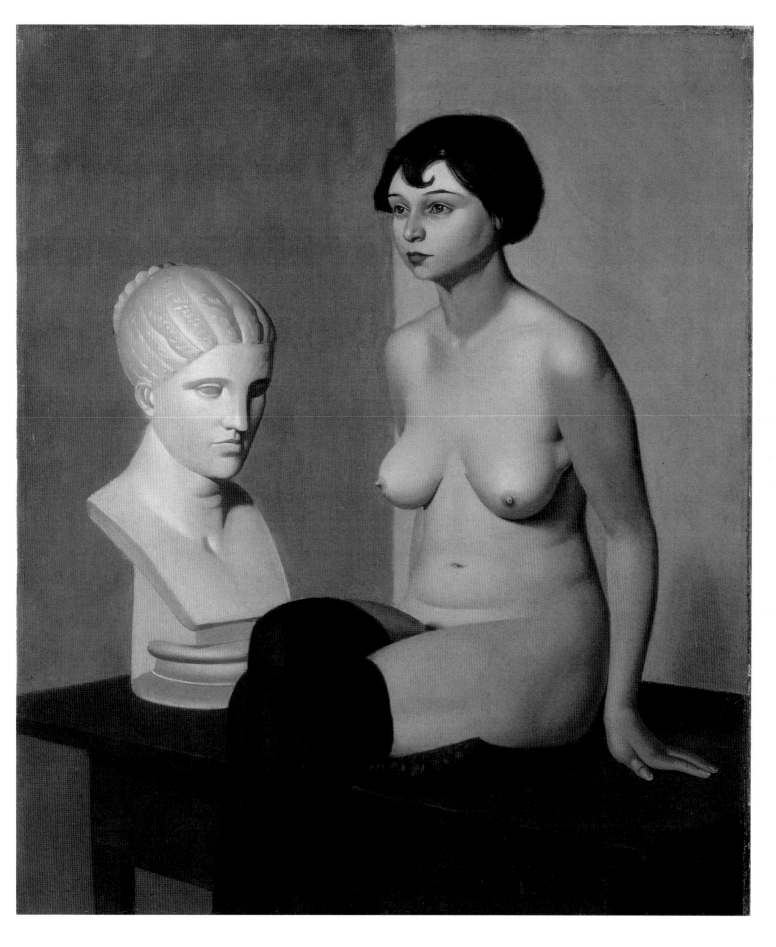

Georg Scholz
Female Nude with Plaster Bust

4. Herbert Bayer, 'Zieh Dich aus und Du bist Grieche', *Uhu*, September 1930, pp. 28-9.

frozen posture invite direct comparison to the sculpture. The plaster head is notable for its hairstyle, while the nude sports the then fashionable *Bubikopf* or page-boy cut, a more androgynous look seemingly at odds with her voluptuousness. The increased access that women had to sporting activities, the emphasis given to health and hygiene, the trends for clothing which allowed movement had actually contributed to a fad for things Greek in Germany at the end of the 1920s. As Herbert Bayer, the Bauhaus graphic designer, titled a satirical article of the time, 'Get undressed and you are Greek'.[4] Scholz had included items of sculpture in his previous paintings, mostly monuments and trinkets representing Germany's imperial past, indications of bad politics and kitsch taste. Rather than a simple return to tradition, or a statement about realism, 'Female Nude with Plaster Bust' continues this interest in the relationship between art, fashion and the circulation of commodities, of which the nude and plaster cast might both be examples.

Michael White

Lemuel Francis Abbott (1760–1802)
Joseph Nollekens, c.1797
Oil on canvas, 74.9 × 60.3 cm
National Portrait Gallery, London, NPG 30

Joseph Nollekens (1737–1823) was the most important British sculptor to emerge in the first twenty years of the reign of George III, whose nearly exact contemporary he was. The son of the minor painter J.F. ('Old') Nollekens, he came to prominence in Rome working up and selling antiquities to tourists; but his name was made on his return to England thanks to a series of commissions from Whig aristocrats, most notably Charles, second Marquis of Rockingham, the leader of the Whig party. Nollekens was a more than competent statuary but his forte was reckoned to be the portrait bust. Although he did not go out of his way to appeal only to clients of one political party, Nollekens was undoubtedly associated in the public mind with portraiture of the Whigs; above all thanks to his two busts of the party's next and most charismatic leader, Charles James Fox. It is the first of these, carved in 1791, which appears in the present portrait. Numerous versions of the bust were made, and ownership of it or its sequel—a second, more severe but equally characterful bust that Nollekens executed in 1802—was regarded as a badge of Whig political sympathies.

Little is known about the circumstances which led to Abbott making this portrait. It was not a formal commission, since the engraving that was made from it recorded that the painting had remained in the artist's own possession. It is traditionally dated to 1797, by which time Abbott's career as a society portraitist in London had been underway for about seventeen years. He was never at the head of his profession and exhibited only sporadically at the Royal Academy, but he was widely respected, probably because his works created the sense of being an excellent likeness. He would achieve his greatest success in 1800 with a much-copied portrait of Horatio Nelson.

During the sittings for this portrait, Nollekens must have mentioned to Abbott his fondness for an earlier portrait of himself by John Francis Rigaud (now in the Yale Center for British Art, New Haven) in which Rigaud had shown Nollekens leaning on the model of his bust of the writer Laurence Sterne.[1] Abbott follows Rigaud's device of having the two figures, painted and sculpted, looking in opposite directions, as though to emphasise the autonomy of the two art forms. But where the effect of Rigaud's picture depends on the contrast between the severity of Sterne's expression and the vivacity of Nollekens' own, in Abbott's picture the effect is more subtle. Abbott slyly creates visual parallels between the sculptor and his bust to the point that they are almost mirror images of each other; he invites the viewer to compare the shape of the mouth, the nose, the locks of hair, the eyebrow, even the hint of laughter in both men's eyes. Instead it is the gaudy waistcoat, placed cheek by jowl against the monochrome bust with an effect

1. As is noted by Richard Walker, *Regency Portraits*, 2 vols, London, 1985, vol. 1, p. 368.

59

Lemuel Francis Abbott
Joseph Nollekens

almost of abstract painting, that rehearses the traditional motif of the contrast between painting and sculpture.

The diarist Joseph Farington recorded that Abbott and Nollekens sat next to each other at a Royal Academy dinner in June 1798, perhaps a sign that this portrait had cemented a friendship between the two men. Only a month after this event, Abbott was certified insane, and although he continued to paint, his health was undermined. A few months after his death, Farington recorded seeing Abbott's only son, aged fifteen, drawing from a plaster cast in Nollekens' studio.

Alex Kidson

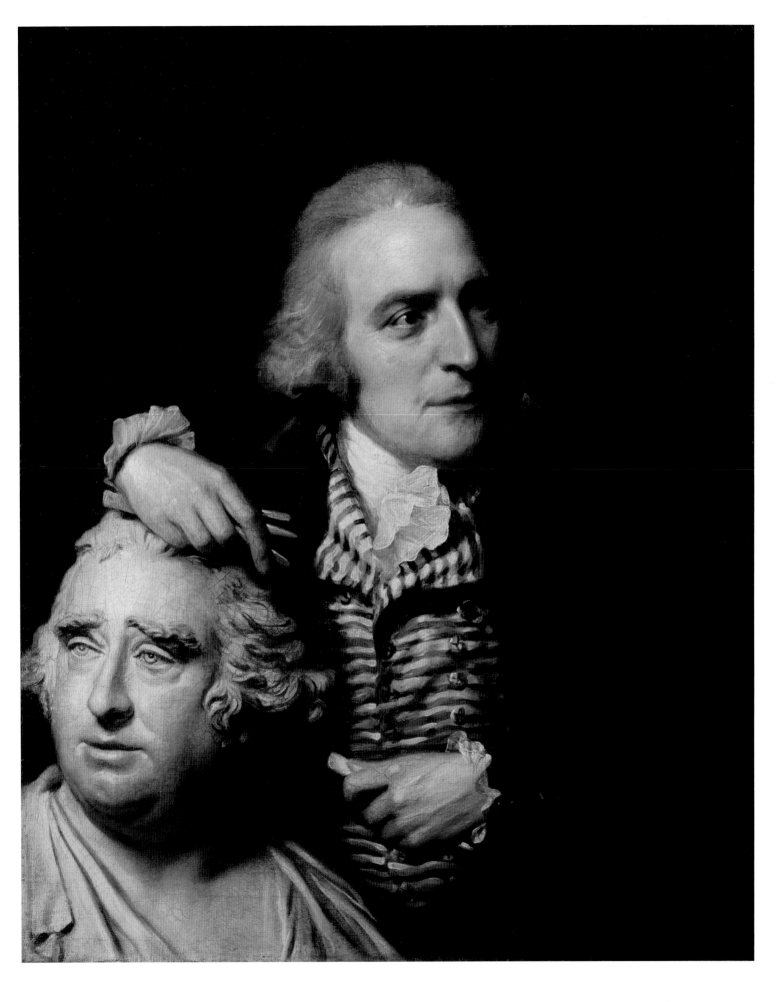

Andrea Soldi (1703–72)
Portrait of Louis François Roubiliac, 1751
Oil on canvas, 97.5 × 83.2 cm
By permission of the Trustees of Dulwich Picture Gallery, London, DPG603/1917

1. D. Bindman and M. Baker, *Roubiliac and the eighteenth-century monument: Sculpture as theatre*, New Haven and London, 1995.

2. J. Ingamells, 'Andrea Soldi: A checklist of his works', *Walpole Society*, 1980, vol. 47, pp. 1-20. Our portrait is no. 50. See also Ingamells' articles on Soldi in the *Connoisseur*, 1974, vols 185 and 186, pp. 192-200, 178-185.

Both the painter of this portrait and the sitter were *émigrés*, skilled professionals who belonged to the diverse migrant population of mid-eighteenth-century London. The French-born Roubiliac was the leading sculptor of his generation—an accolade that is reflected in his being the sitter-subject in three surviving oil portraits, including this one.[1] The painter Andrea Soldi was originally from Florence. Posterity affords him a minor role as an artist who in the early 1750s produced a series of portraits of his professional peers, including the sculptor Michael Rysbrack (Yale Center for British Art, New Haven) and the architect, Isaac Ware (RIBA).[2] This three-quarter-length portrait of Roubiliac from the same series represents the sculptor wearing a working dress consisting of a pink-coloured coat with frogging deriving from contemporary military uniforms and a purple fur-lined cap. The portrait images the creative process of sculpting a work of art in the dynamic encounter between the sculptor and one of his productions. In addition to the likeness of Roubiliac, which dominates the canvas, a work in progress is included on the far left, where it is upraised on a modelling stool to the sculptor's bulging eye level. The model has been identified as that of Charity, an allegorical female figure with a child that formed part of a marble monument to the second Duke of Montagu, which was erected in 1753 in the chancel of the church at Warkton in Northamptonshire. Roubiliac is shown gazing intensely at the model—he is unaware and uninterrupted by the presence of the external viewer. Particular emphasis in the composition is given to Roubiliac's hands, the tools of his trade, if you like. The fingers of his left hand hold the modelling stool in position (note the unbuttoned cuff of his sleeve), while his right hand is po(i)sed armed with a spatula, an instrument for modelling in clay that is shown as the extension of the fingers on his hand. Resting on the lower tier of the modelling stool are additional instruments for modelling and measuring in the composition of sculpture, another spatula and a pair of callipers.

George Vertue, one of the earliest historians of British art and a contemporary of Roubiliac and Soldi, viewed the painting and described it as follows:

> Mr Rubilliac the Statuary, his picture painted by Mr Soldi—portrait painter—Nov. 1751. his portraits are freely & well drawn and his Colouring true and very natural. he is certainly a painter of superior merit in the portrait way. very light and airy.[3]

3. Quoted in K.A. Esdaile, *The life and works of Louis François Roubiliac*, London and Oxford, 1928, p. 190, also 'Vertue Notebooks: Volume III', *Walpole Society*, 22 (1933–4), 159.

Vertue's brief critique focuses more on the painter than the sculptor-sitter. For our purposes, the interface between the two media of sculpture and painting is fairly self-explanatory—this is a portrait that represents the sitter, through his

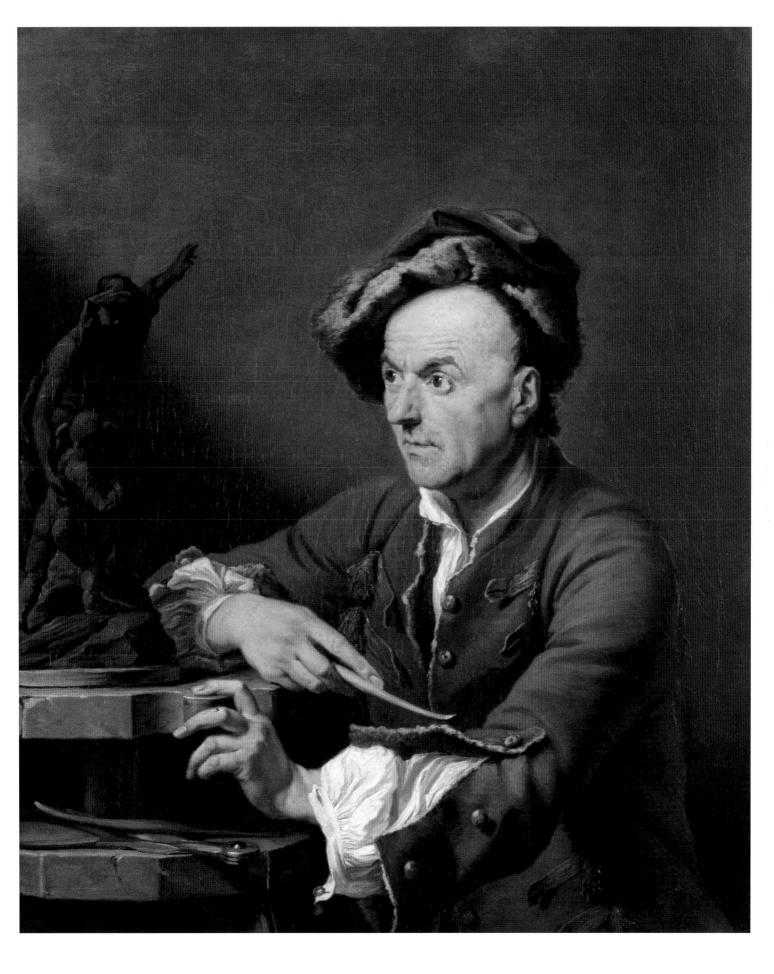

Andrea Soldi
Portrait of Louis François Roubiliac

facial features, his hand gestures, the modello on which he is working, his tools and dress, in terms of his professional identity as a sculptor. The portrait by Soldi also suggests the many interactions, personal and professional, social and commercial, between *émigré* painters and sculptors working in London around the mid-eighteenth century.

There is much we do not know about the portrait which might clarify a more nuanced reading of the relationship between sculpture and painting. For instance, who commissioned it from Soldi and why? Was it a commission from the sitter, Roubiliac himself, or a third, unknown, party? There might be some tangential connection to the second Duke of Montagu and his heirs, given the specific quotation from the monument commissioned to the Duke shown in its evolution on the adjustable stand. Alternatively, the portrait might have been produced as a speculative work by Soldi, looking to capitalise on the professional reputation of the sculptor-sitter that depicts him aping the visual territory of self-representation—the painted portrait—that as a mode of representation was traditionally associated with the aristocracy and gentry.

Viccy Coltman

Etienne Aubry (1745–81)
Louis-Claude Vassé, 1771
Oil on canvas, 119 × 97.5 cm
Dépôt du Musée du Louvre, 1921,
Musée national des châteaux de Versailles et de Trianon, MV 5875

Pupil of Vien and protégé of d'Angiviller, Aubry began his career as a portraitist before becoming a genre painter and achieving fame with his sentimental scenes. The portrait of the sculptor Louis-Claude Vassé (1716–72), painted in 1771, represents his reception piece (or entry submission) to the Academy in the field of portraiture.

As if he wished to illustrate the traditional definition of sculpture as the art of touch, Aubry has represented the sculptor in the act of touching his work with both hands, one of which, holding a small tool, seems to caress the marble, while the other pushes the cheek with the thumb in a gesture which evokes the modelling technique.

It is noticeable that the sculptor touches his sculpture without looking at it, his gaze lost or absent, like that of a blind person engaged in feeling an object with his hands, and as if, indeed, Aubry wished to underline the opposition between touch and sight.

The blind look of the sculptor is counter-balanced by that of the sculpture, the eyes of which have no pupils. Like the blind sculptor whose story is told by Roger de Piles in *The Principles of Painting*, Vassé seems to have eyes at the end of his fingers.

Like a number of painted portraits of sculptors, this example also offers a representation of the paragone, and this one is especially ingenious. In contrast with the up-to-date and richly coloured clothing of the artist, with the delicate tones of the linen, the materials and the flesh, so magnificently captured by the painter's brush, the sculpture, even if it be crowned with laurels, lacks all colour.

The gesture of the right hand, and most particularly that of the thumb, is open, in this regard, to several interpretations. On the one hand it represents the distinctive mark of sculpture in its relationship to painting, or that which Roger de Piles called its 'specific difference'.

But over and above the actual difference between an art of touch and an art of sight, it also suggests a more subtle difference between the real tactility of sculpture and the metaphorical tactility of painting, given that the art of the painter consists precisely in rendering flesh in such a way as to give the spectator the impression that he could, if he approached the work, actually touch it.

In terms of the paragone this second interpretation would tip the balance in favour of painting. But the gesture could also be interpreted as a homage rendered by painting to the magical powers of sculpture and to the talent of the sculptor who knows how to give hard marble the appearance of flesh sufficiently soft for the spectator's fingers to sink into it. 'What soft skin! No, it cannot be marble. Press

Etienne Aubry
Louis-Claude Vassé

your finger and the material, which has lost its hardness, will take your imprint'
wrote Diderot in his review of the *Salon* of 1763 in relation to Falconet's group
'Pygmalion and Galatea'.

Jacqueline Lichtenstein

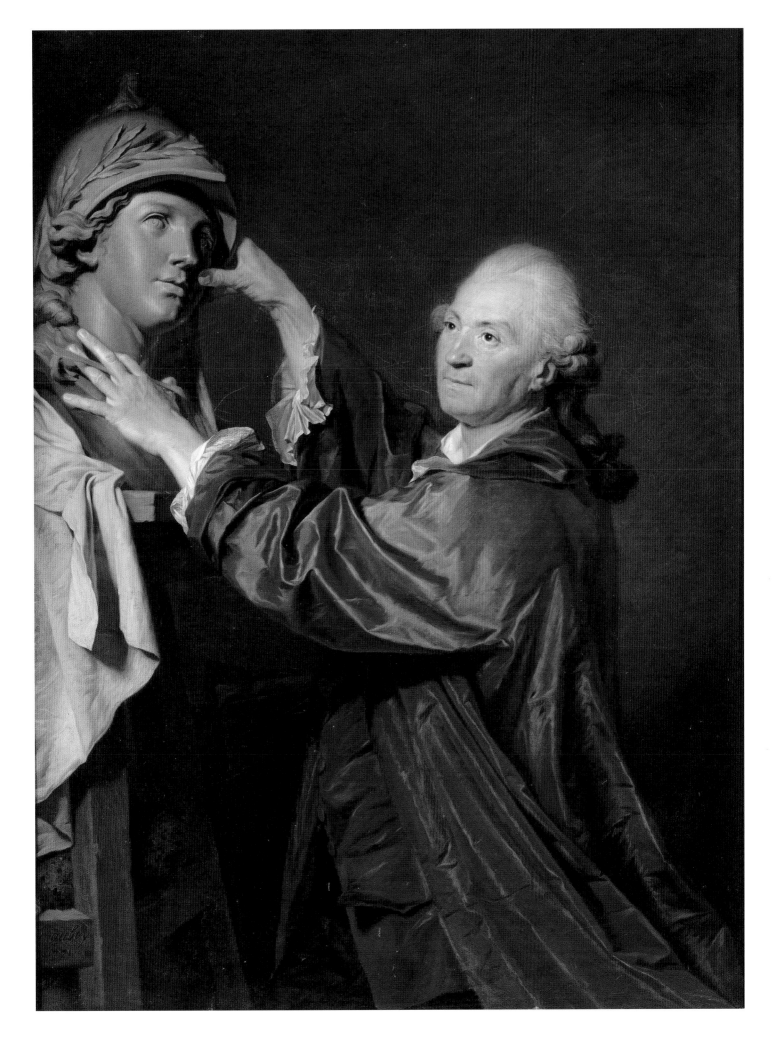

Frederic Leighton (1830–96)
Self-Portrait, 1880
Oil on canvas, 76.5 × 64.1 cm
Istituti museali della Soprintendenza Speciale
per il Polo Museale Fiorentino, 1890/1874

1. Until 1924, the painting was exhibited in the museum itself, in the room of 'Foreign Artist Self-portraits', but went into storage after the Second World War until 1973. Since then it has been in the Vasarian Corridor linking the Uffizi to the Pitti Palace, which is not permanently open to the public.

2. The DCL gown is an explicit reference to Leighton's predecessor, Sir Joshua Reynolds, who wears the same robe in the self-portrait he painted for the Royal Academy in 1773. The medal Leighton wears became an official badge of the office of the President of the Royal Academy in 1820, when George IV presented a medal to Sir Thomas Lawrence. Seventy medals were struck (my thanks to Elizabeth King, Royal Academy Library, for this information).

3. This is one of many different readings scholars have proposed. For a summary of the various interpretations see Ian Jenkins, *The Parthenon Frieze*, London, 1994.

4. See *Frederic, Lord Leighton, Eminent Victorian Artist*, exh. cat., Royal Academy of Arts, London, 1996, cat. 84, p. 190, and Lene Østermark-Johansen, 'The Apotheosis of the Male Nude: Leighton and Michelangelo', in Elizabeth Prettejohn and Timothy Barringer, eds, *Frederic Leighton: Antiquity, Renaissance, Modernity*, New Haven and London, 1999, p. 111.

5. When Leighton was commissioned by the Uffizi's director to contribute his self-portrait to the collection, he was asked to nominate two British contemporaries to be honoured in the same way. He named Millais and G.F. Watts. See *Frederic, Lord Leighton, Eminent Victorian Artist*, exh. cat., Royal Academy of Arts, London, 1996, cat. 84, p. 190.

Frederic Leighton's self-portrait, commissioned by the Uffizi for its world-famous collection of self-portraits, is well-known, if rarely seen.[1] Leighton chose to depict himself in the academic robes of a Doctor of Civil Law of Oxford University, and wearing the medal of the President of the Royal Academy, overt symbols of his intellectual and academic standing.[2] Behind him is a detail from the north frieze of the Parthenon, the section representing the horsemen celebrating the Battle of Marathon.[3] The portrait has been variously described as representing Leighton as a 'Zeus', a 'Phidias', or a 'Michelangelo'.[4] The reference to the Parthenon has generally been seen to serve as a marker of his artistic interests, notably the embrace of sculpture within his own work and in his capacity as the Academy's President. The juxtaposition between the classical sculpture and the Renaissance-like portrait has been linked to the artist's eclecticism, a term widely used to describe his practice at the time, but which later took on pejorative associations.

Read in these broad, generic terms, the portrait can seem bland and unrevealing. Leighton's deliberate foregrounding of his public office—critical to his position in the art world—later appeared as an all-too obvious statement of his endorsement of academic values. There is a noticeable absence in the painting of any of the markers of unique psychology, artistic temperament, or inner creative drive, which we expect from a self-portrait. Indeed, it makes a distinct contrast to contemporaneous self-portraits, such as that by John Everett Millais, with which it was originally hung in the Uffizi.[5] While Millais shows himself with palette and brush, in the act of creating his self-image, Leighton seems deliberately to efface any hint of the studio. Dressed in ceremonial garb rather than work-clothes, his hands are invisible, apparently inactive, the tools and materials of painting out of sight. The presence of the Parthenon frieze further heightens our sense of the work's fictional nature, which comes across as a composite of separate elements, rather than a record of an authentic moment. Indeed, the orientation of the frieze (correctly giving the direction of the horsemen), indicates that this is not a mirror image of an actual scene from life.

But if we consider the self-reflexive nature of self-portraiture, and the choices which Leighton made, our reading can be differently inflected. In its insistent formality the work comes across more as a portrait than a self-portrait, suggesting Leighton sees himself at one remove, a tacit acknowledgment of the public gaze. No distinction is made between Leighton as a figure-head, and as a private individual. The Parthenon frieze functions as a register of the academic values Leighton implicitly endorses and perpetuates. A review dating to 1897 suggests that

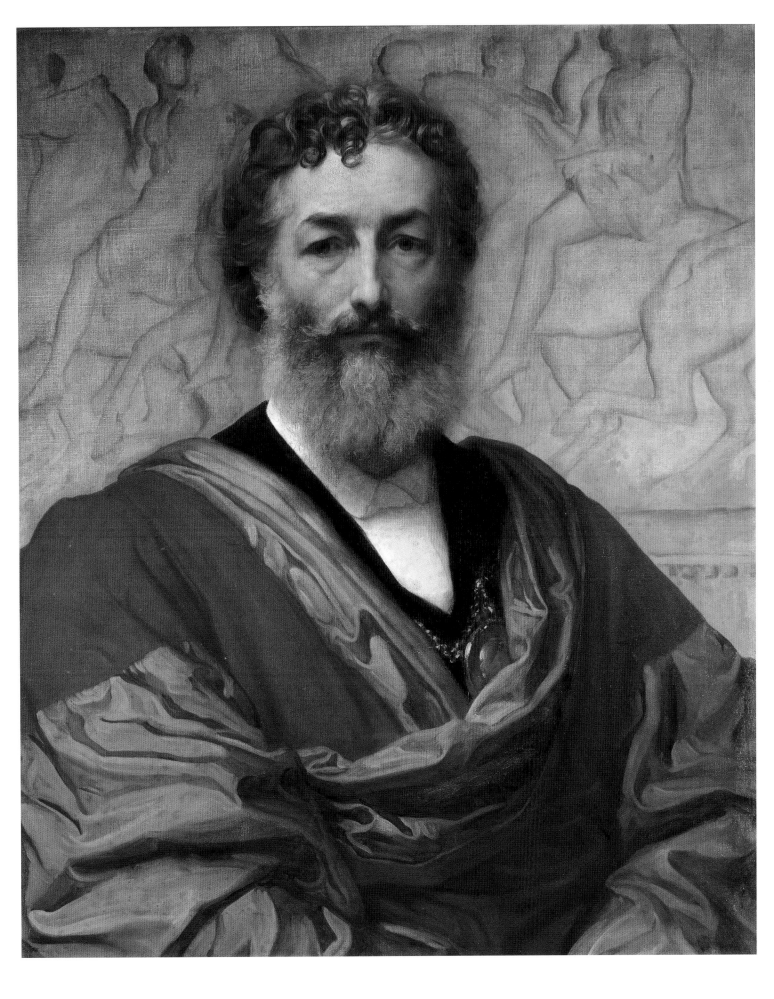

Frederic Leighton
Self-Portrait

6. M. de la Sizeranne, translated from the French by Miss H.M. Poynter, 'A French view of English Art', *The Artist*, London, vol. 19, February 1897, p. 58.

7. See Rosemarie Barrow, 'Drapery, Sculpture and the Praxitelean ideal', in Elizabeth Prettejohn and Timothy Barringer eds, *Frederic Leighton: Antiquity, Renaissance, Modernity*, New Haven and London, 1999, p. 49 ff.
8. Elizabeth Prettejohn links Leighton's reference to the Parthenon frieze to Walter Pater, whose essay on 'Winckelmann' singles out for praise the section of the 'youths on horseback' Leighton depicts. See 'Walter Pater and Aesthetic Painting', in Elizabeth Prettejohn, ed., *After the Pre-Raphaelites: Art and Aestheticism in Victorian England*, Manchester, 1999, p. 45.
9. Some museums invested more heavily in plaster casts than original works, but most collections were dispersed or destroyed when the practice fell out of favour in the early twentieth century. The few that survive now provide a historic document of the condition of antiquities at the time, as they retain restorations that were later stripped away from the original works.

the self-portrait was understood precisely in these terms: 'At the back of all English academic painting, as at the back of its President's portrait, may be vaguely seen the horsemen of Phidias passing by.'[6] The careful elision between the Parthenon's implicit influence on English painting, and its literal presence in Leighton's portrait, suggests the insinuation of academic conventions into an individual act of creativity.

Leighton's frequent allusions to classical sculpture have been analysed in some detail, the poses and draperies of his imaginative figures correlated to the antique sources they approximate.[7] The self-portrait, as a study in realism, operates in a different mode: its depiction of the Parthenon frieze is the most accurate representation of a classical work in Leighton's *oeuvre*. The inclusion of the frieze, rather than any other classical work (or, indeed, any of Leighton's own work), clearly represents a determined choice. One of its functions is to place Leighton's image within a widely-recognised cultural framework.[8] The sculptures attained cult-like status soon after their arrival into Britain, forming the centrepiece of The British Museum's displays and becoming amongst the most celebrated icons of the period. As well as being reproduced widely in prints, the sculptures were disseminated globally in the form of plaster casts. Such casts were taken directly from the original works, and therefore highly accurate. It was commonplace for museums and teaching institutions, as well as individuals, notably artists, to acquire these objects, a practice that reached its peak in the late nineteenth century.[9]

The existence of multiple versions of the frieze raises the question of what we see in the self-portrait. Where was it painted? It is probably not possible (or even important) to know whether it depicts an original antique, or a plaster copy. More significant is the ambiguity that is introduced by the frieze, which makes implicit reference to the cast after the antique, as a *topos*, and this suggestion subtly opens other layers of meaning.

The very act of depicting the frieze in the painting in a sense replicates the practice by which plaster casts were painted to imitate the colour of the original marble. More conspicuously, it also points to an academic training which required students to draw and model from casts after the antique. Leighton literally indexes this practice in the process of making his painting, his rendition of the frieze itself an exercise in copying. Indeed, Leighton owned a plaster copy of the section depicted in the painting, which was installed under the cornice of his studio in Leighton House (where it remains today). Leighton may well have painted from his own copy, which he could easily have moved so that it functioned directly as a prop.

Thus, without being obviously suggestive of the studio, the portrait subtly and self-reflexively points to the painter's practice.

The suppression of any other traces of the studio, however, coupled with the painting's formality, leaves the site open-ended. Among the many other casts of the Parthenon frieze was a set owned by the Royal Academy, acquired in the early nineteenth century and used in the Academy Schools for teaching, and another at Oxford University, incorporated by C.R. Cockerell into the West Wing of the Ashmolean Museum in 1845.[10] Thus, three reference points—to the Academy, Oxford, and Leighton's studio—are brought into play. Rather than being mutually exclusive, these three sites are drawn together by the frieze and embodied by the artist, further accentuating the public/private dimension of Leighton's world.

With this conflation of multiple spaces and identities the self-portrait may be more complex than at first appears. The Parthenon frieze functions as a familiar object in the public imagination, but at the same time it is materially elusive. Its ubiquity is reinforcing, rather than diluting, of its efficacy. The knowledge of its multiplicity could be said to act as a foil to Leighton's own objectified view of himself, the multiple personae that make up his identity. The deliberate institutionalising of his self-image, which on one level seems to efface individuality, also, paradoxically, reinforces his agency. We might read Leighton's decision to frame his self-image within the fold of the Academy as highlighting not only his service to that institution, but his powerful, omnipotent embodiment of it.

Martina Droth

10. Plaster casts from the Parthenon sculptures entered the Royal Academy collection at various points in the nineteenth century, including a number bought from the sculptor Sir Richard Westmacott in 1816, although it is not known which ones. The casts were used for teaching in the RA schools. My thanks to Andrew Potter from the Royal Academy Library for this information. For the casts at Oxford see Nicholas Penny, 'Chantrey, Westmacott and Casts After the Antique', *Journal of the History of Collections*, 1991, 3(2):255-264.

I would like to thank Nicholas Mead for his comments, and Giovanna Giusti at the Uffizi for helpful background information.

Gavin Hamilton (1723–98)
William Hamilton of Bangour, c.1748
Oil on canvas, 91.6 × 71.2 cm
National Galleries of Scotland, PG 310

1. A.H. Smith ed., 'Gavin Hamilton's Letters to Charles Townley', *Journal of Hellenic Studies*, XXI, 1901, p. 317.

2. Hamilton's use of classical sculpture as one source of inspiration for the composition and figures of his subject paintings embraces both statues in the round and bas-reliefs, the shallow depth and linearity of the latter being appropriate to Hamilton's own stylistic experimentation.

3. William Hamilton to Sir Hew Dalrymple [William Hamilton's stepfather], December 1742, GD110, NAS, letter transcribed by Helen Smailes, SNPG Accession Files.

4. See N.S. Bushnell, 'William Hamilton of Bangour', Aberdeen, 1957, *Dictionary of National Biography*, 2009.

Interest in the Scottish artist Gavin Hamilton is usually focused upon his pioneering neo-classical history paintings and his activities as an archaeologist, antiquarian and dealer. Born in Lanarkshire, the second son of a minor laird, Hamilton played a pivotal role in Roman artistic circles in the latter half of the eighteenth century. A key instigator of the growing interest in the classical past, he encouraged many young aristocrats on their grand tour to acquire statuary. Hamilton famously advised Charles Townley that 'the most valuable acquisition a man of refined taste can make is a peice [sic] of fine Greek Sculptour'.[1] Given Hamilton's lifelong devotion to the antique, it is not surprising that classical sculpture features strongly in his work, both literally—he excavated it, had it 'restored', sold it—and as a source of iconic forms featuring in his own subject paintings, including, most influentially, his great Homeric cycle.[2]

The two paintings included in this exhibition date from the less well-known earlier years of Hamilton's career and, as portraits, belong to a genre again less associated with the artist, who was to paint only a handful of such commissions after 1753 when he settled permanently in Rome. Both portraits show Hamilton using sculptural qualities to lend dignity to the contemporary human subject.

The Scottish poet William Hamilton of Bangour (1704–54) was probably a kinsman of the artist and there is some evidence that he made suggestions as to whom Gavin Hamilton should study with in Rome.[3] He wrote poems in the manner of, and imitating, Latin or Latinate poets such as Horace or Pope, but he also composed verses which belong to a proto-romantic discovery of Scottish vernacular song. He had strongly Jacobite sympathies; he joined Prince Charles Edward Stuart in the 1745 Rising and took part, as a cavalry officer, in the battle of Prestonpans, a great Jacobite victory. He remained with the prince, acting as a sort of poet propagandist, and was forced into hiding and then exile after the defeat at Culloden in April 1746.[4]

Gavin Hamilton's portrait of his older relative is no standard head and shoulders, but unusual and individual in format and composition. In the upper, dominant, segment of the painting, William Hamilton, in classical robes, is depicted in strict profile, as on a medal or coin. He is, however, painted in a naturalistic manner, with convincingly rendered blood-infused flesh and vivid red lips echoing the bright drapery. This approach contrasts with the rest of the image, painted in grisaille to mimic lifeless stone. The head and shoulders portrait is set within a fictive carved frame, bordered by laurel leaves. Beneath this is a scene painted to suggest a low-relief sculpture, such as might appear on the side of an ancient sarcophagus. However, the scene does not reference anything which

Gavin Hamilton
William Hamilton of Bangour

5. William Hamilton had substantially written 'Contemplation' by 1739 (see Bushnell, p. 52); a pirated copy was printed in 1747, the poem was subsequently published in his collected *Poems on Several Occasions*, (1748, 1749, 1758, 1760 etc), the 1748 and 1749 Foulis editions appearing without the author's name.

6. Bushnell, p. 89; the version of the print which appears in *The Poems and Songs of William Hamilton of Bangour*, James Paterson ed., 1850 is, unlike earlier impressions, lettered, with the words 'Engraved by Sir Robert Strange from a Drawing by Gavin Hamilton' around the lower circumference of the roundel.

Gavin Hamilton (who studied in Rome from 1744 to 1751) had seen—rather, it is a faithful visualisation of the poem for which William Hamilton was best known in his lifetime—'Contemplation or the Triumph of Love'.[5] Towards the end of this ode lamenting the power of earthly love to invade the mind, the poet, in desperation, considers 'the dominions of the dead'. This has the paradoxical effect of making him end his attempts to avoid thoughts of love, for there he sees a tomb carved with the name of Monimia, his beloved, and he realises that death will all too soon terminate love's tyranny. He and Monimia will be 'Both laid down to sleep in peace/To share alike our mortal lot/Her beauties and my cares forgot'. Monimia herself also appears in the scene; a persistent distraction, as she is led away by an older woman, she turns back to the poet, who sits 'humbled on the earth'. The portrait effectively and appropriately deploys two compatible (as both classical) sculpted forms—the upper portion with its medallic rendering of a real man as a timeless poet, the lower section more lively in its action, but only as an imagined scene carved upon a tomb.

The circumstances and date of the painting are not known, but it was later recorded that Gavin Hamilton drew the poet, presumably in 1748 in Paris or Rouen;[6] the painted composition cannot predate this, as the first published version of 'Contemplation' in 1747 names the beloved as Racelia not Monimia. Robert Strange made his engraving of William Hamilton in Rouen in 1748 after Hamilton's drawing, placing the poet's profile within a small roundel, but without the fictive carved surround or the lower scene. The engraving first appeared as the frontispiece to the 1749 edition of *Poems on Several Occasions*. It was next used in a 1760 edition, published six years after the poet's death. Small but significant differences between the 1749 and 1760 engraving—the latter is 2 mm wider, the poet is facing right not left, the face appears perceptibly older—suggest that Strange reworked the image, and, given that the face in the painting is also more mature than the 1749 engraving, the painting itself may be posthumous, which would add another, appropriately memorialising, dimension to Gavin Hamilton's sculptural borrowings.

Nicola Kalinsky

Giorgio de Chirico (1888–1978)
Petrifying Self-Portrait, 1922[1]
Oil on canvas, 75 × 62 cm
Private collection

1. Though consistently dated to 1922, this has recently been published as 1924–5 in *Giorgio de Chirico*, Musée d'Art Moderne de la Ville de Paris, 2009.

The sitter looks out at us, and he seems worried. It is an unusual expression and one difficult to capture in a self-portrait, but this painting by Giorgio de Chirico comes at the height of his exploration of the potential of self-portraiture that preoccupied him in the early 1920s. Here he is seated, slightly sideways-on, behind a parapet that wraps behind him; an amorphous background rises beyond, like a stormy sky, and the whole scene appears to have been revealed by the dark curtain drawn to the right. He turns towards us as if momentarily interrupted. Of course this is one of several illusions. He must have had the canvas in front him and the mirror to his right, as he scrutinised the reversed world of reflection. His painting hand is shown at rest, and his other (the reflection of his left hand) is dynamically poised on a cane. He commands his subject and its conveyance with great skill: the face and hands are finely detailed with the slightly pasty complexion off-set by his stubble and by the flop of hair arranged above.

The doubled level of illusion—realism to convey reflection—enhances the further illusion and most striking quality of the painting: petrification. The painting hand that rests on the parapet has absorbed the cold colouring of the stone, as if the calcifying process was leaching through it into the body. It has reached as far as his shoulders, with the head under immanent threat. His concern is understandable.

Over the preceding decade, de Chirico had already peopled his canvases with images of sculptures that cast their peculiar spell both directly and through their ominous shadows. They are found in his famous pre-war Metaphysical paintings whose atmosphere of melancholy and uncertainty so captivated the Surrealists in the 1920s, from the Ariadne that dominates 'The Silent Statue' to the torso of Aphrodite in 'The Uncertainty of the Poet'.[2] They jostle with the painter himself in the symbolic self-portraits of the 1920s, including that of 1924 in which he contemplates his own sculptural bust.[3] However, what is unusual in this 1922 self-portrait is the capturing of the *process* of Kafkaesque metamorphosis. In a way that is convincing but not immediately explicable, he shows himself becoming a sculpture and, in so doing, pits himself against the traditional technique of the Renaissance. Like Mantegna's paintings that replace bas-relief, de Chirico attempts to pass his likeness off as sculptural reality, screened through the accepted fiction of self-portraiture.

There would appear to be a sly irony and humour in this self-depiction of the process of petrification passing through his painting hand. By 1922 de Chirico was one of those convinced of the need within modernism for a 'return to craft' (as he called his 1919 article '*Il ritorno al mestiere*'),[4] which aligned him with a wider post-

2. 'The Silent Statue', 1912–3, Kunstsammlung Nordrhein-Westfalen, Düsseldorf, 'The Uncertainty of the Poet', 1913, Tate.
3. 'Self-Portrait', 1924, Toledo Museum of Art, Ohio.

4. 'Il ritorno al mestiere', *Valori Plastici*, no.1, Nov. 1919, republished in Maurizio Fagiolo dell'Arco ed., *De Chirico: Il meccanismo del pensiero; critica, polemica, autobiografia 1911–1943*, Turin 1985, pp. 93-9.

Giorgio de Chirico
Petrifying Self-Portrait

war 'return to order' in response to the radicalism of the earlier avant-gardes. In voluntarily becoming a statue himself, he appears to confront and challenge the perceived loss of vitality that such currents implied. His writings provide a longer-term view. In his novel *Hebdomeros*, published seven years after the painting, the eponymous hero comes across villas with gardens in each of which was 'a gigantic old man made entirely of stone' resting on steel *chaises-longue*s painted to look like wicker. Just as in this self-portrait, these figures turned out to have 'a very small amount of life in their heads and the upper part of their bodies'. Conjuring their link to tradition in language heavy with nostalgia, the painter continued: 'Sometimes their cheeks were slightly tinged with pink in the evening; when the sun had gone down behind the nearby wooded mountains, they chatted from one garden to the next and related memories of former days to each other'.[5] In this way, these figures appear to represent the place of tradition within history, something that is maintained intellectually as is made plain by the longevity of their heads (the seat of sensibility and intellect).

The presence of sculpture within painting (achieved with varying degrees of illusionism) had already been a key means through which de Chirico enacted a juxtaposition of his nostalgic image of the past and his more jaundiced view of the present. Sculpture allowed him to fix temporality within his paintings as it alluded to a tradition still sustained in nineteenth-century painting in which statuary was read symbolically. Art was, as his title 'The Silent Statue' emphasised, associated with silence and demanded knowledge and contemplation: 'as far as painting is concerned it must be considered in silence'.[6] For de Chirico, the 'gigantic old men' of *Hebdomeros* were a link to this earlier period of complex allusion (and this is made evident when, eventually lifeless, these stone figures are broken up and unceremoniously strewn in a valley).[7] In the 'Petrifying Self-Portrait', de Chirico appears—not without humour—to anticipate for himself a similar role of heroic tenacity but inevitable extinction. In turning his own image to stone—a sort of reverse Pygmalionisation—he passes into tradition, a tradition manifest in his command of the illusion through which to depict this metamorphosis.

Matthew Gale

5. *Hebdomeros*, Paris 1929, tr. by Margaret Crosland, Peter Owen, London 1964, p. 77.

6. 'Sur la silence', [c.1924] *Minotaure*, no. 5, 1934, in Fagiolo dell'Arco ed. 1986, p. 264, my translation.

7. *Hebdomeros*, p. 78.

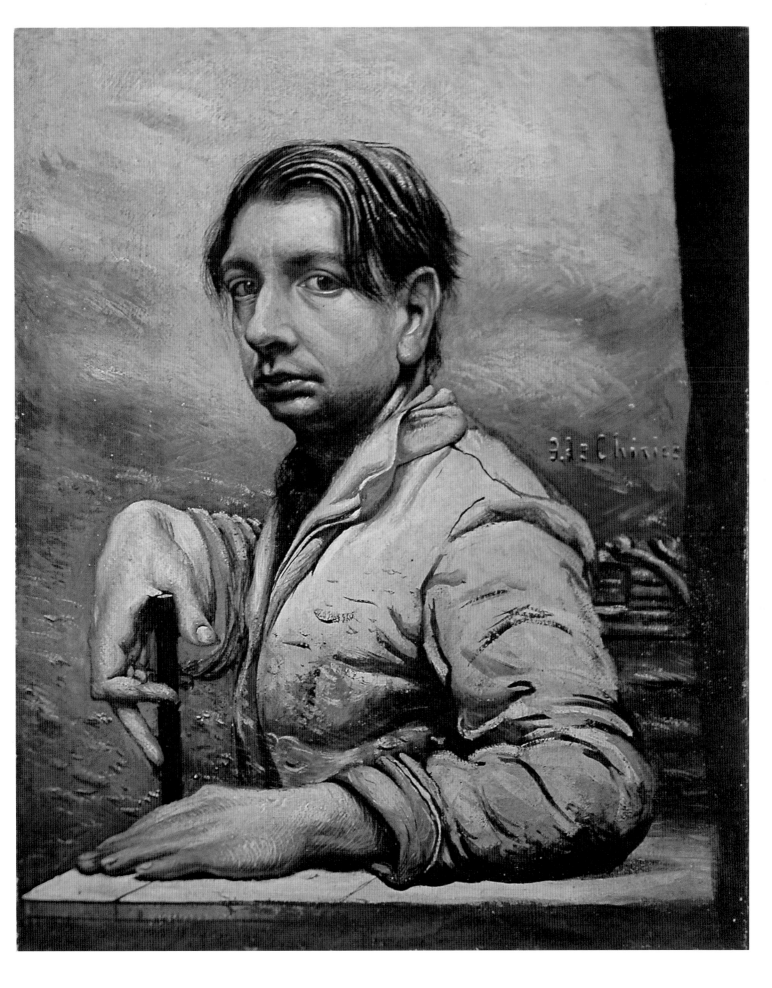

The second section picks up on this deceptive borderline between the apparently animate subject (the painted portrait) and the rendition of an inanimate object (the sculpture). Titian's 'Portrait of a Lady' exemplifies the deception which is perpetrated upon us. The Lady meets our gaze, her lively demeanour and hue striking a chord with her deep red dress and contrasting with the pallid marble relief, which she holds nonchalantly, even if it suggests the posthumous future in which the sculpture will have outlived the sitter.

If Hogarth's self-portrait plays on the new inventions and conventions of sculpted likeness and seeks to harness sculpture by bringing it into painting's orbit, Hamilton's 'Gunning' might be more speculatively read as a painting which seeks the sculptural, or the statuesque. This diverse selection is indeed intended to focus on the sculptural in the painting, and on its very ambiguities. It focuses also on the figure—naked or clothed—and the qualities it shares with sculpture: monolithic, frontal, symmetrical, alone in space.

Do we see here paintings of existing sculptures, or can these sculptures exist only in paint? The grisaille form coaxes us into believing that sculpture exists in reality. If Alma-Tadema demonstrates that ancient sculpture was in fact coloured, he does so through a relief and within the frame of painting. This shallow space, in which three-dimensional space can assert its rights within the two-dimensional, is also that used by Henning. Between the coming-into-form (Tanguy), and its destruction (Pryde), we experience a strangely desolate and alien space in which sculpture is all that remains.

Titian (Tiziano Vecellio) (*c*.1485 – 1576)
*Portrait of a Lady ('La Schiavona'), c.*1510 – 12
Oil on canvas, 119.9 × 100.4 cm
The National Gallery, London, NG5385
Presented through The Art Fund by Sir Francis Cook, Bt.,
in memory of his father, Sir Herbert Cook Bt., 1942

1. N. Penny, in *Titian*, D. Jaffé ed., exh. cat., National Gallery, London, 2003, cat. 4, pp. 80-1.

2. B.L. Brown , 'Titian's Marble Muse: Ravenna, Padua and The Miracle of the Speaking Babe', *Studi Tizianeschi. Annuario della Fondazione Centro Studi Tiziano e Cadore*, 2005, vol. 3, pp. 19-43, esp. 28-32.

3. The coin in Memling's 'Portrait of a Man' (possibly Bernardo Bembo, *c*.1475) represents a small-scale bronze sestertius of Nero, and the medal of Cosimo de' Medici in Botticelli's 'Portrait of a Young Man' (*c*.1475) is made of moulded gesso applied to the panel. L. Freedman, '"The Schiavona". Titian's Response to the Paragone between Painting and Sculpture', *Arte Veneta*, 1987, vol. 41, pp. 33-4, L. Campbell, M. Falomire, J. Fletcher and L. Syson eds, *Renaissance Faces Van Eyck to Titian*, London, 2008, cat. 11-13, pp. 102-5, if Memling's portrait is of Bernado Bembo, it may have been known to Titian, R. Lightbown, *Botticelli Life and Work*, London, 1989, pp. 54-7.

This portrait is one of a group painted early in Titian's career which helped to establish his reputation as a great portraitist and may have been designed to solicit commissions. It became known as 'La Schiavona', the Dalmatian woman, in the seventeenth century, although no evidence to support this identification has come to light.[1]

Titian incorporated fictive sculpture into his paintings at intervals throughout his long career. One of the first examples is the Roman-looking relief below St Peter's throne in the votive image of 'Jacopo Pesaro presented by Pope Alexander VI to Saint Peter' (*c*.1506–11); one of the last is his nearly monochrome 'Pietà' which included the extraordinary statues of Moses and St Helen which looked more alive than actual sculpture. Titian often employed fictive sculpture to comment on the rest of the painting, conceiving it very precisely in order to enrich the meaning of a specific work. In 'The Miracle of the Speaking Babe' (1510–11), for example, the statue of Trajan is placed high on the wall behind the main action, its mutilated form conveying nostalgia for ancient justice, as it addresses the judgment being proclaimed in the modern epoch below.[2] Although the sculpture in 'La Schiavona' is entirely different in form and concept, it too has a direct bearing on the whole painting.

This portrait connects with a long tradition of grisaille (or monochrome) painting and illusionistic sculpture. Giotto in the Arena Chapel had used a cycle of fictive statues representing the virtues and vices to create a moral pathway at the spectator's level, employing sculpture as a rhetorical mode of address. Even in such a different context as Titian's 'La Schiavona', the sculpture is set low down and on the surface, addressing the spectator in a direct, didactic manner. Nor was Titian the first to include a sculpted relief portrait within a painted portrait, though his profile head is much larger and more purely illusionistic in comparison to the coins or medals shown previously.[3]

Titian fused two quite separate visual traditions in his handling of the fictive sculpture—the ancient Roman relief portrait and the use of a parapet at the base of an image. Although antique portrait heads usually took the form of medals or medallions, he removed the encircling frame and embedded the bust in a rectangular slab of marble which he added to a type of parapet long established in the genre of portraiture. Antonello da Messina and Giovanni Bellini had used parapets to carry various identifying or edifying inscriptions or emblems. In this case Titian's parapet started on the left as the usual horizontal ledge, but then

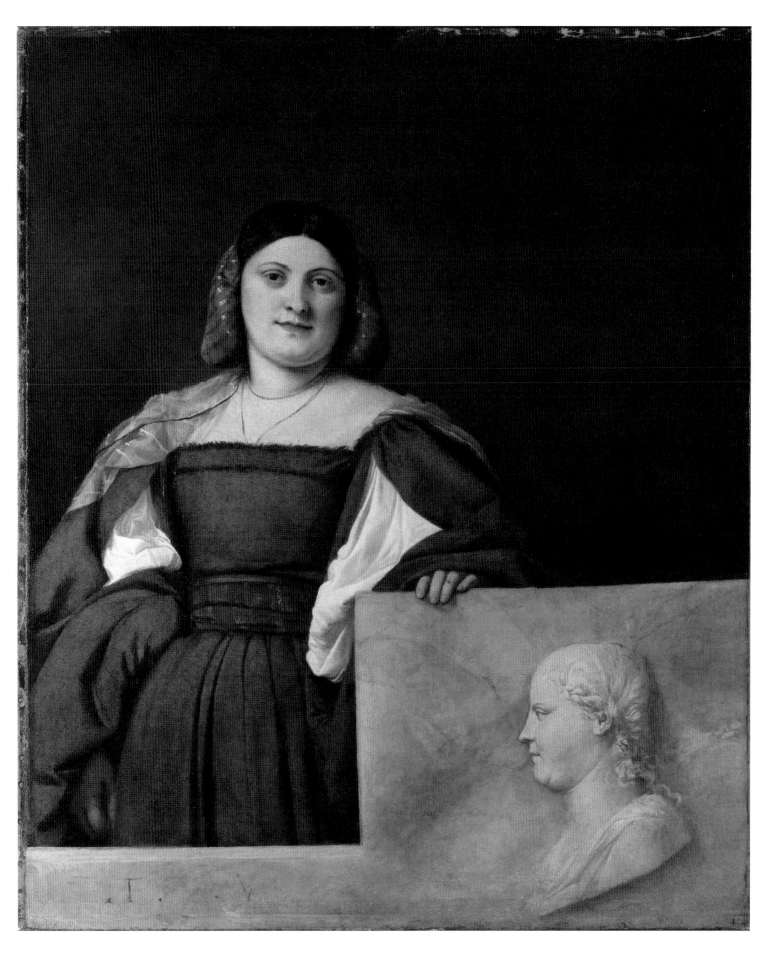

Titian
Portrait of a Lady ('La Schiavona')

4. C. Gould, 'New Light on Titian's "Schiavona" portrait', *Burlington Magazine*, 1961, vol. 103, pp. 335-40.

5. B.L. Brown, idem, pp. 28 and 34.

6. L. Lazzarini, 'Primo studio sulle pietre e i marmi dei Lombardo a Venezia', in *I Lombardo. Architettura e scultura a Venezia tra '400 e '500*, A. Guerra, M. M. Morresi, and R. Schofield eds, Venice, 2006, pp. 255-65.

7. A. Luchs, *Tullio Lombardo and Ideal Portrait sculpture in Renaissance Venice, 1490-1530*, Cambridge, 1995, L. Freedman, '"The Schiavona". Titian's Response to the Paragone between Painting and Sculpture', *Arte Veneta*, 1987, vol. 41, pp. 31-40.

8. C. Gould, idem, p. 339.

9. For a collection of the texts see Paola Barocchi, ed., *Scritti d'Arte del Cinquecento*, vol. III, *Pittura e scultura*, Turin 1978.

10. Leonardo had visited Venice in March 1500, *Leonardo and Venice*, S. Rasponi ed., Milan, 1992. But his writings comparing sculpture and painting were only extracted and collated some time between 1520 and 1570 in the *Codex Urbinas*, which was not published until 1817, L. Mendelsohn, *Paragoni. Benedetto Varchi's "Due Lezzoni" and Cinquecento Art Theory*, Ann Arbor, 1982, pp. 37-41, Claire J. Farago, *Leonardo da Vinci's Paragone: A Critical Interpretation with a New Edition of the Text of the Codex Urbinas*, Leiden, 1992, pp. 3-4, 8-20. On a lost (possibly invented) demonstration of the paragone by Giorgione, later described by Paolo Pino and Vasari, see P. Holberton, 'To Loosen the Tongue of Mute Poetry: Giorgione's Self Portrait "as David" as a *Paragone* Demonstration', in *Poetry on Art. Renaissance to Romanticism*, Thomas Frangenberg ed., Donington, 2003, pp. 29-47.

extends to become a dominant wall-like structure.[4] The enlarged parapet is crucial as it allows the relief to be much bigger and the 'live' woman to establish a direct relationship with it, placing her hand on the wall in a proprietorial gesture. Above all, the comparability in scale between the two figures is essential to bring the two arts into dialogue with each other. The two female images are also tightly connected by a strong diagonal slipstream which draws together the sitter's head, her arm and hand and the fictive relief.

Unlike the Trajan figure in 'The Miracle of the Speaking Babe' which signals its antiquity through its missing arm and encroaching weeds,[5] here the whole marble structure is a crisp, modern-looking slab of grey marble which, from an architectural point of view, is strangely blank.[6] At this date marble parapets would normally have been carved with a projecting cornice or moulding, or at least with a filletted or rounded edge. High relief sculptures by Tullio Lombardo at this date sometimes have raised flat borders, or are frameless, and may have inspired Titian's simulacrum.[7] It is therefore likely that the relief profile is intended not to look ancient, but rather like a modern *all'antica* relief that could nevertheless bestow on the sitter an aura of ancient virtue. What matters is that the two representations look so similar—with their fine brows, the slightly upturned shape of their noses, the soft folds of their double chins, and the brink of a smile in the dimple at the corners of the mouth—that we believe they are the same woman.[8]

This painting is often cited as a key demonstration of the paragone between painting and sculpture.[9] In 1510 however, Leonardo's writings were not available;[10] nor had Castiglione yet published his famous dialogue on this topic in *The Book of the Courtier* (*editio princeps* 1528). Although we should beware of interpreting this painting from the standpoint of the paragone texts written later in the sixteenth century by writers such as Varchi, Pino, Dolce, Doni, and Vasari, this painting can nevertheless be taken as evidence that artists were already engaged in a visual dialogue concerning the relative merits of painting and sculpture and in 'La Schiavona' Titian certainly juxtaposes and compares the two arts.

By choosing to paint a relief rather than a free-standing statue, Titian set up the comparison so that painting inevitably wins the debate. Indeed he goes out of his way to emphasise the sculpture's flatness. Yet it is also apparent that the comparison works so well *because* it is a relief. A sculpture in the round or even a high relief would have presented an absolute contrast and a less close comparison. In other respects Titian's painting plays with the differences between the arts, most obviously showing the same woman from the front and the side simultaneously, a result which could only be achieved in sculpture when the spectator moves around

82

a statue. Another element of the paragone between painting and sculpture focussed on carving as an art of subtraction. The fictive relief in the 'Schiavona' seems specially designed to show the block of marble which has been chiselled back to create the woman's head. Again, a free-standing bust or even a portable relief would not have displayed the art of subtraction as effectively as this unframed relief emerging out of its wall of marble.

The woollen dress is apparently a winter garment, its thickness contrasting with the woman's gauzey stole and gold-striped hairnet. A further feature of the paragone is the claim that painters were better able to mimic different textures, particularly soft, transparent and translucent effects. The two different coloured yarns from which the dress is woven—purply-red and blue-grey—are revealed in the fringes across her chest. The weight of the cloth, and its gratuitous expanse and folds, not only reveal the wealth of their owner, but enhance her physical presence. This bulk makes the painted woman more solid, weighty and three-dimensional, in response to which the sculpted image is made to appear shallow, weightless and truncated. Titian systematically polarises the two forms.

Although the fictive relief was certainly a late addition by Titian,[11] the two figures seem designed to enhance each other's characteristics through the juxtaposition of opposites. This visual dialogue is, however, an unequal conversation, in which the painted woman always dominates. A binary balance was never intended. Paul Holberton has suggested that the initials 'T V' inscribed on the parapet are a pun, not only identifying the artist, 'Tizianus Vercellius', but also implying 'Titianus Vincit', just as the initials 'V V' on several portraits of this date may stand for 'Virtus Vincit'. In this way Titian the modern painter may have announced his triumph over sculpture and antiquity, both represented in the profile bust.[12]

Amanda Lillie

11. C. Gould, idem, pp. 335-40.

12. P. Holberton, idem, esp. p. 44. For other interpretations of the initials see G. Fiorenza, 'Pandolfo Collenuccio's *Specchio d'Esopo* and the Portrait of the Courtier', *I Tatti Studies*, 2003, vol. 9, pp. 63-87, J. Thomson de Grummond, 'VV and Related Inscriptions in Girogione, Titian and Dürer', *Art Bulletin*, 1975, vol. 47, p. 346.

Gavin Hamilton (1723–98)
Elizabeth Gunning, Duchess of Hamilton, 1752–3
Oil on canvas, 239 × 145.5 cm
National Galleries of Scotland, PG 3496
Bought with the support of the National Heritage Memorial Fund
and The Art Fund in 2006

This is one of Gavin Hamilton's last society portraits, dating from the year before he moved permanently to Rome. Again, Hamilton uses sculptural form to lend dignity to the depicted individual. This example is particularly interesting as it lacks the obvious affinity between sitter and sculpture seen in the portrait of William Hamilton—that is, between a poet whose own inspiration was largely classical and antique representational types—the bas-relief and the coin or medal. The gravitas afforded here is, however, arguably even more crucial, as the sitter, painted as Duchess of Hamilton, the premier peeress of Scotland, was a woman with decidedly inadequate form in the social understanding of the word.

Elizabeth Gunning (1733–90) was a famous celebrity beauty. She had been brought over from Ireland to England by her ambitious mother in 1749 with her equally tall and attractive sister, Maria. They were poor (Castle Coote, the family estate, was heavily mortgaged) but they exploited their connections to the full, making sure they were seen at every ball, assembly, race meeting and presentation. Their father courted the press and published, anonymously, poems about his daughters in papers and magazines. For a couple of years the Gunning sisters caused a genuine furore and were the subject of much gossip, some of which delighted in the possibility of the girls failing to make respectable marriages and ending up as mistresses. Author of *Pamela*, Samuel Richardson, sneered at them as 'showgirls' with 'neither sense nor fortune', whilst Mrs Thrale considered them to be 'unblushing husband hunters'.[1]

Both sisters succeeded in their mission and made exceptional matches, Elizabeth marrying James Hamilton, sixth Duke of Hamilton, the most eligible man in Scotland, her sister marrying the sixth Earl of Coventry. Although it was legal, the Hamilton marriage was clandestine and irregular (the Marriage Act of 1753 was intended, in part, to prevent exactly this sort of misalliance). The couple were married in the small hours of 14 February 1752 by Dr Alexander Keith, the 'Mayfair marriage monger', at the Curzon Street Chapel, having met, for the first time, just a month previously at a masquerade.

Completed in 1753, this painting is effectually Elizabeth Gunning's marriage portrait; it was immediately engraved and can therefore be considered as the new duchess's official public image.[2] As such, amongst its many other functions, the image necessarily asserts the lady's unquestionable respectability and inherent right to a place alongside the family portraits at Hamilton Palace or Holyroodhouse. To convey this, Hamilton uses mainly painterly antecedents, making, not

1. Quoted in H. Bleackley, *The Story of a Beautiful Duchess*, London, 1907, pp. 22, 24.

2. The payment to Hamilton is recorded 15 December 1753 in the duke's ledger (Hamilton Archives 621/4); it was engraved by J. Faber and published in 1753.

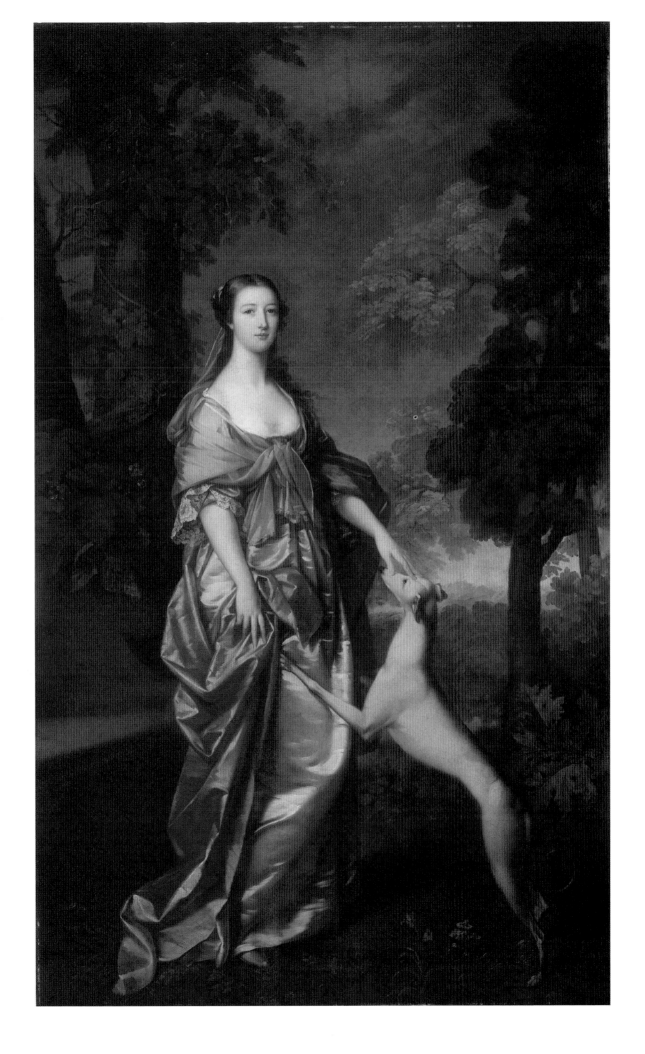

Gavin Hamilton
Elizabeth Gunning, Duchess of Hamilton

surprisingly, obvious reference to Van Dyck in the gesture of his sitter's hands, her dress and drapery, and the wild wood setting. However, there are also sculptural qualities, although these are less overt than in the portrait of William Hamilton. It is not that the pose is based upon a known statue, rather that the duchess has, with her disproportionately small head and tall, columnar body, a powerful sense of volume. The three-dimensional quality of her figure contrasts with both the sketchy background and the flatness and linearity of her accompanying hound.

If the duchess can, in some sense, be said to be statue-like, what does this actually mean? She could be described as statuesque, the adjective used to describe a living person (invariably female) whose body has qualities associated with statuary, usually characterised as height, good but large proportions, and rounded limbs. That the actual word statuesque (formed like 'picturesque') does not appear until the early nineteenth-century, and would not have been used in the 1750s, does not diminish its appositeness. The idea of a female figure being 'statue-like' was perfectly current; in 1759 Oliver Goldsmith wrote of actresses 'who have…what connoisseurs call statuary grace'.[3] Moreover, in addition to being visually statuesque, Hamilton's painted duchess is also like a statue in the similative sense; she seems as still and silent as a marble goddess. Thus, the ideality inherent in classical sculpture here signifies distance from ordinary touch and gossiping voices, demonstrating Elizabeth Gunning's now inviolable aristocratic hauteur.

Nicola Kalinsky

3. *The Oxford English Dictionary*, Oxford, 1989, Vol. XVI, p. 572.

William Hogarth (1697–1764)
The Painter and his Pug, 1745
Oil on canvas, 108 × 87.5 cm
Tate, NO112
Purchased 1824

In this fascinating portrait all is not quite what it seems. While it appears to be a self-portrait of the artist with his pet dog, plus various accoutrements, it is in fact an ingenious pictorial manifesto of Hogarth's views on the purpose and function of the visual arts. Hogarth had probably begun work on the self-portrait in the mid-1730s, when he had conceived it as a formal bust-length image in a fictive oval surround. As x-rays reveal, in that version he had the comportment and dress of a gentleman rather than an artist.[1] In 1743 Hogarth visited France. There, he witnessed at first hand the convention of artists' academic portraits (so called *morçeaux de réception*), which featured still-life tools of the trade; brushes, palettes and engraving tools positioned outside a fictive oval. In such portraits French artists presented themselves in casual attire, with swathes of drapery. It may have been shortly afterwards that Hogarth adapted his own image so that the framed oval appears as part of a still-life composition, wherein the self-portrait, shown unframed, and with the tacking edge visible, sits at a slight angle to the picture plane. Thus, the portrait image is transformed ingeniously into a 'still-life', the only living object in the work being the dog in the foreground. The oval portrait is propped up on the works of Shakespeare, Swift and Milton; three great English authors who collectively inspired Hogarth through the genres of drama, satire and epic poetry. In the foreground, at the left, Hogarth's palette is inscribed with the words, 'The LINE of BEAUTY / and GRACE / W.H. 1745', while the serpentine line itself hovers above, casting a slight shadow on the palette. Tucked under Hogarth's right arm is a piece of red drapery, a commonplace feature of baroque swagger portraiture. Yet, as it sweeps upward, the drapery (now green) re-emerges in the pictorial space occupied by the dog.

A key aspect of the visual conjuring tricks played out in the portrait is Hogarth's exploration of two- and three-dimensional space; notably the relationship between painting and sculpture, which was then a popular topic of discourse in London's artistic community.[2] As Hogarth was aware, the idea of framing a portrait in such a manner derived ultimately from classical sculpture; from the *imago clipeata*, the framed portrait associated with heroes, generals, and emperors. In England the sculpted bust within an oval had been in use since the sixteenth century, appearing for example in the series of terracotta heads of emperors by Giovanni da Maiano on the gateway at Hampton Court Palace. In the seventeenth century this type of image percolated into portraiture, initially via Sir Anthony van Dyck, and latterly through the work of court painters such as Sir Peter Lely and Sir Godfrey Kneller, until by the 1730s it was something of a cliché. Hogarth's interest in the

1. Elizabeth Einberg and Judy Egerton, *Tate Gallery Collections: volume 2. The Age of Hogarth. British Painters born 1675–1709*, London, 1988, p. 112, fig. 36.

2. See Robin Simon, 'Hogarth, sculpture, and the paragone', in *Hogarth, France and British Art*, London, 2007, pp. 171-84.

William Hogarth
The Painter and his Pug

comparison of painting and sculpture, the paragone, may have been stimulated initially by Jonathan Richardson the Elder who, in his *Discourse on connoisseurship* of 1719, asserted the superiority of painting over sculpture. He was influenced more immediately by the rise to prominence of sculpture as an art form in the 1730s through the presence in London of several leading continental sculptors, notably John Michael Rysbrack, Peter Scheemakers and Louis François Roubiliac.

Since the late 1730s, Roubiliac had been involved in teaching at the St Martin's Lane Academy in London, which Hogarth had recently revived. The two men were close friends, and it was as a result of this friendship that in about 1741 Roubiliac made a terracotta portrait bust of Hogarth (fig. 1), and a separate sculpture of Hogarth's pug dog, Trump. In the sculpture Roubiliac emphasised the living presence of the artist, his lips parted as if in conversation, his forehead marked by the prominent scar that also features in Hogarth's self-portrait. This self-portrait, where the artist and pug are united—and yet occupy two discrete pictorial spaces—may be regarded as a continuation of his dialogue on painting and sculpture, and an erudite 'answer' to Roubiliac within a single canvas. Hogarth's exploration of the relation between painting and sculpture, between the two- and three-dimensional, is demonstrated by other portraits of the period, such as 'Mrs Salter' (Tate), where he also experiments with the spatial and colouristic possibilities of the bust-in-an-oval device. He clearly also had ambitions to theorise about the subject, for in his autobiographical notes he wrote of 'Painting & Sculpture considered in a new manner differing from every author that has as yet wrote upon the subjects …'

Martin Postle

fig. 1. Louis François Roubiliac,
William Hogarth, c.1741,
National Portrait Gallery, London

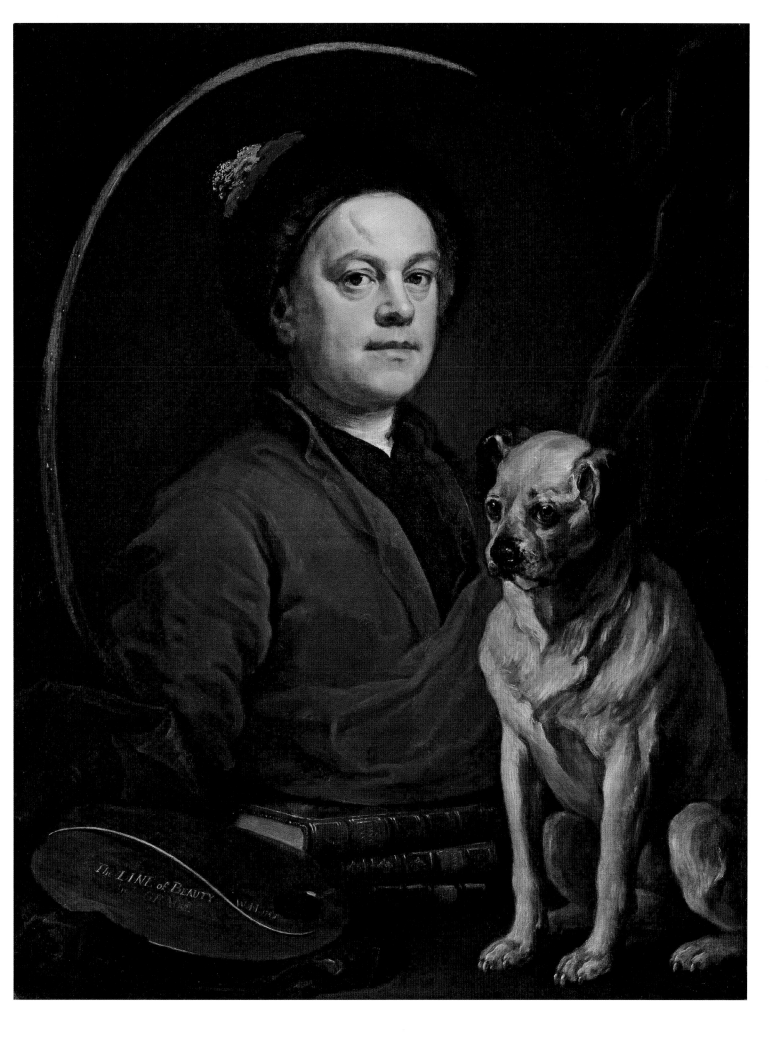

Anton Henning (b.1964)
Blumenstilleben No. 180, 2004
Oil on canvas, 183 × 213.7 cm
Courtesy the artist and Haunch of Venison, London, AH 2004-015

The first impression of Anton Henning's 'Blumenstilleben No.180', which is being exhibited for the first time at the Henry Moore Institute, is of swirling colour. The palette is distinctive: oranges, pinks, pale green, brown, yellow, shades somehow reminiscent of a moment in recent history, perhaps the 1950s or the 70s. We might at first mistake the image for an abstraction. In fact, close inspection reveals that the painting depicts an object—perhaps a tendril of some kind—standing on a flat surface in front of an abstract background, or alternatively in front of one of Henning's characteristic 'interiors', abstract paintings constructed of looping and swirling arabesques of colour. The title of the work—literally, 'flower still life'—leads us to understand that this object is a plant form, its rounded structure corresponding to leaves and petals, flowers and blooms, and recalling the organic line and forms of *Jugendstil*. What is unclear, however, is if this is an abstracted rendering of a flowery still life, or a realistic depiction of an actual object in space, an absolutely straightforward still life depicting a form on a table with a large abstract painting leaning in the background. We might wonder if this is in fact a rendering in paint of one of Anton Henning's recent sculptures, looping painted bronze, wood and plaster constructions which are often, but not always, themselves titled 'Blumenstilleben', and which are derived—or which at least share the same formal language of abstraction—from Henning's paintings.

Anton Henning is a German artist whose work spins semantic webs. Best known as a painter, he in fact works across a range of media, including sculpture, drawing, print-making, video, room installations, architectural settings and even music. Henning's *oeuvre* is forever turning in upon itself in a kind of auto-cannibalism, what Henning himself calls an 'autopoietic system of self-reference…'[1] He makes paintings. He also makes sculptures. His paintings depict interiors containing his own paintings. He also depicts his sculptures, or at least objects which look very much like his sculptures. His installations are settings for the display of sculptures, paintings and furniture. His films range across the surfaces of his paintings, scanning the landscapes of paint in forensic detail, or depict him in his studio acting out a series of characters, one of whom may be an artist called Anton Henning. There is a sophisticated humour in play here, a bold use of wit to dismantle the conventions of art history and the hierarchies of genre. It is kind of funny, but deadly serious too, invoking the weighty histories of oil and canvas, bronze and plaster, even as it debunks such readings. As Martin Hentschel observes: '… the paintings themselves seem to call to us: "This is not simply some post-Dada prank, just take a look—immaculate oil paintings!"'[2]

In Henning's work we can never be completely sure what it is we are looking at.

1. Quoted in Dominic Van Den Boogerd, 'Mercedes by the Sea', in *Anton Henning: Surpassing Surplus*, Tilburg, 2002, p. 54.

2. Martin Hentschel, 'In Manker and the World: Anton Henning and his Art' in *Anton Henning*, Bielefeld, 2006, p. 42.

Anton Henning
Blumenstilleben No. 180

He produces artworks which recall traditional genre pieces—nudes, still lifes, landscapes, portraits and so on—with titles that seemingly contradict one's initial reading. Thus the abstractions are 'interiors', a painting of a chair is a 'portrait', and a painting of a sculpture is perhaps a 'Blumenstilleben'. Additionally, his forms, palette and facture don't look like something made at the end of the first decade of the twenty-first century, but rather like something from fifty or a hundred years ago. According to Justin Lieberman: 'When stepping into an installation by Anton Henning, it is easy to imagine oneself in the fifties when Henning's work would have looked radical…rather than deliberately anachronistic.'[3] In fact Henning's works—especially when seen en masse and in relationship to each other—reveal a very contemporary, (post) post-modern play of image, meaning and intention.

At the time of writing, in May 2009, Henning has painted almost 300 'Blumenstilleben'. The 180th of the series could be described, as much as any of them, as 'typical' or representative. In fact they range from very 'traditional' looking still-lifes to works which are almost completely abstract, in which the title is almost the only thing that returns them to an idea of representation. As a series the 'Blumenstilleben' occupy a central position within Henning's *oeuvre*, suggesting a crossroads between subject and idea, representation and abstraction, a place where painting and sculpture interact with each other. A place of cross-pollination. They are central also as they are perhaps the most archetypically traditional of all the genres Henning explores (or exploits).

'Blumenstilleben No. 180' is a suggestive addition to Henning's world. We feel here that the balance between image and object, between the painted tendril and the imagined line, is somehow fluid. Just what is it we are looking at? It is a shifting picture. As such it is an introduction to and perhaps even summation of the tensions that Anton Henning seeks to explore, dismantle and reconstruct in his ever changing, shifting, complex and contrary work.

Ben Tufnell

3. Justin Lieberman, 'Henningesque' in *Anton Henning: Oasis*, London, 2007, p. 66.

Yves Tanguy (1900–55)
Azure Day, 1937
Oil on canvas, 63 × 81.2 cm
Tate, T07080
Accepted by H.M. Government in lieu of tax on the estate of Cynthia Fraser,
Chairman of the Friends of the Tate Gallery 1965–72, and allocated to the
Tate Gallery 1996

Although he never achieved the celebrity status of Salvador Dali, Yves Tanguy was championed by André Breton as the quintessential Surrealist painter. Born in Paris, he spent his childhood vacations in Finistère, Brittany—a region punctuated by the prehistoric stones echoed in his later paintings. An autodidact, Tanguy was profoundly affected by an encounter with the work of Giorgio de Chirico in 1923, after which he dedicated himself to painting skewed street scenes and barren landscapes in a naïve, expressionistic style. Tanguy's mature work developed during the 1930s, following a voyage to Africa where he was reportedly more impressed by the clarity of the light and the vast, rock-strewn landscapes than the ethnographic artefacts favoured by other Surrealists.[1] On his return, he began to paint enigmatic mineral forms in place of the human, plant and sea-life that had inhabited his earlier works. 'Azure Day' is characteristic of his paintings of the 1930s onwards in its depiction of an alien territory scattered with amorphous, indeterminate objects. Although his detractors found this formula repetitive, Tanguy returned incessantly to these palpable structures, which are undeniably compelling in their peculiarity.

1. James Thrall Soby, *Yves Tanguy*, New York, 1955, p. 16.

The title 'Azure Day' is at odds with the oppressive atmosphere of the painting, in which a smog-grey ground merges incrementally into a heavy sky, leaving no visible horizon line. Laws of space and gravity hold no sway in Tanguy's landscapes where, in Breton's words, 'a feather weighs as much as a lead bullet, where everything can fly as easily as it can bury itself in the ground, where the most irreconcilable objects can confront each other without disaster'.[2] Two vaporous clouds occupy the same plane as a phallic structure erected in the distance, which echoes a similar form in the foreground of the painting. Both appear to be battened down with rods and lines, as if fortified against an approaching storm—the eerie stillness of the landscape only exacerbating this sense of impending danger.

2. André Breton cited in Marcel Jean, *The History of Surrealist Painting*, trans. Simon Watson Taylor, London, 1960, p. 172.

Although frequently said to reference the menhirs and dolmens of Brittany, the forms in Tanguy's landscapes are smoother and more finely hewn, as if moulded according to some unfathomable logic. While some bring to mind the biomorphic sculptures of Jean Arp (which Tanguy would have seen), others suggest husks or carapaces in an unsettling, otherworldly conflation of the animal, vegetable and mineral. Their nebulous contours evoke solidified liquid while mimicking the gaseous clouds in the distance, so that the entire landscape appears to be in a perpetual state of flux. This sense of mutability reflects Tanguy's distinctive

Yves Tanguy
Azure Day

3. José Pierre, *Grove Art Online*,
Oxford, 2009.

4. 'I found that if I planned a picture
beforehand, it never surprised me,
and surprises are my pleasure in
painting.' Tanguy cited in Soby, p. 17.

5. Jean, pp. 171-2.

technique, which evolved rapidly from the late 1920s onwards. Instead of working to a predetermined plan, he allowed liquid pools of colour to form shapes that were modelled and defined to create the illusion of three-dimensional objects, which were then anchored in the landscape with elongated shadows.[3] Tanguy was pleased by this combination of compositional mobility and technical precision, explaining that for him, the pleasure of painting lay in its unpredictability.[4]

Although not explicitly representative of sculpture, 'Azure Day' probes the boundaries between two- and three-dimensional space in a manner relevant to the theme of sculpture in painting. In the course of the work's production, painterly marks were gradually transformed into the strange, sculptural objects that populate Tanguy's landscapes—forms delineated with a tangible exactitude that renders their indeterminacy all the more disturbing. In the foreground of 'Azure Day,' screen-like structures appear propped against bulbous megaliths, producing a further interplay of surface and depth within the illusionistic space of the painting. Later works by Tanguy, such as 'The Invisibles,' (1951, Tate) juxtapose finely modelled forms with flat shards of colour, rendering this tension between the painterly representation of two- and three-dimensional form even more apparent. Shortly after Tanguy's death in 1955, Marcel Jean described the obliteration of sensory and spatial frontiers in his landscapes, where 'transition is constant, opposition and contest disappear'.[5] Jean's comments might also be applied to the dialogue between the painterly mark and the representation of sculptural form operative within Tanguy's practice as a whole.

Anna Lovatt

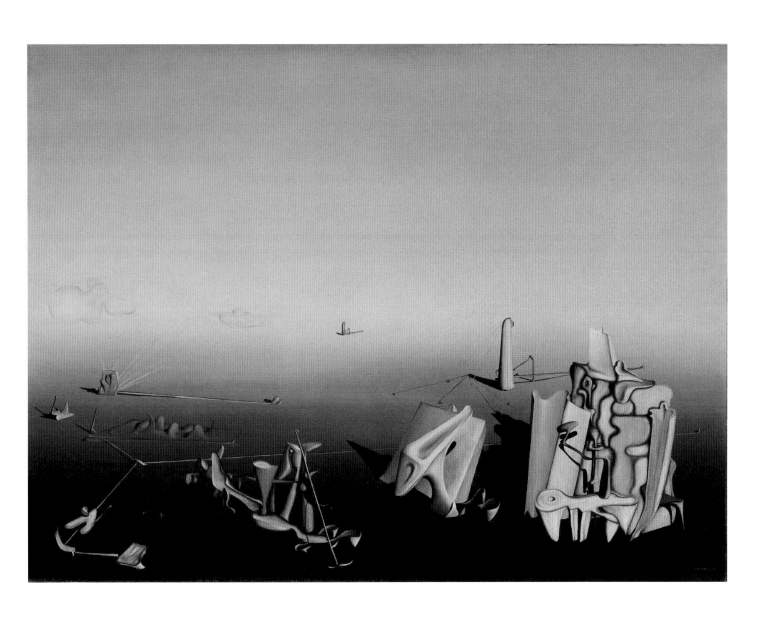

Jacob de Wit (1696–1754)
Autumn, 1740
Oil on canvas, 109 × 110.5 cm
Rijksmuseum, Amsterdam, SK-A-3232

To this day, Jacob de Wit's renown is based on his skill in painting perfect imitations of stucco reliefs. He became so closely identified with this specific type of grisaille work that such paintings came to be called *'witjes'* in homage to his name (and playing on its literal meaning, 'white'). That should not imply that he painted them only in white tones; he also used reds and browns. He would combine these imitations of reliefs with polychrome allegorical, history and landscape painting, executed on the walls or ceiling. Examples of stately room treatments by de Wit are still preserved in situ, mainly in Amsterdam, where he had a wealthy clientele among the patricians of the city as well as from its Catholic churches, being of the Catholic faith himself.

Jacob de Wit was trained in Amsterdam under a pupil of Gérard de Lairesse (1640–1711) and later, between 1708–16, in Antwerp, where he was influenced significantly by the Flemish painting of Rubens and van Dyck. When de Wit worked in interior decoration, he covered every surface in paintings conceived as permanent elements of the architecture. In this, de Lairesse was his pivotal influence: the first Dutch painter to consider the decoration of ceilings and walls as an architectonic unity, de Lairesse demonstrated this through numerous examples in Amsterdam. After losing his sight around 1690 he gave lectures which ultimately led to the publication of his *Groot Schilderboek* (1707). In several chapters, which deal with both ceiling and mural painting,[1] de Lairesse maintains that the positioning of such paintings must never contradict a room's architectonic logic. He found it nonsensical to paint a landscape on a ceiling, because by nature one looks up to see the sky and the clouds. Equally, he thought of paintings as an opening in the wall, like a window. Hence, it should be unthinkable to paint a landscape over a hearth, i.e. above an open fireplace. If a wall is obviously concealing a chimney, how could there be any credible suggestion of a window piercing it? De Lairesse recommended that this and other awkward positions in the room should be decorated with reliefs, or paintings that imitate reliefs.

Jacob de Wit follows these recommendations to the letter. His mock stucco reliefs are placed over doors and chimneys or as corner ornaments on ceilings, the central areas of which are covered with clouds interspersed with historical or allegorical figures. De Wit constantly observes how real light falls in the room in order to create the same lighting effects on his *trompe l'oeil* reliefs.

The piece exhibited here, 'Autumn', was made for Cornelis Hop (1685–1762), who had been the Dutch ambassador to Paris and later became mayor of Amsterdam. He owned two properties on the Nieuwe Doelenstraat, numbers 16 and 18, where he had a shared gable built and the two houses opened up into one.

1. Gérard de Lairesse, *Groot Schilder-boek*, 2 volumes, Amsterdam (1707) 1740, vol. 2, book 8 (Architecture), pp. 47-134, book 9 (*Plafond* painting), pp. 137-59, book 10 (Sculpture), pp. 223-56.

96

Jacob de Wit
Autumn

2. For example, six putti and busts of the gods on pedestals in each of the large-format paintings in the 'Four Seasons' cycle, held in Kassel, cf. exh. cat. *Vom Adel der Malerei. Holland um 1700*, edited by Ekkehard Mai, Sander Paarlberfg, Gregor J. M. Weber, Cologne-Dordrecht-Kassel 2006–2007, pp. 332f.

In 1740, with the alterations complete, he entrusted Jacob de Wit with the interior decoration, which was to remain in situ until 1904. Three paintings have been preserved in the original pearwood frames, which must surely have related to the overall ornamentation. The client chose a cycle representing the four seasons, a theme that de Wit interpreted on numerous other occasions. Generally, he illustrates these with small, wingless putti who frolic with emblems of each season's attributes; seldom does he include a seasonal personification in the form of gods such as Flora, Ceres, Bacchus and Boreas.[2] In the case of the picture exhibited here, Autumn is expressed through the attributes of Bacchus, the god of wine: the grapes with vine leaves, the barrels and drinking bowl, and his sceptre, the thyrsus staff.

Preserved in the Rijksmuseum collection is a painting of 'Summer' in the same format, and a slightly smaller tondo of 'Winter'; 'Spring' has been lost. The light appears to fall differently on each of the three extant paintings, giving clues as to their former positions in the room: 'Summer' hung opposite the windows while the other two works faced one another at either end. Of these, it seems certain that 'Winter' was over the fireplace, partly because that is where the roundel form is frequently found, but also because that is where the allegorical theme of the depiction—three putti warming themselves by the fire—most logically belongs.

Jacob de Wit engages with the phenomenon of sculpture with great pictorial finesse. His medium is colour, which he deploys in all its possible polarities. On close scrutiny his grisaille proves to be astonishingly colourful: he uses cold grey mixed from black and blue pigments alongside warm tones tinged with yellow ochre. Gérard de Lairesse had been quick to recognise that warm light produces cool shadows in the respective complementary colour.[3] De Wit brings out this contrast with a warm tone for the areas lit directly and cool grey for the shadows. An evenly tempered reflex light rebounds from the warmly lit sections onto the areas in shadow—and only this rounds out the three-dimensionality of the image. Shadow contours are defined either softly or sharply, depending on their distance from the object casting the shadow. Highly illuminated sections are painted thickly and opaquely, while shadowed sections are rendered in translucent glazes. Jacob de Wit so perfectly masters these and other optical techniques that he can work his brush lightly and playfully over the canvas even as he convincingly imitates stone and stucco. Thus, in paragone with sculpture, he imitates the optical effect of a relief but not its stony heaviness. At the same time, he invents his own compositions and executes them almost playfully by means of painting. Charac-

3. De Lairesse 1740, vol. 2, pp. 230f. He mentions blue smalt and yellow as pigments mixed with the grey.

teristics like these help to explain the enduring popularity of this kind of painting: it performs its decorative function par excellence as an integral element of the interior architecture; it treats the viewer to a highly pleasurable optical sensation, heightened by the lightness of the execution; and it stands as an enduring display of prowess in the perfect imitation of reality, self-fabricated in relief.

Gregor J. M. Weber

Léon Joseph Florentin Bonnat (1833–1922)
Justice, c.1868
Oil on canvas, 208 × 67 cm
Musée Bonnat, Ville de Bayonne, CM258

1. *Préfecture de la Seine. Inventaire général des œuvres d'art du département de la Seine*, t. 3 (*Edifices départementaux dans Paris*), Paris, 1883, pp. 32-4 and 62-3.
2. Ch. Blanc, 'Le nouveau palais de Justice. II. Peintures', *Le Temps*, 18 November 1868.

Léon Bonnat is known for the portraits which won him fame across Europe. But before devoting himself to this lucrative genre, he had a brief career as an 'academic' painter. After having been trained as a classical history painter in Léon Cogniet's atelier at the Ecole des Beaux-Arts, he largely executed religious paintings, some of which won him a medal at the *Salon*. It was thus to a rather unoriginal—if workman-like—history painter that the Préfecture de la Seine gave its commission to decorate one of the two rooms of the Court of the Assizes (the northern one) in the Palais de Justice in Paris. (The decoration of the other was given to Lehmann, a pupil of Ingres.)[1]

In addition to the ceiling of this room, Bonnat was asked to paint two canvases—'Justice' and 'Strength'—intended to be hung on the wall behind the Court, which is to say in front of the public. In these two pendants, Bonnat represented the usual emblems of Supreme Power, which are indeed always shown together. To characterise the allegory of Justice he retained the attributes which one finds in all the classical manuals of iconology: the scales, symbol of judgement, and the sword, which reminds us that justice requires force in order to be effective.

When the Palais de Justice was inaugurated in 1868, Charles Blanc devoted an article to the paintings which graced its rooms.[2] He underlined that the French public knew nothing of the conventions of decorative art, and judged a mural as if it were a painting. According to Blanc, 'the significance and the dignity' of mural painting resided in its 'submission to architecture'. Bonnat attempted to resolve the question posed by Charles Blanc. The challenge of Bonnat's commission was, effectively, to conceive of a canvas intended to decorate a wall and thus to inscribe itself within an architecture. To make it part of the architecture he conceived of a spherical niche in front of which he positioned a figure and used a grisaille technique. This *trompe l'œil*, and the sculptural forms of the figure, draped in antique style, would give the impression of a niche supporting a sculpture. This illusion resulted in a difficulty for the painter: how to show the upraised arm maintaining the scales upright? This would not have been a problem for a sculpture, as the arm could extend out of the niche. But a painter would have to successfully convey foreshortening, which would have been a test of skill for an artist who was still inexperienced. The young Bonnat got round this problem by placing the scales under the figure's left arm. Hoping to avoid failure, the painter provided an allegory which was more difficult to interpret, confusing the message and forgetting its pedagogical function. If the sword is readily recognisable, it is only by deduction that one identifies the object in the figure's left hand as a pair of scales. Moreover, if it is usual for Justice to hold the scales upright, it is so that

100

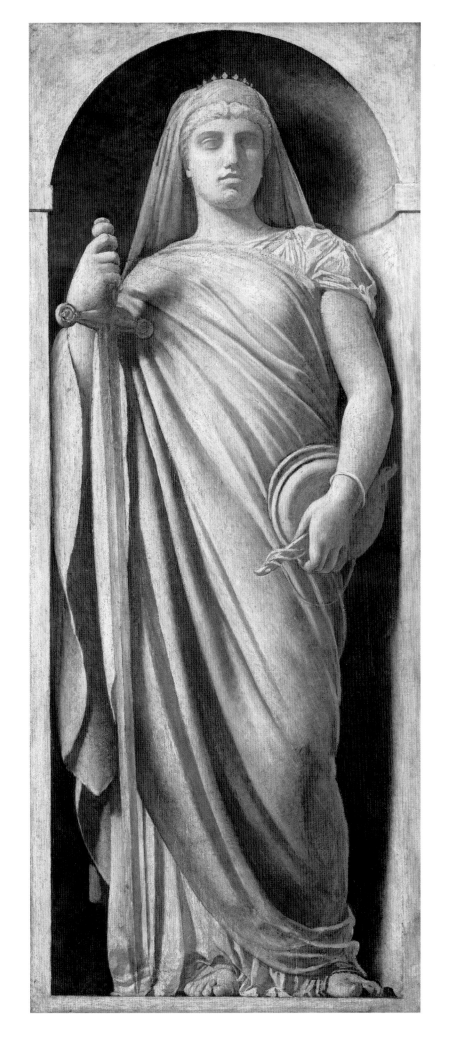

Léon Joseph Florentin Bonnat
Justice

they are ready to be used. A set of scales which is packed up is unusable, and can thus no longer symbolise the act of judgement. In wanting to create the illusion of a sculpture in a niche, Bonnat neglected the meaning of its attributes and re-presented a Justice which does not judge.

Marie-Claude Chaudonneret

James Pryde (1866–1941)
*The Monument, c.*1916–17
Oil on canvas, 151.5 × 138.5 cm
Government Art Collection, 16724

James Pryde was born, grew up and began his art training in Edinburgh. His work has however little in common with his Scottish contemporaries, old masters such as Velázquez, Guardi and Piranesi and the more recent work of Whistler and his contemporary Walter Sickert being more to his taste. In 1890, after a short spell in Paris, Pryde settled in London where he formed a partnership with his brother-in-law William Nicholson, designing posters under the name 'The Beggarstaff Brothers'. Their modern and simplified style revolutionised poster design. During his early career Pryde had some success as a portrait painter, but his favoured subjects were low-life characters, dark interior scenes and architectural fantasies. The majority of his work was done before 1925: thereafter he produced little, apart from sets for Paul Robeson's *Othello* in 1930.

Pryde's portrayal of architecture and landscape is rarely based in reality and there is always a remoteness and an aura of mystery about his work. The exaggerations of scale and the melodramatic lighting effects that characterise his work owe much to his passion for the theatre. Sir Henry Irving and Ellen Terry were family friends and for a time Pryde even worked (though unsuccessfully) as an actor. His architectural reference points came from Edinburgh: the closes of the Old Town, and the giant arches, columns and public monuments of the Georgian New Town. He also drew inspiration from Piranesi's etchings of Rome and, following a visit to Venice in 1911, the paintings of Guardi.

'The Monument' is one of four works painted by Pryde between 1911 and 1917 featuring a giant statue standing high on a plinth set within an aedicule. Three of these bear the title 'The Monument'. The first, which was shown in Pryde's one-man exhibition at the Baillie Gallery in London in 1911, shows a draped classical statue framed by a triangular pediment atop classical columns. The second, painted around 1916, shows a figure with long flowing robes beneath a monumental arch. In both there is a sketchy reference to an urban setting with figures standing bottom centre-stage engaged in some unspecified activity. Pryde painted a variant of the second version of 'The Monument' in which the statue appears as a Christ-like figure and the tiny figures beneath are engaged in the construction of the arch. Titled 'The Shrine', this was shown in London in the Independent Society exhibition of 1916. The present version of 'The Monument', first exhibited in 1917, uses the same architectural setting as 'The Shrine', but here the figure takes on the guise of a Roman warrior, broken and blood-stained. The arch has been shattered and the buildings in the background to the left are ruinous. The role of the small military figures standing below the statue is once again ambiguous. It was Pryde's custom to introduce one or two bright notes of

James Pryde
The Monument

colour into his sombre paintings. Here the red blood gashes in the centre of the image while the bright patch of blue sky is being rapidly overlaid by the lowering black clouds rolling in from the left. Painted during the years of the First World War, 'The Monument' is illustrative of Pryde's growing preoccupation with ruin and decay. It expresses his horror and bewilderment at the atrocities of war.

James Pryde never embraced modernism. The individuality, originality and mystery of his art could provoke extreme reactions. Even his supporters acknowledged his work, with its lack of comprehensible subject matter and distortions of scale, to be an acquired taste. In spite of this, it is clear from contemporary reviews that he was regarded by some as one of Britain's leading painters and he certainly had a loyal following of wealthy patrons. Prominent among these was Lady Annie Cowdray who acquired eighteen major oil paintings, including 'The Shrine', for the walls of the great Library at Dunecht, the Cowdray family seat in Aberdeenshire. After Pryde's visit to Venice, sculpture was given a starring role in his painting. However these are not precise studies of monuments, which appear distant, with the details of carving hidden in deep shadow. Pryde typically adopted a low viewpoint and used heightened perspective to enhance the sense of drama. The viewer looks up towards a stage on which something indefinable is taking place. It could be argued that Pryde used sculpture simply as a theatrical prop, but the aura of unease tells of a greater and more private mystery. It is not for nothing that Pryde became known as the 'Edgar Allan Poe of Painting'.

Ann Simpson

Lawrence Alma-Tadema (1836–1912)
Phidias showing the frieze of the Parthenon to his friends, 1868
Oil on mahogany panel, 72.5 × 109.2 cm
Birmingham Museums & Art Gallery, 1923P118
Bequeathed by Sir John C. Holder Bt., 1923

Lawrence Alma-Tadema, born in Friesland in the northern Netherlands and trained in Antwerp, began his career as a painter of scenes from Merovingian history. A honeymoon trip to Italy in 1863 changed his course: swept away with enthusiasm for the excavations at Pompeii, he turned to painting scenes from classical antiquity. From this moment onwards, ancient sculpture played a central role in his art. Drawing on a vast personal archive of some 5,300 photographs, Alma-Tadema made sculptures into actors, just as important as the human figures in the reconstructed ancient interiors and public spaces of his paintings.[1]

'Phidias showing the frieze of the Parthenon to his friends' is typical of Alma-Tadema's work in placing sculpture at centre stage, but unusual in featuring sculptures from ancient Greece. Most of his paintings are set in Roman antiquity, and they contain diverse assemblages of sculptures to show the Romans as a collecting, if not a plundering, people.[2] On this occasion, though, Alma-Tadema recreated the most important sculptural programme to survive from Greek antiquity: the architectural sculptures of the Parthenon in Athens. At the same time he took the opportunity to explore, visually, the controversies that had emerged around the Parthenon sculptures since the majority of them had been detached from the temple by Lord Elgin, brought to London, and acquired for the British nation in 1816.

What was the role of Phidias in the creation of the architectural sculptures of the Parthenon? The question vexed witnesses to the Parliamentary Select Committee convened in 1816 to consider the acquisition of the sculptures. Phidias' fame as the greatest sculptor of classical antiquity rested on monumental freestanding statues such as the forty-foot high cult image of Athene in chryselephantine (gold and ivory) within the Parthenon. While one ancient source named Phidias as general overseer of the Parthenon project,[3] it remained unclear just how he had been involved, either in the design or the execution of the architectural sculptures, which attracted no comment from ancient authors. Were Elgin's marbles, then, the work of mere labourers, or precious evidence of Phidias' personal style? Alma-Tadema's painting opts decisively for Phidias' authorship: the sculptor stands alone, with no labourers in sight, behind a rope that isolates the working space from the audience of Athenian notables—his 'friends', according to the title, and thus his social equals. His right arm has the powerful musculature of a stone-carver, yet he also carries a papyrus roll which perhaps represents his design. The message of the composition is clear: Phidias is in command, and the unveiling of the frieze is an event important enough to attract the leading citizens of Athens, among them the statesman Pericles,

1. Alma-Tadema's photographic collection, in 167 portfolios, is now held in the Heslop Room, Main Library, University of Birmingham. The photographs represent artefacts of all kinds, primarily although not exclusively ancient, including most of the ancient sculptures that had come to light by the second half of the nineteenth century.
2. See E. Prettejohn, 'Lawrence Alma-Tadema and the Modern City of Ancient Rome', *Art Bulletin*, 2002, vol. 84, pp. 115-29, E. Becker and others eds, *Sir Lawrence Alma-Tadema*, exh. cat., Van Gogh Museum, Amsterdam, and Walker Art Gallery, Liverpool, 1996 (the entry on the present painting, pp. 144-9, contains additional information).

3. Plutarch, *Pericles*, 13.

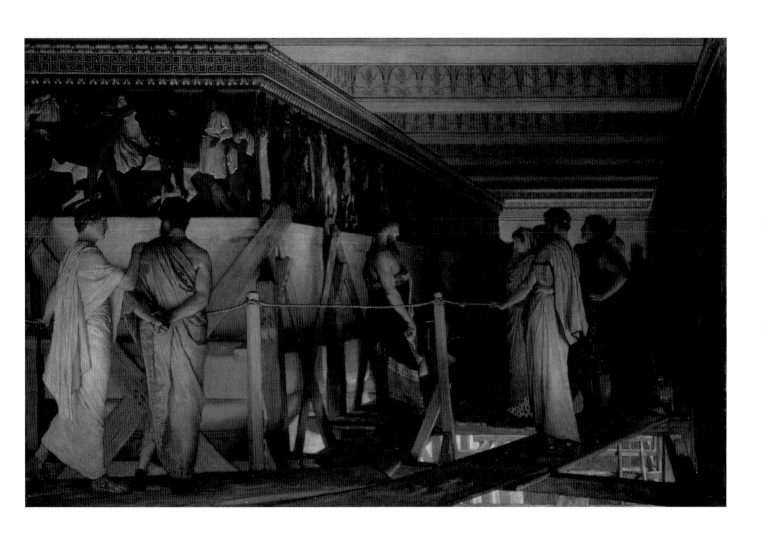

Lawrence Alma-Tadema
Phidias showing the frieze of the Parthenon to his friends

facing the sculptor, and to the left the youthful, beardless Alcibiades, representing the next generation in Athenian politics.

Since the installation of the sculptures in The British Museum, another issue had come to the fore: had the sculptures originally been coloured? Archaeological evidence from a variety of ancient sites increasingly suggested that colouring, or 'polychromy', was standard practice for ancient sculpture of all kinds, yet the evidence was fiercely contested by those who continued to uphold the aesthetic of pure white marble. Here again, Alma-Tadema takes a decisive stance: he gives the sculpture not just a tasteful hint of colour, but vivid polychromy in bold, simplified hues. Moreover, Alma-Tadema shows how the colouring could differentiate the successive planes of the shallow relief, and thus assist the legibility of the frieze to ordinary spectators on the ground forty feet below. Alma-Tadema's visual solution to the problem of ancient polychromy is conjectural, but plausible; the painting has frequently been reproduced in modern texts to show how ancient polychromy might have looked.[4]

Thus the painting takes clear sides in some of the main debates about the Parthenon sculptures. Perhaps, though, it is more searching in its exploration of the most vexed question of all, from 1816 through to the present day: that of whether Elgin was justified in removing the sculptures from the temple building. Alma-Tadema's composition restores the frieze to its original location and imagines its appearance at the moment of its unveiling, glowing with polychrome colour. The compositional techniques are similar to those the French Impressionists would use in later decades to give immediacy to their scenes of modern life; here an oblique viewpoint, dramatic edge-cropping, and moody lighting from beneath the planks of the scaffold convey the excitement of the recreated ancient moment.[5]

We see only a corner of the frieze, but it is carefully selected to reunite sections removed to London with those still in Athens. Facing us is the last slab of the North frieze and just a sliver of the next slab to the left—still to be seen at The British Museum, and among the most famous. But does the abrupt edge-cropping hint at the violence of tearing the slabs from their architectural context? Around the corner are two more of the London slabs, but the rest of the West frieze remains in Athens. The oblique view, with its rapidly diminishing perspective and dramatic foreshortening, projects this side of the frieze into the pictorial distance, progressively more difficult to make out as it recedes from the viewer. Alma-Tadema gratifies the desire to see the sculptures as they might have looked when first unveiled, yet the edge-cropping and foreshortening remind the spectator that the Parthenon can never be restored to wholeness.

Elizabeth Prettejohn

4. For example, in I. Jenkins, *The Parthenon Frieze*, London, 1994, colour plate 11; cf. note 5 below.

5. Interestingly, the caption to a reproduction of the painting in the context of a discussion of polychromy in a recent Louvre exhibition catalogue identifies it, incorrectly, as a detail; presumably the authors thought the unconventional composition could not represent the entire painting. See A. Pasquier and J.-L. Martinez, *Praxitèle*, exh. cat., Musée du Louvre, Paris, 2007, fig. 39 on p. 67.

Euan Uglow (1932–2000)
The Lightest Painting on Earth, 1989–93
Oil on canvas, 69.2 × 54.6 cm
Private collection

Euan Uglow was a distinct and highly disciplined painter who devised working methods and studio environments that were part of the meaning of the work. What some viewers regarded as 'representation' could be described as an investigative art that began, like conceptual art, with an idea; in Uglow's case normally one connected to geometry, scale or time: 'it's nothing to do with being true to life. You're trying to construct a new world so that it can stand'.[1] The special settings, the 'set-ups', determined the position of the subject, the angle of light and shadow, beginning with a plumb line and horizontal string so that what he measured was consistent and relevant to the distance and location of the solid matter from the artist's eye.

1. All quotations come from published interviews, see Richard Kendall and Catherine Lampert, *Euan Uglow. The Complete Paintings*, London and New Haven, 2007.

Very often Uglow invented devices that showed the ingenious functionality of a sculptor or craftsman, props to hold the still-life objects which themselves became petrified and oddly artificial, for instance, a huge loaf of bread or an iced tart. In his determination to address the conflict between perceived perspective and the harmonious depiction of the subject on a flat rectangle, he demanded that reality be adjusted. For example, in 'Curled Nude on a Stool', 1982–3, (Ferens Art Gallery, Hull) Uglow decided to 'combat' the violent (and unattractive) trapezoidal angle of a four-legged stool seen up-close by re-fashioning the length and location of its legs. In a sense the focus on stillness, solids described as discrete faceted planes—and the 'real', without reference to 'natural' surroundings, was the most sculptural aspect of his work. Often the measuring marks seem to score the canvas surface, and if red pigment was used, give rise to some idea of a living person punctured by the point of callipers; however, the models describe a very pleasant, serious studio environment which was adapted for consistency not suffering.

Another obvious connection to sculpture is Uglow's life-long interest in painting plaster casts of classical Greek art, the first made in 1953, a student picture of a standing male figure in the Antique Room at the Slade School of Art placed in a double square, typical of Uglow's preference for an 'ordered' rectangle. 'Cast,' 1987–91, made at the same time as this painting, contrasts the surface screen of measuring marks with the introspective, sensuous expression of the plaster head. Several of his striding nudes stood like *kouroi*, seen in profile, left foot forward. Small clay models, two of which were cast in bronze, 'Egyptian Spearess', 1986, and 'Girl Tripping', 1991, were made by the artist and used as substitutes for a person on the rare occasions when it was impossible to paint from life.

Prior to beginning 'The Lightest Painting on Earth', Uglow had executed five paintings of a similar highly symmetrical pose, the model's body so close to the

Euan Uglow
The Lightest Painting on Earth

seated artist that the lower legs disappear beyond the bottom edge and the triangular shape from head to knees emphasises the stability. The clear fresco-like blue behind the figure was created by rubbing Reckitt's Blue, powdered bleach, into wet plaster directly on the wall and an equivalent oil colour mixed on Uglow's palette. 'The Lightest Painting on Earth' was, in his words:

> … about high daylight. There was so much light coming and she was so pale that she absorbed the light and just threw it off. I couldn't make anything lighter unless you made everything black and that's not the point at all.

To fulfil the intention of 'a structured painting full of controlled, and therefore potent, emotion' the facial expression and even a sense of gaze was eliminated, much like the odd passivity in the portraits and seated nudes of a favourite sculptor, Charles Despiau. The celebration of light and pale flesh was achieved when the figure's solidity, her sensuous gravity, matched the mirage-like feeling of bright insubstantial light and space.

Catherine Lampert

110

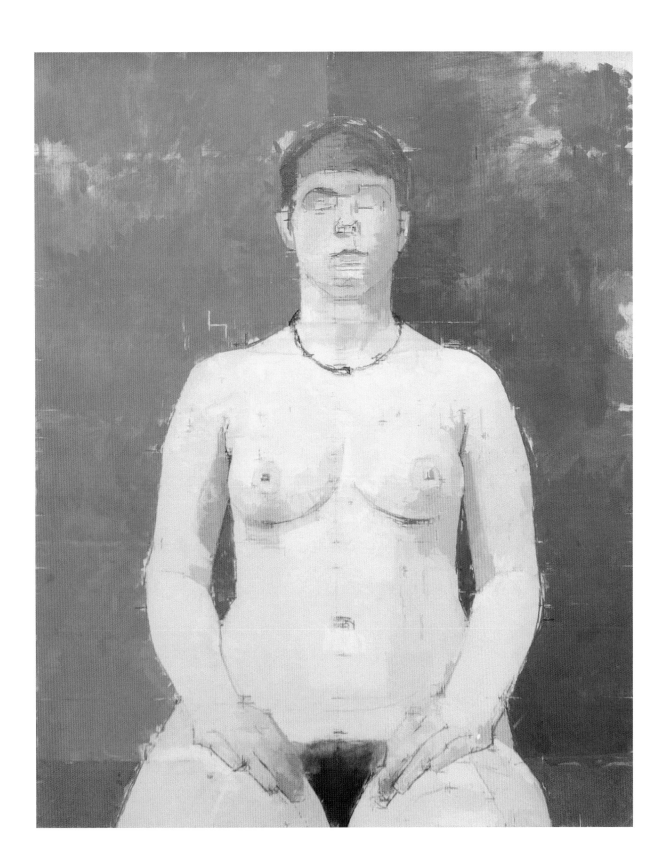

The works in this section allow us to come upon sculpture as we might do ordinarily, in the domestic interior or in the museum. Whereas the former situation allows sculpture to disguise itself, camouflaged among other decorative objects on the mantelpiece, but nonetheless close to us, the museum environment is shown as stark and unrelenting, with the sculpture under glass and at a distance. Nevertheless, the glitter of hard materials, be they glass or porcelain, works to disconcert and disrupt our viewing and understanding.

Vuillard's statuettes on the mantelpiece suggest the ancient Tanagra form, or its modern version, beloved of Maillol. Placed in front of a mirror, these small bodies are strangely fragmented and ethereal. By contrast the solidity of Taslitzky's portrait heads would have us believe that here more is at play than a simple artistic convention in representing likeness, and that the three heads really did exist individually. Blanchet's grisaille appears at first as a beguiling portrait of an apparently available model, but is in fact a record of a famous antique sculpture, the bi-sexual Hermaphrodite. Van Everdingen's inventive interplay between two sculptures is equally lively, and equally beguiling.

These are portraits of sculptures. They show sculptures alone. We come upon them from the outside. If there is an animating presence it is ours, brought to the works from outside the confines of the painting's frame. On occasion our reflections seem to precede us, most especially as we look at Tim Braden's Giacomettis, caught in their plexiglass case. These sculptures are real sculptures, even famous works of art, by Giacometti, Rodin, Maillol or Lipchitz. Even Henning's sculpture—the most fantastic—could in a sense be argued to exist. If they seem exposed, they make us feel similarly. This may be how sculptures are, without us, or it may be how we feel, without them.

Louis-Gabriel Blanchet (1705 – 72)
The Sleeping Hermaphrodite (Borghese version), c.1765
Oil on canvas, 72.5 × 97 cm
Saltram, The Morley Collection, SAL/P/154
Accepted in lieu of tax by H.M. Treasury and transferred to
The National Trust in 1957

1. Like Antoine Favray (1706–98; in Rome from 1738 to 1744, when he left for Malta, where he was to spend the rest of his life)—or for life—like Pierre-Hubert Subleyras (1699–1749; in Rome from 1728 till his death.) The prime source for the French students in Rome is the *Correspond-ance des Directeurs de l'Académie de France à Rome avec les Surintendants des Bâtiments (1666–1793)*, Anatole Montaiglon and Jules Guiffrey eds, 18 vols, Paris, 1887–1912.

2. There is no monograph on Blanchet, but see Olivier Michel's entry in Saur's *Allgemeines Künstler Lexikon*, Munich and Leipzig, vol. 11, 1995, pp. 396-7, s.v.

3. Brinsley Ford, *A Dictionary of British and Irish travellers in Italy, 1701–1800*, John Ingamells ed., New Haven and London, 1997, p. 738, s.v.

4. For all of these, see Francis Haskell and Nicholas Penny, *Taste and the Antique: The Lure of Classical Sculpture, 1500–1900*, New Haven and London, 1981, s.vv.

5. Omitted from the *Catalogues* of 1819 and 1844 (because they had evidently not yet been bought into the main house), these were first catalogued in *The Saltram Collection* [by St. John Gore], The National Trust, 1967, p. 39, no. 79.

6. BL, Add. MS 48218, f. 58. The letter is quoted by Gore (see note 5), but I owe the reference to its British Library number to Richard Stephens (see his essay on 'Parker and Saltram' in the catalogue of the exhibition *Sir Joshua Reynolds: The Acquisition of Genius*, Plymouth Art Gallery from November 2009.

7. *Grand Tour: The Lure of Italy in the Eighteenth Century*, ex. cat., Tate Gallery, 1996–7, p. 252, no. 207.

8. *Masterpieces from Yorkshire Houses*, exh. cat., York City Art Gallery, 1994, no, 34, p. 73 and colour cover. It might be worth noting (in the context of the present exhibition) that this portrait shows Middleton also with a bust of the 'Capitoline Antinous'.

Blanchet was one of those French artists who won the *prix de Rome*, which en-titled them to four years' stay and study at the Académie de France (then still in the Palazzo Mancini) but who stayed on beyond their time, for some years.[1] Much of Blanchet's activity consisted of painting portraits of Jacobites in, and Grand Tourists to, the Eternal City.[2]

The present painting is, however, one of a set of eight that he did, not of, but for, one such Grand Tourist—almost certainly, John Parker, first Lord Boring-don (c.1735–88), Sir Joshua Reynolds' and Angelica Kauffman's great patron, during his sojourn in Rome in 1764.[3] All but one are of celebrated pieces of antique sculpture (in addition to this: the 'Apollo Belvedere', the 'Three Grac-es', the 'Venus de' Medici', the 'Dying Gaul', the 'Farnese Hercules', and the 'Borghese Warrior');[4] the exception is a classical medallion with the 'Head of a Youth'.[5]

Because the eight paintings were later known in the family of the Parker Earls of Morley at Saltram as 'The Ghosts', it has been suggested that they are the paintings referred to in a letter of Anne (?) Robinson's dated 12 September 1780, describing Reynolds' stay in the house: 'He has touched up all the ghosts in the eating room, and improved them very much'.[6] Although this would have been just before Robert Adam's creation of the present Dining Room, with its inset paintings by Antonio Zucchi and Francesco Zuccarelli, it is not really plausible: not only had the Blanchets been painted only fifteen years before, so that they would scarcely have stood in need of retouching, but nor do the paintings themselves betray any sign of such an intervention. Much more probable is it that Reynolds, as a portrait-painter, was invited to touch up what one might expect the adornment of the old eating-room to have been: a set of family ancestors. It seems more likely, from the character of the eight pictures themselves, and from their plain white-painted frames, that they were inset paintings in some since-demolished *tempietto* in the grounds.

What is distinctive about this painting, and the others in the set (for example the 'Apollo Belvedere'),[7] is that the artist did not simply content himself with portraying the antique sculptures, but gave each a setting evocative of transience and decay; sometimes with the withered branches which are characteristic of his work (for example the 'Venus de' Medici' and 'Apollo Belvedere'; *cf.* his portrait of 'Henry Willoughby, later fifth Baron Middleton' in the collection of descend-ants in Yorkshire);[8] and sometimes, as here, with chipped and cracked blocks of worked stone. This gives the sculptures a slightly dream-like quality, and, by means

114

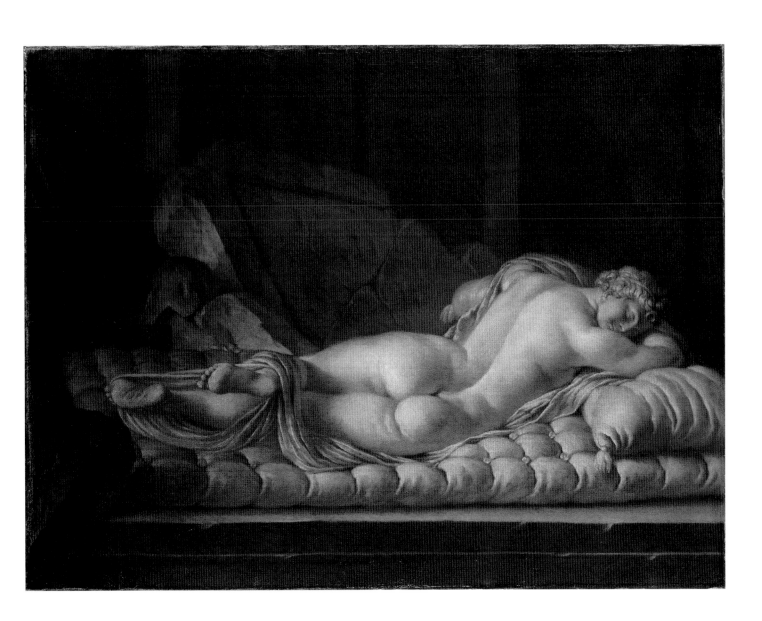

Louis-Gabriel Blanchet
The Sleeping Hermaphrodite (Borghese version)

of the fictive context, approximates them one step nearer than the originals, if not to creatures of flesh and blood, then indeed to ghosts.

The representation of the 'Hermaphrodite' in this set has, however, an added piquancy; for, in the traditional paragone between painting and sculpture, one of the advantages of the latter over the former was that it showed the thing or person represented in the round. In the cast of the 'Hermaphrodite' this was particularly important, because it was only when the viewer, having admired the evidently female posterior, went round to the other side, that he or she would be alerted by the presence of male genitalia to the fact that this was not merely a female nude, and astonished or disgusted accordingly.[9]

Despite this handicap for the painter or draughtsman, painted or drawn representations of the 'Hermaphrodite' are surprisingly common—and almost all of them show it from the rear. That it was often depicted was due to its celebrity as an antique; that this was nearly always a rear view is, quite simply, because this aspect was its most beautiful—as well as its least troubling (even if, to some, its most erotic). In the Borghese version of the 'Hermaphrodite', the mattress added by Bernini—very present in the painting here—added a further layer of ambiguity. It turned a figure of classical mythology (born of the fusion between Hermaphroditus, son of Hermes and Aphrodite, and the spring-nymph, Salmacis, whose overtures he had rejected, but who embraced him so tightly, whilst praying to the gods that they might be united, that they were) into one of a much more terrestrial kind: a two-sexed creature, invitingly recumbent on the classic locus of amorous activity. By placing this semi-domesticated sculpture back in a setting of architecture, vase, and cracked carved blocks of stone, Blanchet cleverly enhances the tension inherent between its existence as a piece of sculpture, and the invitation to imagine it as something more: a creature of actual flesh and blood. The viewer is invited to be the Pygmalion to this two-sexed Galatea, longing in imagination for the corporeal to become actual.

Alastair Laing

9. For a variety of reactions to the original—the most piquant of which is probably Lady Townshend's, as recorded by Horace Walpole, that it was: 'the only happy couple she ever saw'—see Haskell and Penny, op. cit. [note 4], no. 48, p. 235.

Caesar van Everdingen (1617–78)
Trompe l'Oeil with a bust of Venus, 1665
Oil on canvas, 74 × 60.8 cm
Mauritshuis, The Hague, 1088

A bust of Venus stands on a stone ledge before a fluted column. Beside her lies the fragment of a Cupid head, unmounted and tilted back so that the child's sculptural eyes look blankly up towards his mother. Venus instead sits on a pedestal, her stone colouring foiled by a cloth of dusky salmon that runs under the crest of her shoulder to fall in soft folds beneath her breasts. A trail of myrtle, evergreen and so an emblem of love, encircles her neck and twines through her sculpted hair. Fresh cut, its verdant tendrils seem to animate her stony form, to suggest that the colours of painting may revive the sculptures of antiquity.[1]

This graceful, painted Venus looks into the depths of the painting to recollect the manifold histories of her namesake, the ancient goddess of love and beauty.[2] Her gaze into the distance is a metaphor for the temporal journey her form represents. Light falls across her creamy neck from behind, casting her face in veiled shadow to emblematise her view onto the past. Her pose is that of the starred 'Medici Venus', an antique sculpture that counted among the finest possessions of the Medici and which circulated across Europe in drawings, prints, models and plaster casts to engender a multitude of imitations such as this.[3] Early modern princely collections such as the Medici typically juxtaposed antique statuary with Renaissance painting to display the tenets of a comparison between 'ancients' and 'moderns' of which Venus was a common motif. Van Everdingen's painting thus touches on a produring history of Venus mirrored and compared: ancient/modern, sculpture/paint.[4] To render Venus was to re-collect her past.

Definitive evidence of the intended setting for Everdingen's 'Venus' eludes us but archival sources and provenance history suggest that it was displayed in the artist's own home and studio in Alkmaar.[5] It thus forms part of a burgeoning early modern decoration of the artist's studio of which Rubens' house in Antwerp was the most illustrious.[6] In fact, our piece is one of a pair, its counterpart a painting of a bust of the Greek youth Adonis with whom Venus fell in love.[7] Both paintings depict their illusion of sculpture as mirror images, facing each other. Adonis too sits on a ledge, and behind both figures runs a parapet that rises to one side. This shared painted architecture suggests a continuum with the actual architecture of the room, likely a window or door frame. Everdingen's corpus included many such decorative renderings of classical sculpture and architecture designed illusionistically to confuse the threshold of the painting with that of its surround. Rendered in grisaille, its modulations of grey imitate the colour of stone to suggest a fusion of temporalities between the ancient past and the architectural present. Both busts as well as the ledge on which they stand project forward beyond the bounds of the picture plane in the tradition of *trompe l'oeil*—paintings that deceive the eye.

117

1. On the artist and the painting see especially Rieke van Leeuwen, 'Venus en Adonis Herenigd' *Tableau*, 1992/3, 15, 2, 94-101, Albert Blankert in *Dutch Classicism in Seventeenth-Century Dutch Painting*, Rotterdam and Frankfurt, 2000, cat. no. 39, 216-8, Paul Huys Janssen, *Caesar van Everdingen*, 2002, cat. no. 28, 85-86. Blankert identified the plant as *Vinca major*: vinca may have been Everdingen's prop for the painting but the intention was surely to represent myrtle, as Venus' attribute.

2. On the artistic representation of Venus see Caroline Arscott and Katie Scott eds, *Manifestations of Venus: Art and Sexuality*, Manchester and New York, 2000, Reinhold Baumstark, *Venus: Bilder einer Göttin*, exh. cat., Munich, 2001, Ekkehard Mai, *Venus: Vergeten Mythe. Voorstellingen van een godin van Cranach tot Cézanne*, exh. cat., Munich and Antwerp, 2001.

3. On the 'Medici Venus' see Guido Mansuelli, *Galleria degli Uffizi: Le Sculture*, 2 vols, Rome, 1956–61, 1, 69-74. On early modern interest in the collection of antiquities see Francis Haskell and Nicholas Penny, *Taste and the Antique: The Lure of Classical Sculpture*, 1500–1900, New Haven and London, 1981, cat. no. 88, 325-328.

4. On early modern comparisons between painting and sculpture, ancient and modern see Jacqueline Lichtenstein, *The Blind Spot: An Essay on the Relations between Painting and Sculpture in the Modern Age*, Los Angeles, 2008.

5. The work has been linked to an inventory of Everdingen's property made in 1678, published by Janssen, 2002, 180-88. If the painting remained in the artist's possession for thirteen years after its completion it was unlikely to have been destined for a patron.

Caesar van Everdingen
Trompe l'Oeil with a bust of Venus

6. See Elizabeth McGrath, 'The Painted Decoration of Rubens's House', *Journal of the Warburg and Courtauld Institutes*, 41, 1978, 245-77.
7. Caesar van Everdingen, '*Trompe-l'oeil* with a bust of Adonis', oil on canvas, 73.7 x 60 cm, signed and dated: CVE ANNO 1666, Michaelis Collection, Capetown. See Leeuwen, 1992/3; Hans Fransen, *Michaelis Collection*, Capetown, 1997, cat. no. 20, 102-3, Janssen, 2002, cat. no. 28, 85-6.

8. On *trompe l'oeil* see Louis Marin, '*Représentation et simulacre*', *De la représentation*, Paris, 1994, 303-312 and Victor I. Stoichita, *The Self-Aware Image: an insight into early modern meta-painting*, Cambridge, 1997.

Sincere thanks to Quentin Buvelot, Erma Hermens, Tico Seifert, and Robert Wenley.

These are transitive works, situating themselves at the threshold of distant time, fictive space, and feigned materials. Both are thus pictorial manifestos of the artist's skill in illusion.

Like Venus, Adonis too bears emblematic foliage in his hair, the evergreen laurel of Apollo's crown. Apollo's laurels celebrated the immortality of poetry under the aegis of Venus for love unrequited was the poet's perennial theme. The chalky palette with which the busts are painted is signal. It suggests not the translucent whiteness of marble but the milkier tones of limestone plaster. This insistent materiality brings the world of the workshop with its plaster cast props into the mirror of painting's illusion. The drapery too is rendered through an art of describing like a Dutch still(ed) life: the creases of the fabric where it was previously folded, the hem's puckered stitching as it falls across the ledge. Before Adonis lies a hunting horn, semantically occupying the same space of meaning as the Cupid head within the image of Venus. If the horn is an emblem of Adonis' prowess the love child Cupid speaks to Venus' archaic powers as a goddess of fertility, fitting ornament to her femininity. Together, the couple represent beauty. If Venus was the ancient goddess of desire, beauty was her mantle. Her young lover Adonis was no less celebrated for his transcendent if mortal pulchritude. As part of a decorative ensemble within the artist's studio the pair may be said to emblematise the beauty of art. In their knowing engagement with the play of visual deception—the semblance of sculpture in paint, the fiction of volume on a flat canvas, the echo of the classical past within the present—these *trompe l'oeil*s are reflexive, 'self-aware images' that reflect on their status as artificed illusion.[8] Sculpture into paint, ancient into Dutch, the works are consummate declarations of Everdingen's skill. If the absent colouring of grisaille evokes the stillness of ancient statues the play of dappled light and coloured shadows of the framing drapery animate her form. The painting is poised between Medusa and Pygmalion: as it petrifies yet it intimates a quickening, for this is its Venus effect. If Adonis and Cupid, like the viewer, look upon the goddess of desire, Venus turns away. Her gaze into the darkening depths of the picture seems to look back on the long history of her own representation as the classical touchstone of beauty, love, and art.

Genevieve Warwick

118

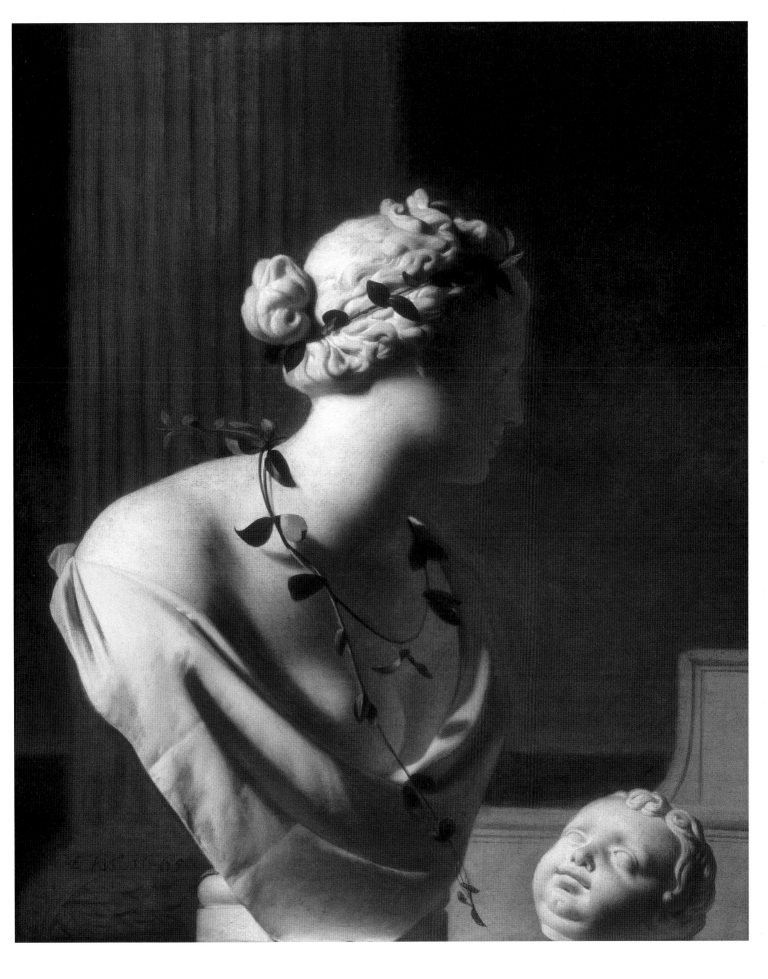

Sir William Nicholson (1872–1949)
Statuettes and Rodin Bronze, 1907
Oil on canvas, 60 × 55 cm
Courtesy of the Fine Art Society PLC

In a small space, artfully arranged with a studied sense of informality, a small bronze stands between two white ceramic figures. The quiet and casual composition may seem, at first glance, to offer no more than the record of a chance juxtaposition, revealing patterns of collecting, or of decorative taste in the early twentieth century. William Nicholson is, however, an extremely ambitious still life painter, and the casual simplicity of the composition masks a profound meditation on sculpture, painting, and objecthood.

The bronze is a cast of Rodin's 'Brother and Sister' of *c*.1890. Rodin was a cult figure in Britain's artistic circles by the time Nicholson made his painting, and 'Brother and Sister' was a particularly popular work. Many casts were exhibited and sold, and it entered the collections of both artists and major institutions, including the Ashmolean, the Fitzwilliam and the Walker Art Gallery.[1] The ceramic figures represent a different world. They are *blanc de Chine*, the characteristic white glazed porcelain from China, first produced in the Ming period, which garnered an extensive export market from the seventeenth century, and which was much imitated by European manufacturers, most notably Meissen. Here we see two of the most familiar *blanc de Chine* figures: the 'Laughing Buddha' and 'Guanyin', the Buddhist Goddess of Mercy.

The aesthetic or painterly appeal of this combination is obvious. Nicholson explores the contrast between the dark patination of the bronze and the bright, creamy whiteness of the *blanc de Chine*. He brilliantly evokes the smooth, translucent glaze of the ceramics and the motile surface of the Rodin, capturing the distinctive ways in which the surfaces catch the light, bringing out qualities of meditative stillness or somatic energy. The rendering of light also amplifies the contrast between the stasis of the Eastern figures and the twisting movement of the Western bronze, providing a visual commentary on different traditions and on different conceptions of the body.

At one level, then, this work demonstrates the ways in which the representation of sculpture can provide an arsenal of effects for the painter. Throughout his career, Nicholson's still lifes address the surfaces of objects, surfaces of silver, pewter, brass, glass and ceramic, surfaces where objects reflect the world. Yet there is something far more pressing here than a mere exercise in visual contrasts, or a commentary on collecting and the global nature of domestic decoration. The subject of sculpture draws out the painter's almost metaphysical approach in a way that the jugs and bowls and vases he more frequently paints may not. In an outstanding essay on the artist, Merlin James has suggested that Nicholson's still lifes are 'dense with consciousness'; they are full of the sense of encountering the world, and, as such, of the ways in which objects can make the world new to us.[2]

1. Antoinette Le Normand-Romain, *The Bronzes of Rodin: Catalogue of Works in the Musée Rodin*, Paris, 2007, vol. 1, pp. 376-7.

2. Merlin James, 'Words about Painting,' in Colin Campbell et al, *The Art of William Nicholson*, London, 2004, p. 23.

120

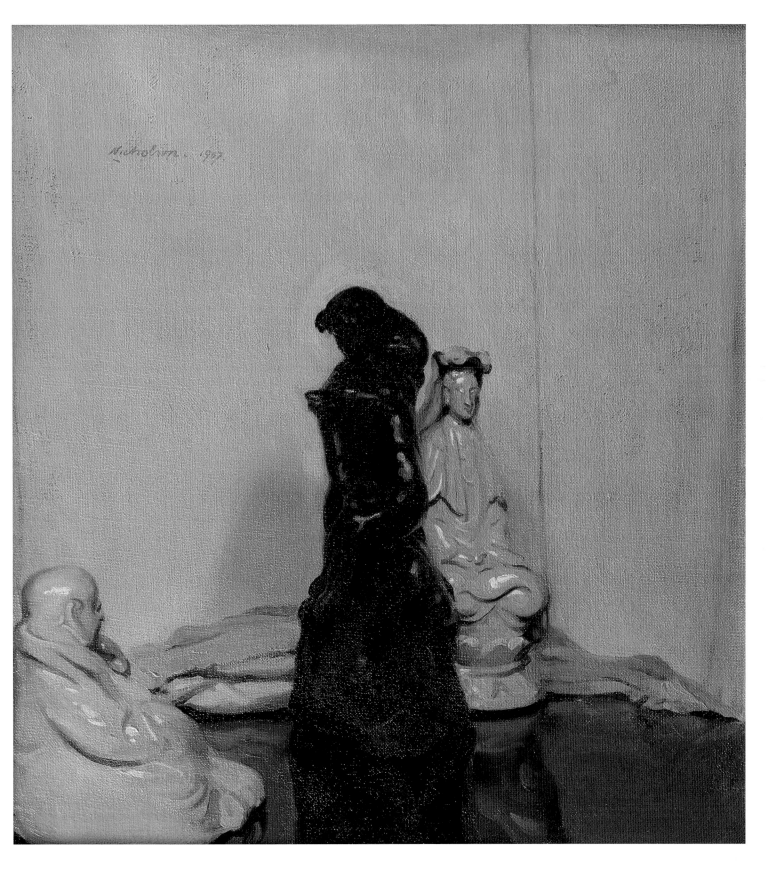

Sir William Nicholson
Statuettes and Rodin Bronze

The corollary is that the artist is equally concerned with materiality, Indeed, 'Statuettes and Rodin Bronze' seems to ask: what does materiality look like? The statuettes are intended as both figure and object. Like so much sculpture, these statuettes aspire to transcend their objecthood and inhabit the world differently from mere things. Nicholson insists on the materiality of the object, however, forestalling this aspiration; and yet, at the same time, his painting endows sculpture with an uncanny ability to bring the density of consciousness to the fore.

How does Nicholson achieve such an ambitious objective? First, light: for light and reflection are also about illegibility. While light may animate surfaces, emphasising the heavy white brilliance of the ceramics and the high polish of the bronze, the figures themselves are not animated. The specific highlights animate the object rather than the figure. Light flickers between consciousness and matter, disrupting the ease with which we believe we view the world. Second, the relationship between the statuettes and the space they occupy is similarly important. Rather than filling the space, the objects are ill at ease within it. The monochrome palette, the large expanse of blank, uncoloured wall behind, and the apparent disorganisation of the objects create a centrifugal composition which moves the viewer from the centre to the edges of the picture's notional space. We become aware of the empty space as if this too had a material presence. This is emphasised by the positions of the sculptures. Everything turns away from the viewer. While sculpture might share our world, in Nicholson's rendition, it tries to evade us. The Buddha, positioned in the bottom left-hand corner has its back towards the viewer, weighting the composition awkwardly, and placed in such a way that the features of face, hands, and the closing of the robe around the corpulent body are all hidden from view. The ceramic form almost melts into undifferentiated matter. By contrast, the Gunayin, partly hidden behind the Rodin bronze, also slightly turned away from the viewer, and sitting at the farthest limit of the pictorial space, creates a surprising sense of distance. The Rodin bronze, caught between illegible paint and legible image, becomes both the focus and the blank dark heart of the painting.

The result is a painting about the strangeness of sculpture; indeed, 'Statuettes and Rodin Bronze' disenchants sculpture. No longer the object that transcends its materiality, sculpture is represented here as stuff. Nonetheless, Nicholson's painting, even in such a quiet manner, captures the unexpectedness of encounters with objects, asking us to consider how sculpture can connect a world dense with materiality and a world dense with consciousness.

Michael Hatt

122

Tim Braden (b. 1975)
Looking at Sculpture, 2006
Watercolour on unprimed canvas, 176 × 139 cm
Courtesy the artist and Timothy Taylor Gallery, London, T004432

Tim Braden, who studied at Wimbledon School of Art, the Ruskin School and the Rijksakademie in Amsterdam, is one of a number of contemporary painters who have consistently made paintings with historic sculptures in them. He has also made sculptures himself, as demonstrated by 'Platform for Collecting Milk' (2005), a small-scale painted steel model of an Estonian milk collecting station, and a number of architectural models executed in wood, metal and concrete, including 'Catapult', 'Jozo' and 'Teka' (2005). Interestingly it is the figurative sculptures of other artists, rather than his own constructions, that have featured in his painting, becoming the focal points of a number of works besides 'Looking at Sculpture'. These include: 'Monumental' (2004), a diptych which offers a panoramic view of a sculptor's studio at the St Petersburg Academy of Fine Art, 'Pompon Studio Shelves' (2008), taken from a monochrome photograph from a book on Pompon, and 'Derain' (2009), a painting of one wall in an exhibition that included a bronze bust by the French artist.[1]

Reconstruction is central to Braden's work and the reconstruction of the art and popular culture of Russia, Algeria, India, France, Holland and other European countries in which he has spent time, simultaneously making their objects and images his own and celebrating their eye-catching otherness. In his two-dimensional work he tends to make large-scale watercolour (or thin acrylic or oil) paintings of snapshot views which have originally been captured by him on camera. The shift in scale—from photographic print to one or two metre canvas—both amplifies and monumentalises these momentary glimpses, slowing them down and allowing us to look and to think about looking. In addition to this, the watercolour ('a devotional medium' for Braden) applied to unprimed canvas gives the subjects a direct and spontaneous life, but one combined with an intriguing ghostliness, melancholy and nostalgia.[2]

Braden first encountered Alberto Giacometti's sculpture as a child on holiday in France. The two small sculptures by Giacometti that feature in 'Looking at Sculpture', namely 'Simone de Beauvoir' (1945) and 'Small bust of Silvia on a Double Plinth' (1942–3), he saw on a recent trip to the Musée Rodin in Paris. The sculptures were displayed behind Perspex, complete with identifying labels, and in order to see and photograph them more clearly, Braden and his girlfriend stood in front of the works so as to cast shadows which served to block the distracting reflective flare from the vitrine's acrylic.[3] This has been carried over into the painting, as we see the shadows of two pairs of legs at the bottom of the canvas and note that there is a subtle doubling and mirroring evoked between the viewers and the viewed, between the two little busts in the vitrine and the two larger gallery visitors outside it.

1. Exhibited in *Tim Braden: As if it were another landscape*, Faye Fleming Gallery, Geneva, 2009. Marie Sellier, *Pompon sculpteur*, Paris, 1994.

2. In conversation with the artist, 21 April 2009.

3. Conversely, in 'Steppe' (2004) Braden painted three stuffed donkeys from a natural history museum and painted a 'flare' over them to suggest the flash of his camera and to make it look as if they were displayed behind glass.

123

Tim Braden
Looking at Sculpture

4. In conversation with the artist, 21 April 2009.

Braden's painting thus gives us a fresh view of such internationally known modern sculpture. Giacometti's sculpture is familiar to us today both through the artist's own studio paintings and through the mediating lens of its photographers, such as Brassaï, Marc Vaux, Ernst Scheidegger and Patricia Matisse, who regularly captured work in progress in monochrome photography in the sculptor's Parisian studio at 46 rue Hippolyte Maindron. Braden, however, disturbs these expectations, giving us disarming 'photographic' gallery views in painted colour. Bronze, as opposed to plaster and clay, is the material represented and the act of encountering the works in the gallery and in the present, beyond the studio and outside this canonised visual history is part of his strategy. The moment of catching sight of an object, as his title suggests, is what these 'animating snapshots' are all about, as he himself states: 'these sculptures are mediated by your experience of them and the viewer animates them as he or she glimpses them'.[4] But if, as his title states, he gives us 'looking at sculpture', he also gives us 'looking *through the camera and through Perspex* at sculpture *in the museum*': a highly mediated kind of encounter which structures and frames the narratives articulated.

What happens to the representation of sculpture in contemporary painting? What stories does it tell about the changing meanings of sculpture in today's multimedia, highly digitised and virtual world? In Braden's work 'sculpture in painting' in the early twenty-first century is ultimately about the mediation of sculpture and painting: about looking at sculpture through photography in the context and regime of the contemporary art museum. Gone are the earlier tales of metamorphosis and the paragone, and instead we find close, melancholic encounters: narratives of vision and exchange conducted, without touching and through Perspex, between viewer and art work, between sculptures, visitors and their shadows.

Jon Wood

ALBERTO
GIACOMETTI

Simone de Beauvoir
1946

Plâtre

Cat. 54

ALBERTO
GIACOMETTI

Petit buste de Silvio
sur double socle.
1942-1943

Cat. 53

Edouard Vuillard (1868–1940)
The Statuettes on the Mantelpiece, rue de Calais, c.1919
Oil on cardboard, mounted on cradled panel, 31 × 58.7 cm
Galerie Rosengart, Lucerne

At first the subject of this painting is barely legible, a jumble of white, pink, pale green and blue brushstrokes on buff cardboard. Only gradually can one make these out as white figurines, the central pink patch as a carnation in a vase; the streaks of blue, gold and pale green resolve themselves into framed works of art leaning against a mirror and the whole ensemble becomes a play of highlights and reflections on a mantelpiece. On closer inspection still, the largest of the seated sculptures proves to be 'Leda' by Aristide Maillol, identifiable thanks to its characteristically modest stance, defensively raised left hand and down-turned head.[1] The figurine (or possibly two—the reflections make it difficult to judge) to the left is recognisable as a Tanagra.[2]

By the time of painting this study, Vuillard was an acknowledged master of the intimate interior. Known for being as attentive to a room's ornaments and furnishings as to its human occupants, his underlying preoccupation seemed to be the secret life of objects. In the 1920s and 1930s his fascination with knick-knacks became something of a fixation, a diversion from the demands of commissioned portraiture. He could devote whole sketchbooks to the study of the details of a décor, such minor elements as a tea service or chair back assuming obsessive importance.

Vuillard was an inveterate indexer of sculpture and other works of art in his paintings, particularly the works in his own growing collection. On occasion he incorporated them, like Chardin before him, into frieze-like decorative over-door panels. For Guy Cogeval, writing in the 2003 Vuillard *catalogue raisonné*, the sculptural relics he accumulated helped him defy the passing years, bearing 'silent witness to Vuillard's enduring presence in time'.[3] Certain favourite works played a recurrent role in his compositions, the 'Leda' figurine being one. Whether a gift from his fellow Nabi, Maillol, or a purchase, Vuillard was the owner of this prized work by the turn of the century and it still had pride of place on his mantelpiece in the 1930s.[4] He first represented it in a trio of casual but animated still lifes, in one of which 'Leda' is presented in isolation on a table top, juxtaposed with a vase of flowers, Vuillard enjoying the conceit of her appearing to shelter under the bouquet's canopy.[5] This group, done around 1900, coincided with a phase of his returning to nude studies from hired models. How much more convenient to pose the nude Maillol statuette, or the Tanagras, and view them from different angles to suit his fancy.

Unmarried, though by no means celibate, by 1919 Vuillard was still living with his elderly mother who, in return for this filial devotion, put up with the encroachment of his studio apparatus into her domestic realm. There seems to have

1. Maillol's first public showing of 'Leda' was probably in 1902, when it was noticed by Félicien Fagus in a group show, mainly of Nabi paintings, at the Galerie Bernheim-jeune. Cf. *Revue blanche*, vol. 28, mai 1902, p. 217.

2. Tanagra figurines, mass-produced, moulded and hollow Hellenistic sculptures dating from between the third and first centuries BC, were highly popular at this period.

3. Salomon and Cogeval, *Vuillard: Critical catalogue of paintings and pastels*, 2003, vol. III, p. 1261.

4. Rodin is reported to have judged Maillol's 'Leda' one of the most beautiful examples of modern sculpture: cf. Bernard Lorquin, in *Maillol: La Méditerranée, Les Dossiers du Musée d'Orsay*, Paris 1986, p. 9.

5. See Salomon and Cogeval, 2003, VII-267, 268 and 269.

Edouard Vuillard
The Statuettes on the Mantelpiece, rue de Calais

been no distinction between living and working in the salon of the rue de Calais apartment which they occupied from 1908 on, cluttered as it was with portfolios, easels, stretchers and canvases and a large plaster-cast of the 'Venus de Milo'. At this date the 'Venus' stood on the same mantelpiece as Vuillard's collection of small statuettes, and the comic disparity of scale between them informs several compositions.[6] In this work, however, he has indulged in a little scene-setting, an informal dialogue between the evenly-matched ancient and modern figurines, perhaps in tacit acknowledgment of the debt Maillol owed to the classical source.[7]

In this spirited painting the role of friendship also played its part. Maillol's painful struggle to effect the transformation from painting to sculpture was one that his Nabi friends had encouraged.[8] Vuillard assisted in a practical way by introducing Maillol to the dealer Ambroise Vollard.[9] A couple of years later Vuillard would embark on a larger painted homage to Maillol, showing the sculptor at work in the garden of his Meudon studio, putting the last touches to the reclining nude that was his 'Monument to Cézanne'.[10]

Belinda Thomson

6. For example 'Madame Vuillard lighting a "Mirus" stove', 1924, Flint Institute of Arts, Flint, Michigan. Salomon and Cogeval 2003, XI-128.
7. It is not clear whether Vuillard's Tanagras were originals or reproductions, most likely the latter. Emmanuelle Héran also identifies Vuillard's Maillol statuette as a 'copy'. See 'Vollard, Publisher of Maillol's Bronzes: A Controversial Relationship', in *Cézanne to Picasso. Ambroise Vollard, Patron of the Avant-Garde*, exh. cat., Metropolitan Museum of Art, New York, 2006, pp. 173-181.
8. Apart from Vuillard, an artist who supported Maillol through painting was Renoir, whose 1908 portrait of Vollard shows him fondling a small Maillol statuette (Courtauld Institute Galleries, London). Maurice Denis paid homage in written form, publishing a book on Maillol in 1925.
9. In 1902 Ambroise Vollard organised Maillol's first one-man exhibition in his rue Laffitte gallery and also instigated the first edition of his small statuettes, 'Leda' included, in bronze.
10. Salomon and Cogeval, XI-116, XI-120.1 (Musée d'Art Moderne de la Ville de Paris).

Anton Henning (b. 1964)
Blumenstilleben No. 286, 2005
Oil on canvas, 50.3 × 60 cm
Courtesy the artist and Haunch of Venison, London, AH2005-144

Henning is known for busy, colourful installations, in which his paintings are usually hung salon-style and surrounded by sculptures, films, painted walls, rugs, lamps, chairs and tables. Specially constructed rooms within room, such as 'Interieur No. 117' (2001) 'Frankfurter Salon' and 'Oktogon für Herford' (both 2005), have a stage-like appearance in that each item has a place and a role within an overall setting. On a smaller scale, tableaux such as 'Cranberry Juice, Virus and Band-Aid' (2006) suggest a more domestic interior—a *belle époque* study perhaps, where one might meditate on a collection that seems diverse at first glance, but which coheres because a discernible sense of taste has brought it together. Henning's unifying factor is the winding, serpentine line with which he creates patterns across all painted surfaces, leading the eye on a chase from work to work and from plane to plane.[1]

1. J. Bader, 'Little Henning-Reader' in *Anton Henning: 20 Jahre Dilettantismus…*, Berlin and Zurich, 2008, p. 8.

Many of Henning's paintings share the generic title 'Blumenstilleben', which usually are still lifes though may not contain flowers at all. 'Blumenstilleben No. 288' (2005)—a similar work to 'Blumenstilleben No. 286' shown here—was included in his show at the Haus Esters in Krefeld, the installation of which responded to the entire building whilst being hung in different rooms.[2] More usually regarded collectively, focussing on one Henning painting in isolation is perhaps unusual, though in the present exhibition one has the opportunity to compare his work with that by other artists and there has been a tendency to liken Henning to painters from all periods, in order to try and understand an artist who is by all accounts characteristically hard to nail down. Whilst looking for equivalents—with Arp or Picasso for example—might make Henning seem less puzzling, it remains difficult to draw concrete conclusions about him. His activities are not prescribed by walls or plinths and he slips too easily between 2D and 3D to be categorised straightforwardly as a painter, sculptor or designer. Whilst Henning undoubtedly uses the conventions of all these idioms, his diversity, and his references to both high and low art, suggests somebody keen to avoid a simple tag.

2. M. Hentschel, J. Hoet & U. Kittelmann eds, *Anton Henning*, Bielefeld, 2006, p. 97.

To continue in a similar vein, by comparing Henning with works by other artists, then it could be said that 'Blumenstilleben No. 286' is vaguely reminiscent of a Dutch interior (a Vermeer perhaps) only darker and more austere. A limplemon light falls onto an object that is somewhere between an arabesque and a clover leaf in an otherwise empty box-like room. The gloomy colours are at odds with the jollier palette of other Hennings (see page 90), which is more representative of his work and it also has a more melancholy air than most other paintings exhibited here. To an extent—as with the other paintings in the last section of the exhibition—this is a portrait of a sculpture: a biomorphic statue in

Anton Henning
Blumenstilleben No. 286

3. R. Cork, 'Out on his own' in *Anton Henning: Sandpipers, Lizards & History*, exh. cat., London, 2005, unpaginated.

4. Duchamp instructed the collector Walter Arensberg to insert an object into 'With Hidden Noise' (1916) but whether it was 'a diamond or a coin' should remain a secret, a work which has inspired sculptures by Robert Morris, Bruce Nauman and Sol LeWitt. See S. Feeke & J. Wood, *With Hidden Noise: Sculpture, Video and Ventriloquism*, exh. cat., Leeds, 2004, pp. 28-31.

a dark-cube gallery. The loopy lines of the sculpture recur in much of Henning's work, whether in the form of actual 3D objects, as decorative effects in paintings or applied to things. At times the line takes on distinctly human qualities: a figure gazing out across a Friedrich-style landscape or lounging on an MR10 and having a smoke, its boggle-eyes like those of a cartoon character. However the line cannot be simply regarded as the portrayal of three dimensions in two. The artist calls it 'Hennling',[3] with the implication being that this character is not just an artist's signature but is a 'mini-me' and stands in for the artist himself. And in 'Blumenstilleben No. 286', 'Hennling' looks as if he is somewhere institutional though it is not clear whether it is somewhere safe or somewhere secured.

We might therefore say that this work is about self-containment; that Henning's painting boxes in its own maker. Whilst no work literally has this ability, we might helpfully compare the painting with sculptures—and not other paintings—since its three-dimensional, spatial quality compels us to think about the inside of the box and to wonder about the secret thing that has been hidden there.[4] However, Henning removes one side of the box, as it were, and reveals an object that's possibly even more curious than we might have imagined—not animal, vegetable or mineral nor a diamond or a coin. The overall experience is rather theatrical and we look into the picture as through a proscenium arch. However a barrier remains—the imagined 'fourth wall'—so that the painting feels intimate without being inviting; we are implicated within the scene, but it seems private and we are not a welcome presence. Here then is the space to which the artist has retreated. Ignoring us, he contemplates instead something through the window to the right. Whilst it is claustrophobic inside this cell, there is a sense of space beyond the confines of the box. Though what is through the window, we wonder, and who else might be looking in?

Stephen Feeke

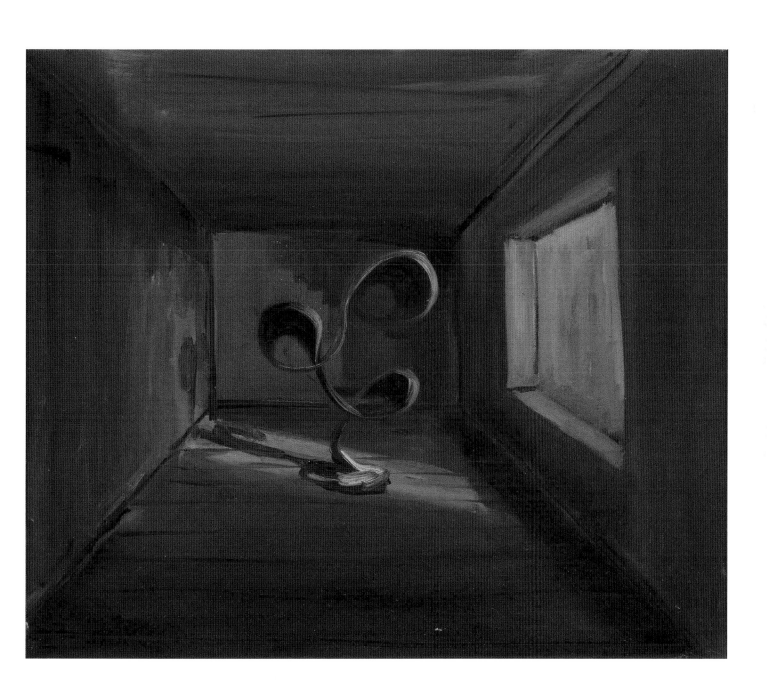

Boris Taslitzky (1911–2005)
Head of Géricault by Lipchitz, 1937
Oil on canvas, 50 × 72.5 cm
Musée des Beaux-Arts, Rouen, 2004.6.1
Don Ruben Lipchitz, 1988

Boris Taslitzky, born in Paris to Russian Jewish *émigré* parents, is best known for his harrowing drawings of Buchenwald concentration camp, executed during his imprisonment there in 1944. An active member of the French Communist party from his early twenties, much of his artistic output both before and after his internment was inextricably bound to his political beliefs, committed to the socialist realist aesthetic and bearing witness to many of the twentieth century's conflicts and international left-wing causes.

However, in his 'Head of Géricault by Lipchitz', Taslitzky's political engagement is not explicitly represented. Rather, this painting centres on Taslitzky's relationship with and reverence towards his two most influential artistic idols, the great French history painter Théodore Géricault (1791–1824) and Lithuanian-born French sculptor Jacques Lipchitz (1891–1973).

From 1935–9 Taslitzky was apprentice in the studio of Jacques Lipchitz. He later declared the sculptor to be the sole teacher from whom he learned anything at all about art. It was Lipchitz, himself an ardent admirer of Géricault, who introduced Taslitzky to the painter's work, encouraging him to visit the Louvre in order to study and copy the paintings on view there. In Géricault's work Taslitzky found preoccupations that chimed with his own; the rights of the people, justice, liberty. He admired Géricault's depictions of *le peuple* (the people), his denunciation of oppression, and his defence of human dignity. He extolled him as a revolutionary, a soldier-painter whose uniform was his artist's smock and his weapons his paintbrushes.

The principal theme, then, of the 'Head of Géricault by Lipchitz' is homage, and it is a theme that works on three levels. The bust represented is Lipchitz's own homage to the painter he described as 'a genius…whom I loved very much'. In painting the bust Taslitzky marks his own homage first to the sculptor to whom he claimed he owed his artistic formation, and second to the painter to whose ideals he aspired. Though only one artist is depicted figuratively, all three painters are in company by being textually inscribed into the work; Géricault's name is emblazoned in clear black capitals, Lipchitz's name is fixed on the crumpled label attached to the bust furthest to the right, and Taslitzky has signed his own in the bottom left-hand corner. Three artists, three inter-relationships, three forms of homage. We are left to wonder why Taslitzky has painted the bust three times?

Formally the painting is somewhat reminiscent of portraits of living sitters such as Phillippe de Champaigne's 'Triple Portrait of Cardinal Richelieu' (1642, The National Gallery, London) and Anthony van Dyck's 'Charles I in three positions'

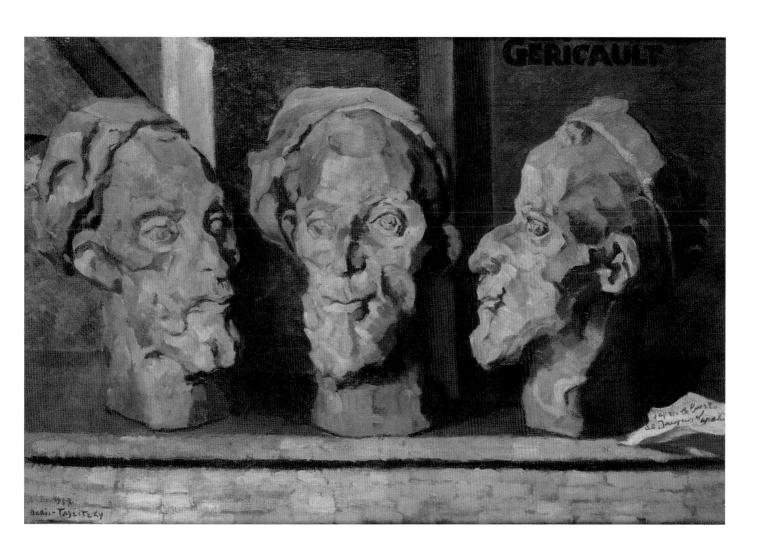

Boris Taslitzky
Head of Géricault by Lipchitz

(1635, The Royal Collection), in which the subject is depicted from three angles in order to provide visual assistance to a sculptor in the making of a bust. However Taslitzky represents the sculpture/s rather than the sitter and his painting conveys a more intimate and informal atmosphere existing between them, implying an almost conversational pose (indeed, the shadow in the left eye of the left-hand bust seems to suggest that it is stealing a glance at the middle bust). Unlike the Champaigne and van Dyck works, where the sitters are placed against an impalpable, indistinct background, the space behind the busts is a clearly defined one, emphasising that these sculptures are occupying the same, genuine space. By painting one bust three times over Taslitzky deliberately plays with our understanding and perceptions of the dimensions of time and space; we are essentially looking at three separate periods of time (during which one bust was placed and painted in three, separate positions) that have been laminated together into one spatio-temporal unit. This manipulation of time can be seen as the key to understanding Taslitzky's aim in the painting. The depiction of the group of busts seems to convey an intimate moment of Géricault's internal communion with himself (or selves); this moment is all the more emotionally charged when one realises that the bust was created from a death mask. If these sculptures are communing with or reflecting upon each other, they are doing so in death. One might thus see Taslitzky's painting as a moving attempt to revivify the dead Géricault, to immortalise the man at the point of reaching the end of his own life. We may read the painting's temporal play as an attempt to reverse time in its creation of an active, animate relationship between the three depictions of a bust which itself portrays the artist at a moment soon after his passing.

Ruth Garde

134

Karin Mamma Andersson (b.1962)
So long Salong, 2005
Oil and acrylic on panel, 94 × 122 cm
Åmells, Stockholm, 7401

Karin Mamma Andersson was born in Luleå, a city near the Arctic Circle in northern Sweden. Here the sun never sets during the short, intense summers, while winters are long and dark. Profoundly distinctive and enigmatic, her painting contains evident references to art history and she has received much international acclaim since the early 2000s.

As the eye looks over a painting by Karin Mamma Andersson, one is led into a space that is anything but straightforward. Here the absolutely authoritarian rules of central perspective do not apply and the painting portrays a multi-dimensional world in a very tangible and visible way. However, the subject is seldom hard to identify and frequently shows interiors of various kinds, as well as places in the open air. Alternatively, by turns, there are paintings crowded with people or otherwise empty; and where people do appear they seem to be kept at a distance—both mentally and physically. The strongest presence in Karin Mamma Andersson's paintings are actually other pictures (and here I include paintings and sculptures). They seem to push through from an underlying source, as if her work was saturated—impregnated—by art.

This applies especially to the painting 'So long Salong' which shows a large room in a museum or, to put it another way, the place where works of art meet the public and become part of the common whole. We see this room from a highly elevated point of view with bright daylight flooding in through tall, narrow windows which create distinctive patterns on the floor. Even though the windows themselves are not seen, the light provides a sense of the room's size. The space seems considerable and has a sparse purity common to most contexts where art is exhibited. The idea is that the place, through its 'neutrality', will not compete for attention, but instead provide a background for the objects on show. If you have ever been in a room like this—or indeed any one of her rooms—then you are familiar with Karin Mamma Andersson's painting.

Sculptures in a modernist style, usually called organic abstraction, are spread out across the room. Karin Mamma Andersson's references are always very particular and in this case she has taken works by the Swedish sculptor Eric Grate (1898–1983).[1] They are placed directly on the floor or on white pedestals and positioned solitarily or alongside each other as pairs. The shadows they cast contribute to the sense of volume but, due to their blackness, these sculptures appear more like silhouettes than bodies of objects and, in a striking way, seem to cut holes in the surface of the picture. The black areas join together and terrifyingly there seems nothing behind the thin veil of everyday existence except utter darkness.

1. See www.grate.se

135

Karin Mamma Andersson
So long Salong

The room in the museum is divided by partition walls which would normally be used to hang paintings, but here we see the surroundings being reflected, although—and this pushes the boundaries of reason—the reflection is identical to its surroundings (which is contrary to how a mirror works) and inexplicably also shows part of a landscape. Stranger still is the somewhat warped repetition of the room within the painting itself. The sculptures and partitions recur but in a completely different hue and the two different spaces are partly complementary; perhaps it may be described as an after image or a double exposure. The permanence of things dissolves and the effect is dreamlike and destabilising in an enriching way.

In a conversation with playwright Lars Norén, published in the Moderna Museet's 2006 exhibition catalogue, the origins of her creative work and its circumstances are discussed with the artist. The matter of finding yourself in different worlds arises and Karin Mamma Andersson says that she has always lived a double life in some sense, because in art fiction and reality are constantly interacting. Apparently this has been very fruitful and in 'So long Salong', as in most of her other paintings, there is a line of sight that switches viewpoints and creates openings leading to unknown aspects. The past, the present and that which is yet to come is all joined together to form a fragmentary whole—contradictory and self-evident all at once.

Niclas Östlind

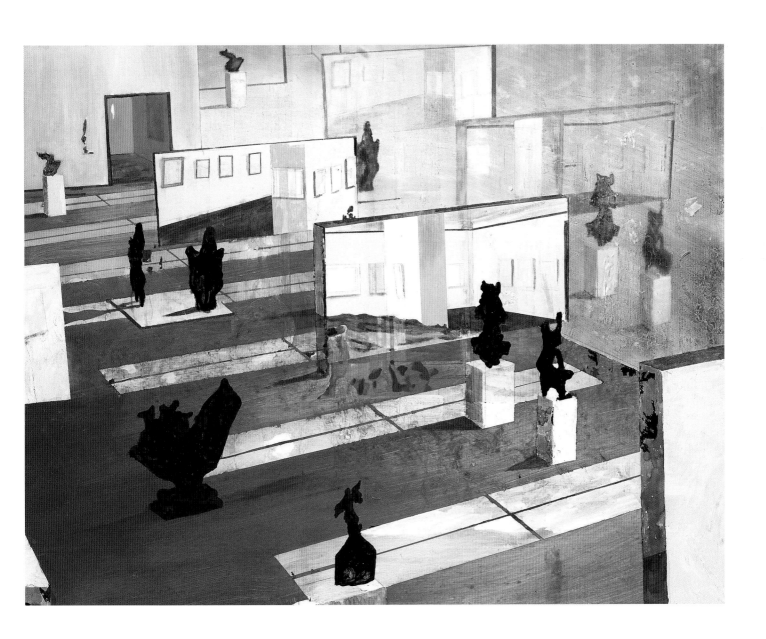

ACKNOWLEDGEMENTS

About half the paintings selected here were discussed in the workshops which preceded the exhibition and guided us in its conception. Most of those who took part are further represented as the authors of this catalogue, and we are grateful to them for their initial support and continued participation. In a few cases potential authors were too busy to accept our invitation to write, or we failed to match a painting to their interests; I must therefore thank here these few exceptions: Elizabeth Cowling, Peter Dent, James Holloway and Jonathan Katz. The workshops were held in 2007 at the The Paul Mellon Centre for Studies in British Art and in 2008 at the Scottish National Portrait Gallery as well as at the Institute, and we are grateful to those institutions for their hospitality. We are grateful in a different way to the eight additional authors who joined our project somewhat later than the others.

The workshops were organised, in the first instance, with Martina Droth, and subsequently with the help of Ruth Garde who also helped us with initial research for the exhibition. The nature of the exhibition was established with the help of everyone at the Henry Moore Institute. I want particularly to thank Stephen Feeke, who regularly brought his energy and commitment to bear on the selection; Gill Armstrong, who helps us all in visible and invisible ways; and Ellen Tait, who has managed the administration of loans and transport.

This exhibition is the first at the Institute to show nothing but painting. In this respect it might be seen as a daring departure, but it seemed somehow especially appropriate to mark the tenth year of the Institute's exhibition programme with an exhibition which shows how we can think about sculpture without showing sculpture, and which asks why so many painters take sculpture as their subject. To celebrate the nature of our enquiry to date, which has been very much about exploring sculpture by looking at what is around it, or at where it is situated, we wanted to stage an ambitious exhibition. That we have been able to realise this ambition, with the diverse and wonderful loans that we have here, is entirely due to the generosity of our lenders. I wish to thank them very sincerely for entrusting the Henry Moore Institute with their work.

Penelope Curtis
Curator of the Henry Moore Institute

CONTRIBUTORS

Fabio Barry
University of St Andrews
David Batchelor
Artist, London
Brendan Cassidy
University of St Andrews
Marie-Claude Chaudonneret
Centre national de la recherché
scientifique, Paris
Viccy Coltman
University of Edinburgh
Martina Droth
Yale Center for British Art,
New Haven
Stephen Feeke
Henry Moore Institute, Leeds
Matthew Gale
Tate, London
Ruth Garde
Independent, London
Vicky Greenaway
Royal Holloway,
University of London
Michael Hatt
University of Warwick
Etienne Jollet
Université Paris X Nanterre
Nicola Kalinsky
Scottish National Portrait Gallery,
Edinburgh
Alex Kidson
Walker Art Gallery, Liverpool
Catherine Lampert
Independent, London
Alastair Laing
The National Trust

Jacqueline Lichtenstein
Université Paris Sorbonne-
Paris IV
Amanda Lillie
University of York
Anna Lovatt
University of Nottingham
John Milner
Courtauld Institute of Art, London
Niclas Östlind
Åmells konsthandel, Stockholm
Martin Postle
The Paul Mellon Centre for Studies in
British Art, London
Elizabeth Prettejohn
University of Bristol
Ann Simpson
Scottish National Gallery of
Modern Art, Edinburgh
Ann Sproat
Henry Moore Institute, Leeds
Belinda Thomson
Independent, Edinburgh
Ben Tufnell
Haunch of Venison, London
Genevieve Warwick
University of Glasgow
Gregor J. M. Weber
Rijksmuseum, Amsterdam
Michael White
University of York
Jon Wood
Henry Moore Institute, Leeds
Richard Wrigley
University of Nottingham

Printed to accompany the exhibition
Sculpture in Painting

Henry Moore Institute
10 October 2009 – 10 January 2010

Curated by Penelope Curtis
Coordinated by Stephen Feeke and Ellen Tait
Technical supervision by Matthew Crawley

Catalogue prepared by
the Henry Moore Institute,
The Headrow, Leeds, LS1 3AH
www.henry-moore.ac.uk

Text © the authors and The Henry Moore Foundation

Catalogue edited by Penelope Curtis

Texts on Aubry and Bonnat translated
by Penelope Curtis, text on de Wit by
Deborah Shannon

Catalogue coordination and
picture research by Gill Armstrong
Designed by Thomas Desmet,
Studio Luc Derycke, Ghent
Printed by Lannoo, Belgium
Distributed by Cornerhouse
(www.cornerhouse.org/books)

ISBN 978-1-905462-28-5

The Henry Moore
Foundation

The Henry Moore Foundation was founded by Moore in 1977 to
encourage appreciation of the visual arts, especially sculpture. Its
responsibilities are preserving Moore's legacy at his Hertfordshire
home and in exhibitions worldwide; funding exhibitions and
research at the Henry Moore Institute in Leeds; and awarding
grants to arts organisations.